S T O R I E S

eleven aboriginal artists

S T O R I E S

eleven aboriginal artists

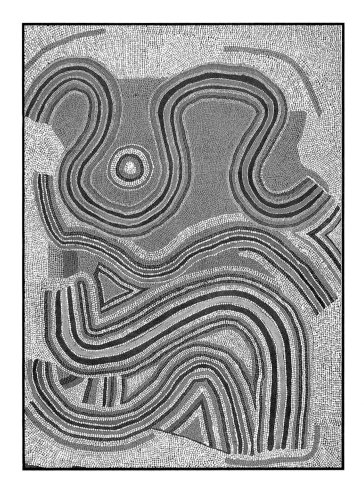

Edited by Anne Marie Brody

CRAFTSMAN HOUSE
An Art & Australia Book

This publication has its genesis in *Stories: Eine Reise zu den großen Dingen*, an exhibition catalogue published in 1995 by the Sprengel Museum, Hannover. The project was commissioned by the Australia Abroad Council for Erlebnis Australien '95. 'Stories' was shown at the Sprengel Museum, Hannover; the Museum für Völkerkunde in Leipzig; the Haus der Kulturen der Welt in Berlin; and the Ludwig-Forum für Internationale Kunst in Aachen. With the exception of a new introduction, one that better reflects the place of this publication in a largely Australian context, this English edition of *Stories* remains substantially the same as the original with minor revisions, corrections and updating of the text.

Distributed in Australia by Craftsman House,
20 Barcoo Street, Roseville, Sydney, NSW 2069,
in association with G+B Arts International:
Australia, Canada, China, France, Germany, India,
Japan, Luxembourg, Malaysia, The Netherlands,
Russia, Singapore, Switzerland, United Kingdom,
United States of America

ISBN 905 7041 31 6

Designed by Kerry Klinner
Printed by Kyodo Printing, Singapore

Frontispiece:
Water Dreaming 1987
synthetic polymer on cotton duck
91.5 x 122 cm

CONTENTS

Foreword **6**

Acknowledgments **7**

Introduction: A Journey around 'Big Things' **9**

Peter Skipper DUNCAN KENTISH **18**

Jarinyanu David Downs DUNCAN KENTISH **32**

Eubena Nampitjin and Wimmitji Tjapangarti CHRISTINE WATSON **49**

Rover Thomas ANNE MARIE BRODY **63**

Emily Kame Kngwarreye ANNE MARIE BRODY **75**

Maxie Tjampitjinpa VIVIEN JOHNSON **89**

Abie Jangala ANNE MARIE BRODY **100**

Ginger Riley Munduwalawala DJON MUNDINE **113**

Jack Wunuwun DIANE MOON **126**

Jimmy Wululu DJON MUNDINE **139**

The Artists **146**

Bibliography **174**

The Authors **176**

F O R E W O R D

Collecting and promoting the work of Aboriginal artists has been a strong focus of The Holmes à Court Collection for many years. When Robert and I first became interested in Aboriginal art in the late 1970s, it was mainly to be found in museums, consisting as it did of traditional bark paintings, ceremonial objects and artefacts. During the early 1980s, when Aboriginal art was 'discovered' by the wider art community, many of these pieces found their way into public and private collections, and a strong focus was on the acrylic paintings on canvas and board which came from communities such as Papunya and Utopia. These pieces began to be seen as important contemporary artworks in their own right without the need for tribal or ethnic definition.

We were very fortunate, during this time, to be able to acquire extensive bodies of work by individual artists in order to trace their development. We also became involved with community-based projects. In the Utopia community, for example, a number of women who had previously worked in batik were given acrylic paints and canvases and produced a wonderful array of paintings. It is believed that this was Emily Kame Kngwarreye's first experience with painting in acrylics.

The original exhibition, 'Stories—A Journey Around Big Things', was put together for a tour of Germany as part of the Australia Abroad Council's Experience Australia '95 project. It tracked the works of eleven Aboriginal artists through their personal lives and art careers. This book is a development from the German catalogue and updates the information on the artists and their stories.

Anne Brody is to be congratulated on her dedication to this project—as curator of the German exhibition, and thus the works illustrated in this book, and as editor of the catalogue for the exhibition and now for this publication. She introduces the artists and their works with her thorough and compassionate understanding of Aboriginal people, their lives, language groups, the regions in which they live and the ways in which they go about producing their artworks.

I hope you will enjoy both the visual and the biographical stories presented in this book.

JANET HOLMES À COURT

ACKNOWLEDGMENTS

THE HOLMES à COURT COLLECTION

Belinda Carrigan — *Manager*
Anita Danby — *Administrator*
Karl Wiebke — *Technical Co-ordinator*

The following people are acknowledged for their assistance and support in relation to this project: in particular, Janet Holmes à Court, Chairman; Darrel Jarvis, Chief Executive Officer; and the personnel of Heytesbury Pty Ltd: Belinda Carrigan, Anita Danby and Karl Wiebke at The Holmes à Court Collection.

ORIGINAL PROJECT

The exhibition 'Stories: Eine Reise zu den großen Dingen — Elf Künstler der australischen Aborigines. Werke aus der Sammlung Holmes à Court, Perth' was developed and curated by Anne Marie Brody, Curator, The Holmes à Court Collection (1987–95), for the Australia Abroad Council to tour Germany as part of a Department of Foreign Affairs and Trade cultural program, Erlebnis Australien '95.

The exhibition catalogue was produced by Dr Ulrich Krempel, Director, and Elisabeth Bahr, Project Assistant, the Sprengel Museum of Hannover; and Anne Marie Brody, Editor. Invaluable support and assistance were provided at the time of the project by Sandi Logan, Counsellor, Public Affairs, Australian Embassy, Bonn; Colin McKenzie and Jim Meeses from the Department of Foreign Affairs and Trade; and Beverley Copeland of the Australia Abroad Council, Canberra.

RESEARCH

The people and organisations listed below provided invaluable information and advice in the research stages of this publication:

Wally Caruana, National Gallery of Australia, Canberra; James Cowan, Warlayirti Artists, Balgo Hills; Kerry Davies, Broome; Terry Gandadila, Maningrida Arts and Culture, Maningrida; Rodney Gooch, Mulga Bore Artists, Alice Springs; Christopher Hodges, Utopia Art Sydney; Andrew Hughes, Maningrida Arts and Culture,

Maningrida; Vivien Johnson, Sydney; Duncan Kentish, Adelaide; Beverley Knight, Alcaston House Gallery, Melbourne; Mary Mácha, Perth; Diane Moon, Sydney; Djon Mundine, Museum of Contemporary Art, Sydney; Adrian Newstead, Coo-ee Aboriginal Art, Sydney; Warwick Nieass, Broome; Belinda Scott, NIATSIS, Canberra; John von Sturmer, Sydney; Anthony Wallis, Aboriginal Artists Agency Limited, Sydney; Christine Watson, Canberra; Barbara Weir, Alice Springs; and Daphne Williams, Papunya Tula Artists, Alice Springs.

DOCUMENTATION OF WORKS OF ART

The Story documentation for the works of art in this publication have been provided by the following individuals and organisations:

Peter Skipper and Jarinyanu David Downs: © Duncan Kentish, Adelaide
Eubena Nampitjin and Wimmitji Tjapangarti: courtesy Warlayirti Artists, Balgo Hills
Rover Thomas: courtesy Mary Macha, Perth
Emily Kame Kngwarreye: courtesy Mulga Bore Artists, Alice Springs
Maxie Tjampitjinpa: courtesy Papunya Tula Artists, Alice Springs

Abie Jangala: courtesy Sharon Monty, Perth
Ginger Riley Munduwalawala: courtesy Alcaston House Gallery, Melbourne, and Sharon Monty, Perth
Jack Wunuwun: courtesy Maningrida Arts and Culture, Maningrida
Jimmy Wululu: courtesy Bula Bula Arts, Ramingining

CATALOGUE PHOTOGRAPHY (WORKS OF ART)

John Austin, Perth

PHOTOGRAPHS OF ARTISTS

Jarinyanu David Downs: Duncan Kentish
Abie Jangala: Nic Ellis courtesy the *West Australian*
Ginger Riley Munduwalawala: Mario Borg courtesy *Sunday Age*
Eubena Nampitjin: Robin Beesey
Peter Skipper: Tracey Moffatt
Rover Thomas: Martin van der Wal
Maxie Tjampitjinpa: courtesy the *West Australian*
Wimmitji Tjapangarti: Robin Beesey
Jimmy Wululu: courtesy Federal Capital Press of Australia
Jack Wunuwun: Martin van der Wal

I N T R O D U C T I O N

A J O U R N E Y A R O U N D ' B I G T H I N G S '

tories presents the work of eleven Aboriginal artists accompanied by short biographical stories which weave together aspects of their personal histories and artistic careers. Readers of this book should keep in mind that *Stories* was originally conceived as an exhibition for a German audience and produced within all the parameters – time, space, audience – that such an exercise imposes. Moreover, works that were new to Europeans will possibly appear 'historical' to Australian eyes. Aboriginal art is not exempt from the fate of other contemporary art which quickly passes into history bearing a revised classification. These artists in *Stories* are destined to become, in due course, the 'old masters' of a modern movement. The majority of works in this publication were produced around the end of the 1980s and the beginning of the 1990s. An exception is the group of five paintings by Rover Thomas from the mid-1980s. Such chronological dislocation is not intended to convey the impression that these periods represent the peak of these artists' careers. Because *Stories* originated as an exhibition, several factors were involved in determining its shape and content. It had been preceded in Europe by 'Aratjara: Art of the First Australians', an impressive chronological survey; *Stories* aimed to look at a select group of artists at close range. One unstated intention was to maximise the diversity of aesthetic information that even such a relatively small exhibition would carry. The earthy, eroded surfaces of Rover Thomas' early works were chosen in favour of his later, more refined, works, and the shimmering, unsteady dotting technique of the husband and wife 'painting team', Eubena Nampitjin and Wimmitji Tjapangarti, was favoured over the geometric perfection, the neat dots that are a hallmark of much desert art. In short, consideration was given to expanding the audience's experience of Aboriginal art as well as to 'stories', the exhibition's theme. It should perhaps also be mentioned that while all the artists in *Stories* have made a major contribution to the contemporary painting movement, their inclusion here is not intended to imply any canon. *Stories* is not about any top ten (or eleven), although all in this publication would more than qualify.

The writing of life stories is a centuries-long tradition in Western culture, but the stories of Aboriginal people are only beginning to be told in Australia. The current inquiry into 'The Stolen Generation' is one of the first opportunities that a wide cross-section of the Aboriginal community have had to tell their personal stories in public and talk about the hard things they have experienced under oppressive administrative policies. During the 1980s, however, a significant number of Aboriginal writers did emerge, mostly from urban and rural centres. These writers took up the Western genre of autobiographical narrative and made it their own. The voices of non-English-speaking, indigenous Australians from traditional communities have largely been 'heard' through art and art-related contexts. The writing of Aboriginal artists' biographies, particularly those of 'traditional' artists, is also a recent phenomenon, but one which has ventured a long way from the 'anonymous tribal craftsman' and 'artist unknown' labels of the recent past. Even the journalistic tendency, which evolved in tandem with the contemporary art movement, to treat 'bush artists who came to the city as colourful curiosities with a passion for op-shopping and excursions to the zoo' is gradually receding. But it is not so long ago that print and radio interviewers were thrown, at least momentarily, by the fact that the artists they were seeking to interview were from Australia and spoke another language.

Any attempt to locate Aboriginal life stories in a biographical context involves the challenge of tracking information that we take for granted. The categories that one would normally seek to fill in writing an artist's biography cannot easily be defined or even found. Matters concerning place and date of birth, education, art school, aesthetic influences and affiliations with other artists and groups — such things are elusive. Chronologies are particularly difficult to establish for the older generation of 'bush' artists. This is not to say that they live 'outside' of time, but that time is constructed in terms that are meaningful to them. There are no 'births, deaths and marriages' statistics for people who were not even included in the census until 1967. Some of our historical landmarks, such as the Second World War and the Whitlam era, have inserted themselves into indigenous chronologies by virtue of their impact on people's lives. Abie Jangala, for example, was one of many men from remote communities who were drafted into the army at the outbreak of the war, and the Whitlam government brought in policies of self-determination and land rights, which radically changed the lives of many. However, it is reasonable to say that the challenge of eliciting biographical information has tended to place an unbalanced emphasis on the exotic, 'mystical' sources of Aboriginal art and on the Dreaming. This is not to deny the paramount significance to people of their Dreamings or their stories, but is more a comment on how little we know Aboriginal people, including the icons of the art world, as individuals. They are, after all, contemporary people as well as contemporary artists, with the same concerns as the rest of us.

All but one of the eleven artists in *Stories* grew up 'out bush'. English was not their first language and in some cases neither was it their second or third. With the exception of Maxie Tjampitjinpa, whom Vivien Johnson describes as a 'child of the settlements', whites were not a part of the world into which these artists were born. They were raised in the traditional way in places remote from urban and even rural Australia but nonetheless, sooner or later, were affected by its culture, politics and policies. For many, their first encounters with whites occurred in childhood. For Abie Jangala this experience was something of a curiosity, observed at a distance under his father's protection. For others, like Eubena Nampitjin and Emily Kame Kngwarreye, the experience was traumatic; they were terrified and felt vulnerable. Remoteness for these people was short-lived and has remained relative ever since. While historical circumstances have forced most to lead expatriate lives, their places or 'countries' of origin constitute their primary personal story and point of reference. Between them they represent at least seven different language groups —

Anmatyerre, Warlpiri, Wangkajunga, Kukatja, Mara, Djinang and Gupapuyngu — which identify them in the same way that a French-speaking person might be considered French. Language and country are mirrors of personal and group identity and form a rich confluence of meaning in people's lives.

A common thread runs through the biographies of these artists, although their personal histories and experiences are, as one would expect, quite different. They are all initiated, ritually senior members of their societies and have been involved in the art business for at least a decade. Most of them worked for a period for whites in the cattle industry and as labour on Aboriginal settlements and missions. In more recent times they were obliged to exist on social security or 'sit down' money, some having greater opportunity than others to also maintain traditional economic strategies based on natural resources. It is highly likely that the paths of all of these artists crossed different forms of Christianity at some point. However, if painting is any evidence, the late Jarinyanu David Downs is the only one to have taken it to heart. Downs' preoccupation with the ancestors of Christianity, particularly the lawman–ancestor Moses, fed his natural talent for speculation and synthesis, a position that left him ambivalent about some aspects of his traditional culture. However, the importance of Wangkajunga culture in his life and art does not seem to have been diminished by his encounter with fundamentalism, which rather seems to have given him a zest for rethinking his relationship to the traditional world as well as the wider one he travelled in as a contemporary artist. On the whole, all of these artists remained philosophically and spiritually committed to their religious culture and their roles within it as 'Lawmen' (and women). The importance of culture in people's lives is brought sharply into focus when ceremonies are held. These important gatherings of traditional owners and custodians run according to seasonally significant schedules known colloquially as 'business time'. On these momentous occasions, initiations take place and powerful forces coalesce along the clan and kin networks which form at special sites to realign themselves, socially, politically and spiritually, with the traditional order of existence laid down in the Dreaming.

'What's your story'? has become part of the Australian vernacular. Such a question implies a degree of familiarity — personal and cultural. It is up-front, a touch aggressive and demands something personal in response. To be asked for one's story is fundamentally a matter of producing an identity. It is not a question that most white Australians could comfortably put to an Aboriginal person, particularly someone from a bush community. The question does not translate easily across the cultural divide and besides, for most of us, Aboriginal identities are still merged into a bundle of stereotypes. The growth of the Aboriginal painting movement has meant that one possible response many Aboriginal people can make to questions about their personal stories is to describe themselves as artists. The role of artist is much more immediately accessible to non-Aboriginal people than traditional identities such as *kirda* and *kurdungurlu*, desert terms for custodian and caretaker of country. It is as artists that most Aboriginal people from remote areas are known in Australian cities. And art is one of the few 'languages' in which Aboriginal people have been able to communicate with outsiders on relatively equal and often superior terms. Indeed the notion of being an artist has become so entrenched in Aboriginal culture, within a short generation, that it is possible for children, some with few career prospects and role models, to imagine their own futures as such. But, lest one lapse into romanticism, in the words of one ingenuous four year old from Alice Springs, it is more a matter of: 'If I grow up I am going to be an artist'.

The men and women in *Stories* all became artists relatively late in life, through the initiative of community-owned arts cooperatives or else the adult education programs which preceded them. These coops have generally been managed by whites, in the capacity of art advisers, who mediate the whole business process from the supply of materials to the point of sale. Many of the advisers who have worked for Aboriginal communities have been artists themselves on a journey of discovery, or else were

people affiliated with the art world who also brought a collaborative and empathetic spirit to the enterprise. This is one of many symbiotic relationships which originated with the contemporary Aboriginal art movement and its centrality and importance should not be underestimated. The internal workings of the painting movement have themselves been extraordinarily colourful and bear the characteristics of many a frontier enterprise. An undeniably impressive humanist endeavour, the 'art business' is also replete with its own stories involving entrepreneurs, tragedies, farce, rivalries, comedies and carpet-baggers. But the best story rises above such profanities and distractions and belongs to 'art'.

One 'big story' that nobody imagined at the start of the 1980s concerns the way that numerous Aboriginal people living in bush, rural and urban communities would become, in the course of a decade, makers of art and 'travel it' in and around white culture. This transformation was a dauntingly fast but nonetheless evolutionary process, which rolled itself out during the 1980s. It was not simply a matter of people taking up canvas and paints and becoming artists, although the proliferation of Aboriginal art in the 1980s and 1990s might make it seem like that. However, before that could happen, before any image could be put onto canvas, a consensus had to be reached within each community about what could be painted and by whom. Each work of art that leaves a community and becomes public takes shape, at the highest level, on the basis of an *a priori* consensus. This is a matter of traditional Law, not art. Each community that became involved in the art business went through this process, particularly after the Papunya Tula group, on whom they were all modelled, had painted first and endured later the consequences of inadvertently revealing too much Law and story. The contemporary Aboriginal art market did not exist when the Papunya artists started painting in 1971, although it came to exist because of them. They started painting with some prospect of selling their work in mind, but they had no real conception of the places and circumstances in which their works would be seen and circulated. Their focus was more immediate; their works were statements, documents, about stories and country far away from their actual circumstances in a demoralising, administrative settlement. Indigenous artists today participate in an art environment that is well known to at least some members of their communities who have been to exhibition openings in Australia and overseas, and spent time participating in the system. But the paintings that are credited with starting the movement were not conceived as works of art by artists. This attribution has been imposed in retrospect and no doubt those 'painting men' from that era who are still alive would be astounded at the prices that those first works command today at auction.

One of the complexities of studying Aboriginal art is that the paintings we see on gallery walls are authorised versions of other forms of art that are hidden from our gaze. Ceremony is the inside, sacrosanct context and source of the contemporary painting movement. For Aboriginal artists, true aesthetic importance and power reside in the ritual artefacts and enactments of ceremony. In the production of contemporary art, ceremonial forms of expression are left behind, hidden at the heart of the culture where they belong. It is simply one of many fascinating conundrums surrounding contemporary Aboriginal art that what Westerners perceive as significant and powerful through the lens of art is not what these traditional men and women perceive as powerful and significant through the lens of their culture. Nonetheless, the accumulated knowledge, experience and authority that ceremonies invest in individuals over a long period of time leave their mark on paintings made for the art world. This is what gives the ceremonial body markings, effortlessly reworked in the linear paintings of the late Emily Kame Kngwarreye, a charisma beyond formalist abstraction. This numinous quality is present in many contemporary works of art, and intuitive observers can recognise its presence, blurred in the depth of field that forms each painting's context. It is the quality that many collectors search for in paintings and that art workers refer to when they say that Aboriginal art will never be the same when the older generation or

particular individuals pass away. The human and cultural dimensions of such losses are profound.

The notion that every Aboriginal person is an artist is a commonplace that is often invoked to 'explain' the phenomenon of the contemporary art movement, its overwhelming dimensions, and indeed the notion of a whole society predisposed to making art is an enviable one. This truism does at least remind us of the fact that Aboriginal culture works, perhaps more than any other culture in the history of the world, with aesthetic forms and systems and that Aboriginal people possess visual intelligence and skills of the highest order. Does this make every Aboriginal person an artist? The evidence would suggest not, at least not in terms of the standards and definitions of the art world. It is evident that art has opened up a new space on the traditional cultural landscape. This is a place where individuality, originality and idiosyncrasy, aspects of art and creativity that the West has cultivated since the eighteenth century, are able to flourish. These subjective, psychological spaces have been taken up by some Aboriginal artists more than others and their communities have, on the whole, made room for them, despite the disruptive potential (and reality) of an alien and elitist arts system.

It is clear, however, that every Aboriginal person is not an artist in the way that Rover Thomas, Emily Kame Kngwarreye, Jarinyanu David Downs and others in this publication are all artists. On one level, this has a lot to do with accidents of circumstance and timing, and with the methods of the art market which declares its prejudices and singles a few out of the crowd for special treatment. But it also has to do with the fact that art has exerted a stronger gravitational pull on certain individuals. These are people who have lingered in the spaces opened up by art and seriously taken on the role of artist. As artists, they have established a personal heritage as though it were, like country, their birthright, stories and country continue to be central — these artists could not imagine, create or dream a significant world, in life or art, in any other terms. But for someone like Ginger Riley Munduwalawala, painting is something more than story according to traditional definitions — it is *his* story too. This is revealed in the remarks he made about possibly going to Beijing to see the commission he painted for the Australian Embassy: 'People will know me next time I go to China. They will say this is Ginger Riley's painting and there's the bloke now. That's the way I want it'.

Recently, I saw a video on Balgo art and artists which showed an old man, John Mosquito, talking about one of his paintings. This work was, from one perspective, a superb example of abstract art, yet the artist's lively engagement with his painting was not something that one associates with abstract art. There was no intellectual distancing or anything like the physical respect that one expects to see in the presence of delicately surfaced minimalist paintings. His hands worked across the painting as though it were written in braille as he spoke about things that were happening in places defined by formal rectangular zones. This video vignette was a very direct reminder of the fact that the land itself is a very big story or a place made up of little stories webbed together. However right (or wrong) we are to appropriate these Aboriginal works of art as abstraction, for our own pleasure and interest, this is really only a very small part of their story. This video image of John Mosquito and his painting made a forceful point about the fact that traditional art, in particular, needs its makers to speak for it. These artists never really talk about their paintings as isolated aesthetic objects. Such conversations will always revolve around three key things — 'my painting, my story, my country'. These three things are the bones of a conceptual universe in which metaphoric understandings, the ability to image one thing in terms of another, are seminal. Painting — country — story express, as best an alien sequence of language can, the connective tissue of identity, meaning and art.

Very few contemporary works of art come onto the market with a ready-made story, although they subsequently accumulate numerous texts and contexts, and most Aboriginal art travels with a

certificate. It is virtually de rigueur for an Aboriginal painting to be sold with a certificate of authenticity which includes a photograph or diagrammatic sketch of the work purchased and some notes as to its story. This document, the absence of which makes some buyers nervous, is reminiscent of the papers Aboriginal people once needed to move from place to place. The certificate is the painting's permit, conferring the necessary authority (authenticity) for it to pass across into the art world. What version of the story or story fragment the collector ends up with on their certificate may depend on a number of conditions and circumstances. It could, for example, come down to how busy the art adviser doing the documentation was on the day; there might have been people present that the artist did not wish to speak in front of; or the manager might be someone new who did not yet have the confidence of the artist. Such hypotheticals are not cited in order to diminish the importance of these story texts per se, but to question the extent to which their value lies, as it is often purported to do, in the areas of iconography, authenticity and meaning. What do or should people make of these bits of information when they look at a picture on the wall? The story documentation for the works of art included in this publication is virtually in its pristine form, frozen as if at the moment of purchase, as a means of exploring the relationship between the painting and the story, the work of art and its possible meanings. One highly important function of the ancestors of the Dreaming is naming, and all of the stories, or fragments of stories, that enter the art world as documentation for paintings bear an aspect of this function. For an outsider, these texts name and map the identities of people, places and events and, in however small a way, enlarge our knowledge of the indigenous cultural landscape.

Stories are governed by the same restrictions under traditional Law as designs and images. The story that an artist gives out to put on the certificate is, or should be, an authorised 'edited' version. There are many details and aspects of stories that are only known to initiated people and available to be used by them in the proper context. In committing a story to canvas, an artist is working with a coded information system, some of which is open, some closed to outsiders. The aesthetic process, painting stories, becomes a matter of negotiating different kinds of disclosures, of imaging the story in ways that meet other (non-art) requirements. From an indigenous perspective, authenticity is chiefly a matter of authorisation. The degree of negotiation involved in finalising the story documentation for this publication was a salutary reminder of the fact that the personal use of stories and images in art is a matter of extreme sensitivity. A painting might be considered to have revealed too much story through image, text or even the title. If this situation should arise, there are very real consequences involving perhaps minor discontent or possibly major conflict.

It is the long process of education and acquiring knowledge through initiation and ceremony which gives artists their 'editorial skills' and authority over content. Such authority does not exist in isolation. It is also a form of power that is held and exercised in relation to other custodians. Art is thus an extended family affair and infringements of the traditional value system through the improper use of cultural material are a threat to the inheritance of the whole group. It is in this context that painting for the market has the potential to become volatile. These pressures have resulted, at one end of the spectrum, in safe pictures which can, although not necessarily, lead to different kinds of routinisation. The opposite can also be said to happen when artists are engaged in a formalist negotiation of their imagery, when such pressures may sharpen the edge of creativity. One only has to look at the history of Western Desert art to see how dotting techniques have been used to develop new aesthetic strategies based on concealment and disclosure or what the art world calls innovation. Personal style has everything to do with the way that stories are represented. The visual system of desert art, based on a sparse vocabulary of symbols, is an immensely rich medium in the hands of an innovative and creative talent.

The superficial resemblance of much desert art to abstraction means that it can be appreciated and valued to a certain extent beyond its immediate cultural context. This is also true, to a lesser degree, of figurative art. With figurative art, however, the story is more of a necessity to its audience. Explanations of pictorial narratives, the iconographic branch of art history, are something of a Western requirement. Many Aboriginal stories and images do work together in an overt iconographic relationship and in one instance in *Stories* this was the artist's formal intention. Jack Wunuwun's *Morning Star Cycle* or *Barnumbirr Manikay* was conceived as a means of instructing his daughter Sherron and also *balanda* (white people) in his clan's stories. This thirty-one part series is arguably the most conventional narrative work in this publication, certainly by Western standards and possibly by *yolngu* (Aboriginal) standards. Wunuwun eschewed esoteric, symbolic forms, except for the configuration which represents the clan waterhole at the heart of the story (and the centre of the large painting). The stories are presented in a stylised, naturalistic manner in which everything is identifiable to some extent (if not in detail) and named. All this is in keeping with Wunuwun's intention for this work. His striving for visual and narrative clarity, expressed in the paintings' exquisite technical refinement and precision, had a didactic purpose. Wunuwun once revealed to Diane Moon his great concern that stories were being lost: 'We only know part of the story; if our great grandfather were here, he could have told us many more ...'. This beautifully ordered work is the outcome of his wish to use painting as a means of putting his story together in one place (the work of art) for the benefit of future generations.

Metaphor is a strong feature of indigenous intellectual systems, which is one of the reasons why stories which move along endless trajectories, taking this turn or that across the geographical and spiritual landscape, can also be present in a single person, rock or tree. The smallest things might have the biggest story. Jarinyanu David Downs is the only traditional artist to have brought the Ancestors, as people, so vividly into our imaginations. Downs' figures often 'wear' their stories on their persons, in the form of ritual paraphernalia and designs. The story also comes to life in the personalities he creates for them. His paintings of single figures, suspended in the space of a work of art, are posed before us, standing (or is it floating?) on their inflated feet, bearing witness to their whole story. There is a great deal of subjectivity and autobiography in Downs' work, detectable in his quirky portrayal of the Storm Ancestors, Japingka and Kurtal. At the time that he painted this work, Downs and Peter Skipper were, as senior Lawmen, the living representatives of these two Ancestors, and this relationship seems to have given a wonderful human dimension to his portrayal of their epic encounter. Japingka and Kurtal could be standing on a street corner as well as at a junction in the landscape where their two 'big' story tracks intersect and go their different ways.

Autobiographical and historical subjects have gradually been edging their way into the traditional story repertoire and also into paintings, although it would be misguided to categorise such subjects as non-traditional. It is more a matter of the traditional story culture having its own dynamic capacity to absorb new or different elements. Dream visitations, which are a not uncommon psychic phenomenon in Kimberley culture, are one medium through which new stories and imagery come into being. Rover Thomas' paintings of massacre stories from this region are based on oral histories but they are, as well, independently authorised and sanctioned by tradition, having been given to him in a sequence of dreams. It should perhaps be remembered, at this point, that although 'Dreaming' is a most inadequate word in relation to what it sets out to encompass, dreams themselves are a significant and powerful psychic principle and source of creativity in traditional Aboriginal culture.

The Krill Krill corroboree is constructed around a series of songs centred on the spiritual journey of the artist's recently deceased 'mother'. The woman's journey, back from where she died to her clan homeland, is creative and revelatory; she sees and hears the voices of the massacre victims and names

Dreamings belonging to the places she passes through. Her story, revealed to Rover Thomas in a sequence of dreams, is that of a strong woman-spirit, a powerful seer who gathers into her vision all that unfolds on her homeward journey, weaving her own rich narrative. Places, people and stories — historical and Dreaming or both — are drawn into an extraordinary work of art, a corroboree–opera, the Krill Krill. No less extraordinary is the psychic exchange between Rover Thomas and his 'mother', between the communicative power of the dead and the receptive power of the living, through which a new songline and contemporary Dreaming can be said to have come into being. Rover Thomas' paintings of the Krill Krill have extended the cycle of exchange and included us in the gift of stories that began with a sequence of dreams.

Concentric circles, lines, dots, animal tracks and body markings are the most familiar story imagery in contemporary Aboriginal art. Most story documentation for desert paintings generally describes the meaning of these symbols for a specific work of art. These symbols have standardised meanings that can be read by anyone, for example a circle is a campsite, but it is also well known that they have extended meanings. Such symbols are in fact highly mobile visual–story metaphors. What a particular configuration of symbols signifies in one artist's work may be quite different in another's. The meanings that reach the general public will again be different and less than the resonant meanings they hold for the initiated who are educated in manipulating and interpreting this sophisticated visual system. In the case of desert art, story documentation is often useful for determining the basic outline of the subject of a painting and performs the simple iconographic function of attaching names to arcane symbols. While it is satisfying to know a place name, identify an animal track and know that a rock represents an ancestor, such documentation leaves much unsaid. The quality and power of a work might well be due to the iconography being not literal but metaphoric. Thus symbols are pivotal elements in desert art, but its point of departure, the paintings themselves, have extended meanings (aesthetic) that are not exclusively tied to them. The works of Abie Jangala and the husband and wife team, Eubena Nampitjin and Wimmitji Tjapangarti, are cases in point which reveal, at least in visual terms, opposite approaches to the representation of stories.

Abie Jangala's 'first painting' consisted of *kuruwarri*, graphic symbols comprising circles, curved and straight lines, and iconic bird tracks set out in a formal symmetrical design against a field of mostly white dots. It included some dotted areas suggestive of topographical features, in ochre colours. In time he came to place less emphasis on coloured background patterning and preferred the underpainting to be done in a specific shade of green rather than reddish brown or black. Abie Jangala made this change in order to restrict the colour in his paintings to his *kuruwarri*, ancestral designs or story signs. He played with these designs, calligraphically drawing them out across the surface of the canvas. The green underpainting had the effect of lightening the background, turning it into an enlivened zone on which to draw his powerful designs, creating an effect whereby all the elements in the painting have an aura of perpetual radiance. In this respect Jangala's work appears to have a deep kinship with ceremonial artforms, especially ground paintings.

In the work of Wimmitji and Eubena the land itself, imaged as landscape, is the focus of the story. Their exquisitely detailed paintings represent places where a story is happening. Narrative references to the ancestors are embedded in the scene, the country, and one can follow the storyline visually with the aid of the documentation. But the impact, the holding power of these images, is something more than we would normally attribute to narrative art. Rather it resides in the concentration of emotion, knowledge and experience of the places they represent. These scenes are Eubena's and Wimmitji's Mont Saint Victoire, their 'haystacks'. These small-scale works have the preciousness of miniatures; to look at them is like lifting back a veil from a treasury. The artists'

technique, sometimes called the shaky dot style, is similar to that of other senior Balgo painters, although more distinctive. Their manner of painting most probably does have something to do with age and infirmity, but it is also surely the effect of great sensibility, of hands working to create a shimmering, numinous surface, one which reflects the soul of a place.

Many of the paintings by Maxie Tjampitjinpa and Emily Kame Kngwarreye, at first glance, display few features that would clearly identify them as Aboriginal art. Symbols, the overt story signs of desert art, are often absent. Yet just as the smallest stone may hold the biggest story, what is imaged on the surface, and however minimal it may seem, still serves as a visual metaphor which symbolises the whole. Maxie Tjampitjinpa's *Flying Ant Dreaming* is a landmark work in which circles, lines and dots have disappeared. Instead we see masses of shed ant wings formed by an innovative technique involving a flurry of impressionist brushstrokes. The result is a work of art that looks abstract but which is more a micro view of a natural phenomenon, a close-up of flying ants in metamorphosis. A similar kind of interest in the surface of things is evident in his later *Bush Fire* paintings; in this instance, it is the appearance of the land after fire that engages him. Both works represent states or conditions of transformation — the massed ants shedding their wings and the surface of the charred land, poised between destruction and renewal. Metamorphosis (animal into human; ancestor into country; spirit into matter) is central to indigenous concepts about creation and creativity. Transformative processes are also an integral feature of ceremony and include evanescent events such as when an individual, wearing the proper body designs, becomes an Ancestor for a brief, powerful moment. The transience of these dramatic events is also reflected in the way that, at the end of ceremonies, ground paintings which involve much time and labour are erased and de-sacralised. Maxie Tjampitjinpa seems to have taken the idea of transformation and linked it to his detailed observations of natural phenomena and, in the process, reinvented impressionism, a classic Western technique for imaging states of flux in nature. However, it is something more than nature which attracts his vision. When Maxie Tjampitjinpa takes a naturalist's interest in flying ants and bushfire, he does so as both a ritual and an aesthetic specialist. In indigenous terms, nature is a totemic domain and *Bush Fire* and *Flying Ant Dreaming* are both stories, part of the artist's Warlpiri heritage.

If one must borrow, in the absence of an indigenous aesthetic vocabulary (at least for contemporary painting), some Western art terminology, then one would be tempted to call Emily Kame Kngwarreye a great expressionist (although she has also been called an impressionist, which shows up the difficulty and poverty of transferring terminologies). Like all the artists in this book, Emily was engaged in dynamic 'conversation' with her own culture. Like them she was involved in an artist's journey, redefining, recreating and transforming stories into art. There are few iconic referents in her paintings, which has resulted in her whole *oeuvre* taking on the semblance of abstraction. This has placed her work at the centre of a postmodern dialogue, the ongoing conversation between the self and the other. Her work seems to be closer to our modernist aesthetic than anything produced by her peers, although this is in a sense only a marvellous illusion. When asked for the story for a particularly abstract work Emily once replied that her painting showed the 'whole lot, everything'. Apart from pointing to the fact that appearances can be superficial, that there is always a lot more than meets the eye of an outsider, it is also a way of saying that a painting is not just the sum of its stories, that it is a work of art. So much is involved in Emily's paintings — emotion (love of country), knowledge (of stories, places, law), ceremony (the rhythms of women's business), nature (good and bad seasons), experience (hunting, gathering, travelling), to name some of the more obvious. One is tempted to take her remark as a sub-text for the contemporary painting movement — it's the whole lot, everything, that makes these painters artists.

ANNE MARIE BRODY

Peter Skipper

Peter Skipper grew up in the Great Sandy Desert of Western Australia where he was initiated and married and followed a traditional lifestyle until his early twenties. Around 1950 the desert was losing its population in many different directions, in a drift towards fringe camps associated with stations and settlements on the perimeter, where food resources were more reliable. Skipper and his wife Jukana were becoming increasingly isolated and, finally, they too joined the exodus. They were among the last Juwaliny to leave, moving north into the southern Kimberleys[1] where they then worked on sheep and cattle stations for almost twenty years. In 1978 Skipper wrote about this migration:

> In the wet season they eat plant food, Janiya and meat, lizard-meat, lizard and wild onion plants, wild onion.
> In the wet season they eat them, bush-walnuts as plant food, bush walnuts they eat.
> In the sandhills they lived like this the people lived in that former time in the sandhills.
> They were eating meat and plant food. Plants that they ate were various, various. They were eating all kinds of plant food, all kinds of plant foods they ate, until what they ate was finished, a finish to eating plant food and meat.
> Well, they ate meat only, then that finished. And the people they went this way to other kinds of plant food, Whiteman's tucker.
> Well, those people too, they went north to the stations. Then they gave them plant food, the people from the sandhills.
> Those people went for good, never to return. Well, they went on a journey for plant food, Whiteman's tucker.
> Then they stayed there, those people. So they ate the plant food of the Whiteman, and so they stayed there, the people, never to return.[2]

In the mid-1960s Skipper and Jukana moved to Fitzroy Crossing, a small administration and supply depot that soon became a regional population centre as Aboriginal people were forced off stations in the late 1960s, in a savage response to the 1967 High Court's Equal Wage determination. Here they joined the Summer Institute of Linguistics, assisting linguists in translating the Bible and working on a dictionary of the Walmajarri language, which had by then become the main Aboriginal language in the Fitzroy Crossing area.

Skipper started his art career painting small canvas boards for the local tourist market in the early 1980s. I first saw such paintings in late 1986, and was struck by their strength of design and bold use of contrasting bright colours. Some people expressed doubts about Skipper's palette of almost luminous paints, obtained from Burawa Store or else cadged from school supplies or from his artist nephew, Jimmy Pike. These colours were in dramatic contrast to the 'acrylic orthodoxy' that had grown up around Western Desert art in Central Australia, with its insistence that the acrylic palette should attempt to replicate the traditional ochre, kapok and charcoal colours of black, red, yellow and white.

I saw Skipper's work while visiting Fitzroy Crossing, where I had gone to meet and commission paintings from Jarinyanu David Downs. I met Skipper shortly afterwards and was immediately attracted by his intelligence and wit, and an immensity of presence much greater than his considerable physique. These qualities I later saw articulated through a generous sense of vision and responsibility for the wider Walmajarri community, and also in the scale of his art. I asked if he would paint for me and he agreed, though he was initially reluctant to accept the large stretched canvas I offered, it being much bigger than anything he was used to. His first work was *Purnarra I*, 1987, a fairly tentative, simple piece employing hugely expanded design-forms. But Skipper had enjoyed the experience of painting on a large scale and declared that he never wanted to paint small boards again. Initially I was a half-hearted supporter of four-colour 'acrylic orthodoxy', but quickly recognised its logical absurdity. Instead, I gave Skipper a colour chart and ordered from Perth the full range of paints chosen.

After the completion of his first work, communication with Skipper progressed sufficiently for me to ask him to paint 'country-map' images after the manner favoured by Western Desert people. From this point Skipper's style and range of forms began to develop considerably. Many works from this period have an experimental and exploratory feel to them as he met new challenges of scale, technique and representation. His imagery expanded on design elements used in body painting or incised on pearl-shell and wooden artefacts — designs first generated by *Ngarrangkarni* (Dreaming) Creator Beings. His rare human-figure works and paintings which involve idealised maps of country also incorporate these design elements. Here they combine with other forms representing journeys, waterholes and various natural phenomena.

Aboriginal people sometimes have an emotional depth and complexity of relationship towards painted images that is foreign to outsiders. Something of this was demonstrated in the reaction of Skipper's countrymen-brothers when I was collecting his first major 'Japingka' painting to take away to Adelaide. Ostensibly, this was a 'map' image of Japingka Country, a place of great regional significance, but it also suggested a portrait of Japingka Rain Man — perhaps once the most powerful spiritual presence for all Juwaliny. While I was viewing the work in Windmill Camp and recording Skipper's description, many people approached with shining eyes and said to me 'My Story!'. Japingka wasn't simply Skipper's creation — he had an independent existence going back to the beginning of time. Skipper's creative role could more accurately be described as that of invoking or conjuring up Japingka. This was underlined for me after I had photographed the painting and was loading it into

the Landcruiser. Several of the men from Windmill Camp had been standing nearby, and they called out 'Goodbye old man!'. I thought they were addressing me at first, since I was then a bearded forty-one year old, and 'old man' was accordingly regarded as an appropriate term of address — which incidentally I had quite some difficulty getting used to. But Skipper told me they were calling out to the painting, saying they were 'sorry' for that Japingka.

They were excited that Japingka had been so powerfully brought to life, and they were probably responding to the haunting quality of the image and the 'refugee nostalgia' it evoked. It was a strangely beautiful work, with a vague anthropomorphic nuance, and clearly much more than a painting. In fact, it was the essence, the iconic centrepoint of their distant country, which they had not seen for a generation. I had encouraged Skipper to paint Japingka, and now I was loading him into my car as though he were a mere object, dishonouring his integrity and power and reducing him simply to 'art', arguably engaged in Foucault's dark horror of transforming the wonder of birth into an archive. I was enormously impressed with the work, but I knew my response could not compare to theirs. For a moment I felt confused and slightly uneasy with what I was doing, and I asked Skipper for guidance. Should I leave Japingka with them? 'No no! It's all right. You take him', said Skipper, clearly understanding the difference between sentiment and business. Given that religious items and knowledge were traded between groups in the Kimberleys in traditional times, perhaps the notion of selling the conjured presence of Japingka was neither foreign nor repugnant. Besides, Skipper may even then have faintly apprehended the possibilities of using his art to emphasise the message of Juwaliny relationship with land. Certainly this one painting has since achieved tremendous visibility.[3] It was included in the 1988 'Dreamings' exhibition organised by the Asia Society of New York, exhibited in major cities in the USA and Australia, and is still being referred to. But the uneasiness lingers.

Some of Skipper's most significant paintings have been representations of Japingka and Mangkajakura rockholes, which he describes as his two 'main country'. These were created in the Dreaming, which is known locally as the *Ngarrangkarni* or 'Early Days'. This was a time of spatial and social innocence when the features of the country were still being shaped and named, and when great happenings were observed, and languages and customs established. But the *Ngarrangkarni* is far more than history, since every ancient moment is still palpable, part of the present — a timeless unfolding *now*, reverberating in the lives of living people like Peter Skipper. Jila Japingka is the spirit-birth country for Skipper's parents and many other close relations, and all Juwaliny hold it in great awe and affection. Mangkajakura is Skipper's own personal Story and also one of the key paintings in his repertoire.

Mangkajakura is an important spring-soak or *jila* in Walmajarri language, roughly 400 kilometres south to south-east of Fitzroy Crossing, deep in the Great Sandy Desert of Western Australia and slightly west of the Canning Stock Route. It is considerably east of the equally important Jila Japingka. Because of the east–west lay of the intervening sandhills to the north, it is now only approached from Fitzroy Crossing indirectly by vehicle via the Canning Stock Route.

Jila such as Mangkajakura are called 'living water' in local Kriol English, because they never dry up, though they are sometimes buried by drift-sand which has to be dug out to reach the water. *Jila* are contrasted with surface water-soaks called *jumu* which do dry up in hot weather. Once the sand at Mangkajakura has been dug out to reveal surrounding rock-ledges, the water is very clean. Mangkajakura is often painted by Skipper with a dense surround of concentric circles to indicate its steep sides and depth down to the water. The rock-ledges are sometimes represented by scalloped forms. The Mangkajakura *Ngarrangkarni* epic recounts the origin of the Mangkaja bird at

Wiringarrijarti, evidence of its special powers, and its long journey south to Mangkajakura where it sank into the earth and created the rockhole-soak there.

In 1991 Peter Skipper and Jarinyanu David Downs were both included in the exhibition 'Aboriginal Art and Spirituality', which was held at the High Court in Canberra to coincide with the Canberra meeting of the World Council of Churches. In recent years the connection between Aboriginal art and spirituality has been confidently assumed rather than discussed in detail. For traditional Aboriginal people, the issue of spirituality in art is closely related to the way in which they are authorised to paint particular Story-images. Generally, traditional artists only feel permitted to paint subjects associated with their own personal identity or that of their local group — commonly referred to as 'painting my country'. Designs left in the land by an Ancestor Being may potentially be available to everyone connected with that country. At a more intimate level a person may paint his own particular Story. This might be accompanied by the singing of sacred verses detailing Ancestral actions which resulted in the initial 'birth' of his child-spirit at some identified site in his country. Associated rights may also allow a person to paint the personal stories of parents and other close relatives. Skipper's fidelity to the concept of authorisation can be appreciated in his strict choice of permitted stories, and in his use of traditional Juwaliny design-forms to develop the imagery of his paintings.

But orthodoxy itself doesn't guarantee brilliant artworks suffused with spirituality. Local assessments of Aboriginal art also include guarded aesthetic judgments, and arguably these appear related to the presence or absence of 'spiritual' energy. 'Good Story! — painting, he little bit', an artist might reflect on one of his lesser works. Politeness rules, but oblique comments about the work of other artists also occasionally surface. Usually these take the form of generous praise for the best pictures and faint affirmations for the more ordinary — a local version of the damning art-speak comment 'interesting'. Of course, admitting the possibility of 'bad' Aboriginal art quarrels with the orthodox view that Aboriginal art productions *are* all suffused with spirituality — and hence aesthetic splendour — because they are images that arise from the land, which is itself permeated with spiritual energies. In reality, anyone can paint, but only some people are artists.[4] And even the best of artists have their off days, for aesthetic excellence is an elusive feat. In these terms, the best of Skipper's paintings represent a happy confluence of good authority and great aesthetics.

Skipper's right to sing, talk about and paint Mangkaja Story is authorised by the fact that his spirit was identified as having originated from Mangkaja waterhole. His father and mother were camped near Mangkajakura, gathering and eating Ngurjana seeds. After eating, Skipper's father saw Skipper's *murungkurr* or baby-spirit in a dream, and told his wife 'One boy been coming to me — little baby — *murungkurr*'. Later he told Skipper his *jarriny* or totem was Ngurjana seeds, evidenced by a flattened area on the upper back section of his skull caused by the action of the grindstone on the seeds. Skipper's identity is focused on the Mangkaja bird which created the waterhole at Mangkajakura. His spirit *is* the bird, and really originated at Wiringarrijati, where it separated from the flock of Mangkaja birds camped there.

Marawali refer to cursive body painting designs used in Juwaliny country by the travelling Two Men or Nganpayijarra, known as Watikujara by Western Desert people. The travels of the Two Men link neighbouring groups over vast distances, but also authorise cultural uniqueness through their sequenced use of the languages and designs of the countries they passed through. *Purnarra* designs are more angular and had a different origin, resulting from travels through Juwaliny country by the Tingarri Men. These designs were incised on shields and pearl-shell pubic coverings. However, Purnarra can also refer to patterning in a more general sense, including body painting, patterns found

in natural phenomena — and even modern clothing designs. During his 1989 Sydney exhibition, Skipper bought the striped shirt shown in his photograph. 'Purnarra!' he announced with satisfaction. Skipper sees these designs as both a kind of 'signature' for the country and a form of inexhaustible 'wealth' for its people. This 'signature-wealth' is all around them, expressed in patterns within natural phenomena, such as sand-rippling created by wind and water, lightning, wood-eating insect tracks, and the maze effect of sandhill-ridge formations. It is also expressed in painting.

Skipper's first solo exhibition was held at the Craft Council Gallery, Sydney, in 1989. The space was a National Trust classified, ancient sandstone wool store of enormous proportions, and perfectly suited to the scale of Skipper's paintings. The effect was even greater, as the images all seemed to extend outwards beyond the canvas. Skipper was somewhat overwhelmed by the impressive line-up of some twenty-eight works from nearly three years of painting. 'This is all my stories', he said. 'The whole lot. I've got no more. Everything is here.' Usually operating in the cultural shadow of Anglo-Celtic Australia, this singular exhibition of his own Juwaliny imagery and culture moved him profoundly.

DUNCAN KENTISH

NOTES

1 The plural form is favoured by Kimberley people, though the singular is used when context requires.
2 B. Hodge & V. Mishra, *Dark Side of the Dream: Australian Literature and the Postmodern Mind*, Allen & Unwin, Sydney, 1991, pp. 93–4 (Skipper's text re-translated from Hudson & Richards, 1976–84, pp. 5–6).
3 P. Sutton (ed.), *Dreamings: The Art of Aboriginal Australia*, exhibition catalogue, Viking, New York, 1988, see reproduction, pp. 100–1, and 227.
4 Dr John von Sturmer, personal communication, July 1996.

MANGKAJAKURA I 1987
SYNTHETIC POLYMER ON LINEN
121.5 x 183 cm

PURNARRA V 1987

SYNTHETIC POLYMER ON LINEN

183 x 121.5 cm

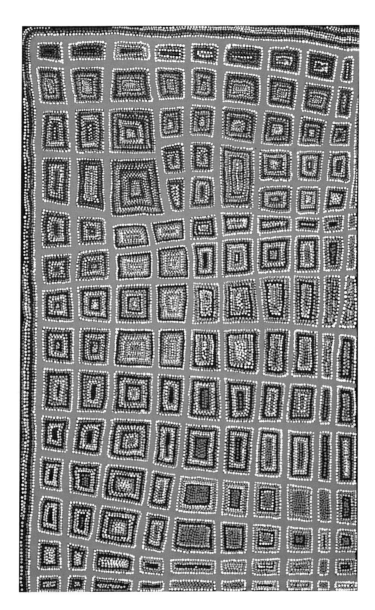

KURRKUMINTI KURRKUMINTI 1987
SYNTHETIC POLYMER ON LINEN
198 x 121.5 cm

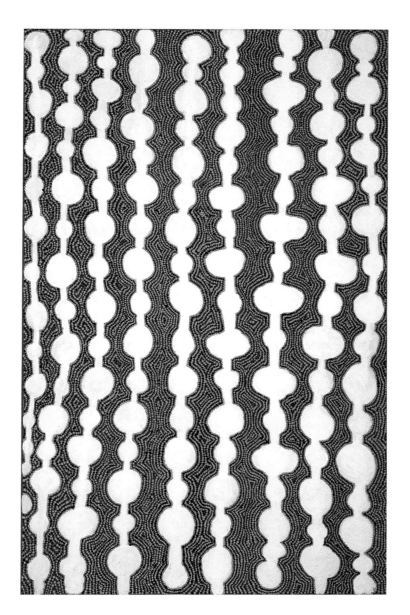

JILJI 1988

SYNTHETIC POLYMER ON LINEN

182.5 x 121.5 cm

MEN STANDING ON OTHER MEN'S SHOULDERS 1988

SYNTHETIC POLYMER ON LINEN

152 X 106 cm

S T O R I E S

P E T E R S K I P P E R

M A N G K A J A K U R A I

Mangkajakura is an important spring-soak or *jila* in Walmajarri language, roughly 400 kilometres south to south-east of Fitzroy Crossing, deep in the Great Sandy Desert of Western Australia and slightly west of the Canning Stock Route. *Jila* such as Mangkajakura are called 'living water' in local English, because they never dry up, though they are sometimes buried by drift-sand which has to be dug out to reach the water. *Jila* are contrasted with surface water-soaks called *jumu* which do dry up in hot weather. Once the sand at Mangkajakura has been dug out to reveal surrounding rock-ledges, the water is very clean.

Mangkajakura waterhole is Skipper's conception site and the place where his spirit was born, and the nearby soaks of Milparnta and Malajapi form part of this Story. The painting shows these three waterholes set within a stretched-grid representation of east–west parallel sandhills. The image poetically celebrates this east–west lay of the country with its line-up of the three watersoaks along the same axis, though in reality these form a triangular configuration some 1.5 to 3 kilometres apart. When it rains, all three soaks become lakes for a short while. The dotted areas between the sandhills are *parapara* (open country).

Mangkajakura waterhole is the central focus of the painting, emphasised by the north–south fracture across the parallel sandhills at this point, and by the enclosing curved sandhill to the west, complemented by an opposing cluster of terminating sandhill shafts from the east. This enclosure discourse is continued in the framing of Milparnta and Malajapi water-soaks by hook-shaped sandhill-forms — which seem to echo traditional bush-camp windbreaks and perhaps reference the semi-domestic themes alluded to in the Stories about these sites. Fitzroy Crossing is positioned north of the image, following the direction of the north–south fracture, and this intersection of the east–west lay of the sandhills seems to underscore the emotional tensions of contemporary Juwaliny living so far from their country.

Mangkajakura is described by Skipper as his 'main country'. It was created in the Dreaming — known locally as the *Ngarrangkarni* or 'Early Days'. This was a time of spatial and social innocence when the features of the country were still being shaped and named, when great happenings were observed, and languages and customs established. In this time, some people were travelling east from near Broome. They came up to a big mob of Mangkaja birds sitting in front of them at Wiringarrijarti. The people wanted to knock down these Mangkaja and cook them. But they missed them every time they tried, because the Mangkaja were really spirits and couldn't be knocked down. They missed them and all the Mangkaja flew off east. But one Mangkaja flew south to Mangkajakura where he stayed. This place was his country now. This Mangkaja was Peter Skipper: 'I belong to Mangkajakura. I came from Wiringarrijarti — that's where they missed me — and I flew away and landed at Mangkajakura'.

The Two Men or Nganpayijarra were travelling from the east when they came up to Mangkajakura

where they found that Mangkaja bird sitting in a hole. They were frightened and said 'Watch out!'. But after a while they said 'Let's go and see it close up, eh?'. So they came closer and saw the bird sitting in the waterhole. 'Ah! It's that Mangkaja.' Both men called its name. 'It's that Mangkaja sitting down. So we'll call this waterhole Mangkajakura.'

The *Ngarrangkarni* Mangkaja is still living deep inside the soak at Mangkajakura. People can't see him. When they dig out the soak they only dig halfway. 'We can't dig anymore — the Mangkaja might be there — Old Man.' When the Mangkaja bird sank beneath the sand, he turned himself into a water snake — the symbol for death and transformation and also the Story-marker for a 'living water' — denoting the active nature and permanence of the spring.

Skipper's unborn spirit or *murrungurr* was born at Mangkajakura during the creation of the waterhole. The Mangkaja bird is ambiguously both his Ancestor and himself. He describes it as being a white bird with a white face surrounded by an outer edge of black, and identifies it as the species called Barn Owl. This is a night bird and is hunted for food.

The ovoid water-soak is Milparnta. In the *Ngarrangkarni* an old woman was camped here with her young daughter. A young boy was also camped nearby, on a big sandhill to the west. The old woman had sore eyes, and she sang to her daughter: 'Go and call that young *Mapurn* [doctor boy with healing powers]. I've got sore eyes and maybe he can touch me and make it better'. But the girl didn't go, and the mother and daughter finished there. The young boy is still camped in that big sandhill. He is also Skipper's *pirlurr* or spirit, transformed from his *murrungurr* condition, anticipating incarnation.

Malajapi is an insignificant water-soak west of Milparnta. But under this water-soak and deep beneath the sand, there is a spring with two cave-tunnels connecting it with the surface some distance away. Inside Malajapi spring there are spirit kangaroos. These can be released by ritually digging at the surface soak, and then, while camped that evening at Mangkajakura, an old man will dream of spirit kangaroos leaving Malajapi through the cave-tunnels. Soon there will be plenty of kangaroos — after it rains.

PURNARRA V

Skipper has painted a series of large-scale works based on the traditional *Purnarra* design-forms carved on shields and pearl-shell ornaments, and also used in body-paint designs. These designs resulted from travels through the country by the Tingarri Men. Purnarra tend to comprise parallel lines and concentric rectangles, and angular maze forms incorporating these elements, such as are found in *Mangkajakura I*, 1987, *Purnarra V*, 1987, *Kurrkuminti Kurrkuminti*, 1987, and *Men Standing on Other Men's Shoulders*, 1988. However, Purnarra can also refer to patterning in a more general sense, including body painting, patterns found in natural phenomena — and even in modern clothing designs.

Marawali refer to body-painting designs used in Juwaliny country by the travelling Two Men or Nganpayijarra — known as Watikujara by Western Desert people. The travels of the Two Men link neighbouring groups over vast distances, but they also authorise cultural uniqueness through their sequenced use of the languages and designs of the countries they passed through. Marawali designs are more cursive, as shown in *Jilji*, 1988. However, the two forms are occasionally present at the same time, and Skipper will sometimes describe a work as both Marawali and Purnarra.

Skipper sees these designs as both a kind of 'signature' for the country and a form of inexhaustible 'wealth' for its people. This 'signature-wealth' is all around them, expressed in patterns within natural phenomena, such as sand-rippling by wind and water, lightning, wood-eating insect tracks, and the maze effect of sandhill-ridge formations.

KURRKUMINTI KURRKUMINTI

This image represents a particular variety of sandhill country in the Great Sandy Desert, composed of intermittent sandhills bordered by open, flat country or 'valleys'. The desert commences some 200 kilometres south-west of Fitzroy Crossing, extending some 400 kilometres further south and some 600 kilometers across. *Kurrkuminti Kurrkuminti* are found throughout this range but are more concentrated in the first 100 kilometres of the northern section. The southern section is more dominated by parallel east–west sandhill-ridge formations, which are represented by *Jilji*, 1988.

Kurrkuminti Kurrkuminti translates as 'every hole, every hole', implying repetition and recurrence. In the image, the dotted rectangular forms represent the compound structure of an outer sandhill rim enclosing an interior depression. These echo certain traditional designs incised on shields. The outer rows of dots represent the sandhill rims, while the varied dotting within each rectangle represents the shallow depression. The 'valley' areas between the sandhills are represented by an irregular grid of flat orange. Skipper differentiates these valleys in terms of their relative 'openness'. The more open valleys are called *parapara*. The 'little bit small ones' are *wirikari*, and the 'skinny ones' are called *wurjuwurju*. These distinctions also mark them as different kinds of country within a broader typology of sandhill terrain. The construction of this image is exactly the reverse of *Jilji*, 1988, where the flat white forms are, at least in part, sandhill-ridges, while the dotted areas between them represent the intervening open country. The subtle irregularities in *Kurrkuminti Kurrkuminti* stimulate a meditative consideration of an almost uniform terrain, and this is assisted further by the cast in the upper centre of the image, created by gradually changing concentrations of paint colour.

JILJI

This painting represents an aerial view of *jilji* (sandhills), joined together in parallel east–west ridges. These formations are interspersed with *Kurrkuminti Kurrkuminti* in the Great Sandy Desert, which commences some 200 kilometres south-west of Fitzroy Crossing, runs over 600 kilometres east–west and extends a further 400 kilometres south. Large, high *jilji* are called *tulku*, and in the southern section of the desert these tend to form into almost impassable east–west ridges. The orientation of the top of this painting is east, reflecting the easier west–east direction of travel preferred in earlier times. Nowadays there are north–south cutlines which have been bulldozed by mining companies, and these provide a certain degree of north–south access.

The flat, whitish areas of the painting represent bright sunlight reflecting off sandhill-ridges. Between these parallel formations, cadmium red underpainting is overlaid with a dazzle of alternating lines of black and orange dotting, representing the open spaces between the ridges. These are designated *parapara*, *wirikari*, and *wurjuwurju*, according to their size, as in the case of *Kurrkuminti Kurrkuminti*, 1987. This open, flat country contains low bushes, spinifex grass and trees, with the occasional rockhole soak or spring. Bushes and trees also grow in the sandhills, some of these being large enough to carve into coolamons (carrying dishes). In some places (not represented in this work) there are breaks in the sandhill-ridges called *jitpari*. This is often the location for soak-waters (*jumu*), and 'living waters' or springs (*jila*) like those at Jila Japingka.

On a later occasion, Skipper revealed that the curvilinear white shapes can also be said to represent parallel banks of clouds commonly seen in this region, and the shadows these cast on the country below. This design–form interrelationship is to be expected, since the travelling Two Men used this cursive *Marawali* form while they travelled through Juwaliny country, and as a result it

remains forever embedded within the land. It will consequently tend to express itself in the forms of the land, such as sandhills, and even the clouds and their shadows.

MEN STANDING ON OTHER MEN'S SHOULDERS

This image was loosely inspired by Skipper's memories of men standing on the shoulders of other men to create human viewing towers in order to orientate themselves in relation to discernible features in the almost uniform undulations of desert country. Skipper encloses the men within *Kurrkuminti Kurrkuminti* type structures, perhaps implying that they are positioned on the outer ridges of sandhills, the highest points in the landscape. The concentric rectangles also reference shield designs which invoke the Purnarra style of regular patterning left in the country by the Tingarri Men.

Jarinyanu
David Downs

Jarinyanu died in Adelaide on 3 April 1995. He had been preparing for the trip across to Sydney for his solo exhibition at Ray Hughes Gallery, opening less than a week later. In recent years he was much concerned with mortality, noting the increasing number of deaths among the members of his own generation. Those who had been born and raised in the Great Sandy Desert were fast disappearing. And this had moved him to make his own arrangements — instructing me on many occasions that if he died, we should keep using his name and exhibiting his pictures, and not follow the convention of name avoidance and destruction of photographs and other personal property usually favoured by Kimberley Aboriginal people.[1] 'I'm different' Jarinyanu would explain, employing his favourite description of himself. He certainly was.

Jarinyanu's radical departure from convention was partly due to his growing awareness of the wider society's concepts of posterity and individual fame — keenly brought into focus by viewing his own paintings in art museums, and the experience of having his portrait painted by Robert Hannaford and then hung in the Archibald Prize at the Art Gallery of New South Wales (now in the National Portrait Gallery in Canberra). But it originated out of the ongoing interplay between his long involvement with the United Aborigines Mission, and his developed identity as a senior Aboriginal Lawman who was also a deeply committed Christian.

Jarinyanu was born near Lake Gregory around 1925, in country belonging to the Wangkajunga language group in the Great Sandy Desert region of Western Australia. Here he followed a completely traditional lifestyle until his early twenties, engaged with desert country in a manner that inscribed a life-long perceptiveness for subtle distinctions of topography, vegetation and weather, and

how these related to the fluctuating availability of different food resources. Each detail was cross-referenced to other forms of desert knowledge, and poetically reverenced through ancient Story-songs.[2] The cultural encoding of these details was imparted to him through extensive journeyings with elder kinsmen which formed preludes to revelatory initiations — first as a boy, and again as a young man, enduring the harsh demands of an ancient tradition. These initiations included tough discipline he described as 'punishment'.

Jarinyanu was ambivalent about his experiences. He was critical of their 'truth' claims, yet in awe of the spirit forces invoked, and sometimes voiced a nostalgic respect for the implacable severity of his own treatment. This last aspect resonated with certain Bible stories particularly mentioned by Jarinyanu, similarly involving extreme levels of 'punishment' being imposed by God and His agents. Many of his paintings reflect this orientation, with disproportionate 'punishments' being inflicted by Ancestor heroes through bushfires, drownings and even the genesis of mortality itself. The image of *Moses and Aaron Crossing the Red Sea* echoes this interest, including a detailed frieze of drowning Egyptian soldiers clinging to their donkeys.[3] Self-portraits, too, occasionally include this theme. His attitude here was ambiguous, identifying sometimes with the self-righteous oppressor, and at other times with the knowing innocence of Jesus the God-child, the Victim Archetype.

In his early twenties, Jarinyanu left his country for Billiluna Station where he learned about station life and stock work. At times he fossicked for gold around Halls Creek, but mostly he worked with cattle, moving between a number of Kimberley stations over the next fifteen or so years. He also drove large mobs of cattle over great distances — across to Wyndham or Broome, and down the Canning Stock Route to Wiluna. During this time he married Mary Anne Purlta, finally settling at Christmas Creek Station where they started a family of four children. Recollections highlighted his role as donkeyman here, transporting stores to the stock camps, and developing a rapport with his donkey team that allowed control through voice commands alone. Indeed, he appeared to engage with all animals as individuals, and this feeling is expressed in his images.

When he was about forty, Jarinyanu converted to Baptist-style Christianity. He was already familiar with Christian teachings through Catholic priests and United Aborigines Mission preachers, who were active in Aboriginal communities in the fringe camps around stations and other settlements. Conversion in the mid-1960s led him to move his family to the mission at Gogo Station near Fitzroy Crossing — then a small administration and supply depot in the southern Kimberleys. In the late 1960s they moved to the mission complex at Fitzroy Crossing, by now rapidly expanding into a regional population centre as Aboriginal people were increasingly forced off the surrounding stations in savage response to the High Court's 1967 Equal Wage judgment. Conversion was undertaken for a complex of reasons, but concern with the devastation caused by alcohol remained central. Indeed, his crusade against grog was original and disturbing, and he stayed uncaring about his own safety, or the apparent futility of his message.

Leaving his own country involved considerable adjustments for Jarinyanu, now far removed from the solicitude of its local guardians. In this new land he had to negotiate huge rivers many times greater than transient desert creeks, and guarded by unfamiliar forces requiring much circumspection. Ironically, Jarinyanu's adjustment to river country may have been aided by his conversion, since this implied acceptance of the rite of full immersion baptism in the Fitzroy River. And just as baptism was viewed as the ritual of incorporation into the local Junjuwa Peoples Church, this same rite probably included a traditional sense of protective introduction to the resident forces in the Fitzroy.[4]

Jarinyanu's conversion led him thereafter to denounce vigorously the contemporary practice of traditional Law. This form of 'witnessing' by converts is still encouraged. At the same time, however,

Jarinyanu continued to paint the epic events or stories still celebrated in such ceremonies, and did so with tender authority. He explained this apparent contradiction quite simply: God is the originating power behind the Genesis creation of everything in the whole world, so it is perfectly acceptable to reverence His powers in whatever form they are locally manifested. God has created rain, and Kurtal is simply a vehicle for the expression of this creation. But more than this, Jarinyanu was a loner, cut off from traditional fulfilment by his rock-solid style of Christian proselytising against traditional Law. Hence his art curiously allowed him to invoke traditional Story-cycles and thus flirt with his previous Lawman identity, while at the same time it granted him a platform to dedicate *all* his artworks as a form of 'witness for Lord Jesus'.

Jarinyanu's cultural background led to an acceptance of Christianity very much in terms of his own Walmajarri philosophy. Local landforms, languages and cultural patterns were all established in the *Ngarrangkarni* or Dreaming, and verified through their mention in sacred Story-cycles. Similarly, Bible Story-cycles provide a basis for comprehending key elements of Western culture, notwithstanding the very different religious language employed. Moreover, since Jarinyanu was a traditional Lawman, and an Elder of the local church, he felt equally authorised — in terms clearly sanctioned by traditional concepts of authority — to paint both *Ngarrangkarni* and Bible stories. His Christian images he painted as a form of evangelism, later incorporating their display into his performance-sermons. These evolved into a kind of 'witnessing', with the congregation at hand to witness this 'witnessing'. When Jarinyanu began his painting visits to Adelaide in late 1987, Moses Story-cycles surfaced out of his experience of attending a Bar Mitzvah. *Moses Leading the Jewish People Across the Red Sea* was the first of these (highly commended in the 1988 Blake Prize for Australian religious art), closely followed by *Moses Belting the Rock in the Desert*.

There is an obvious link between the desert-travelling momentum of both the *Ngarrangkarni* and Bible Story-cycles, suggesting a common cognitive space. This is locally implied by occasional use of the term 'Wilderness' when referring to the Great Sandy Desert — though it was certainly no such thing to Jarinyanu. A sense of commonality was underlined further when he discovered that the Bar Mitzvah was an initiation ritual for Jewish boys, and that it employed the singing of Bible texts. To him, this seemed to offer vital direction for people in Fitzroy Crossing; conceivably, similar induction rituals could be devised to encourage reluctant younger men into Junjuwa Peoples Church.

The *Ngarrangkarni*–Bible link invited theological merging too. Equations were proposed between Kurtal and the inaugural Rain of Genesis, between the Two Men and Moses and God, and between Jarinyanu's Ancestor Piwi and Noah. The same linkage possibly inspired the tentative notion that all Story-cycles might well have Story-sites in Australia, Bible stories being no exception. Jarinyanu vaguely referred to an Adam–Eve site near Geikie Gorge and a Ten Commandments site on Mt Gambier. He also drew a connection between the Piwi and Noah Story-sites by asserting that Owl Man Piwi's deluge of excrement at Jilpinu was washed away by the Flood of Noah.[5]

Jarinyanu's art career in the Western sense began at Fitzroy Crossing in the late 1960s. He started by carving shields, boomerangs and coolamons decorated with incised designs and ochres, selling them to locals and tourists. In 1981 he was privately commissioned to paint a number of works on paper, using local ochres with natural resins as the fixative. These were mostly figurative works, representing Ancestor Beings in human form. Some autobiographical sketches came shortly after. Jarinyanu also did a small number of works on canvas board in this early period, and around 1983 he started decorating shields and coolamons in the same figurative manner. Throughout the 1980s Jarinyanu continued painting on canvas boards, as well as occasionally executing commissions. These involved an increasing use of acrylic paints in combination with ochre pigments. His subject matter

also broadened occasionally to include Christian stories, reflecting his ongoing involvement with the Junjuwa Peoples Church.

I had been impressed by photographs of Jarinyanu's images, and decided to visit him at Fitzroy Crossing in late December 1986. The weather was surreal — over 50°C most days, with 100 per cent humidity — thunder and lightning announcing the coming 'wet', attended by the emergence on canvas of Jarinyanu's heroic Ancestor figures, alive to the drama of their surrounds. Eventually I became his commissioning agent and curator of exhibitions, and a strange sort of kinship developed. Annual painting residencies in Adelaide followed, and slowly I encountered the astonishing power of an intensely focused genius.

Jarinyanu's paintings share similarities with works by other Kimberley artists — particularly those from Turkey Creek — in the construction of large, open forms free of the intensive dotting found in Central Desert art. However, his figurative artistry and emphasis placed on individual personality make him unique.[6] Complex Story-cycles are represented by precisely chosen moments, and the focus of these dramatic characterisations is usually on the human forms of the Creation Heroes. Sometimes his images are based on memories of the ceremonial re-enactment of these stories. This figurative style has parallels in traditional rock art from the Kimberleys and the Victoria River region. Closer to home, there is the unpublished cave art from Jarinyanu's own country near Percival Lakes on the Canning Stock Route. Here the poses of the figures strongly resemble those of Jarinyanu's own early style, but without that singular quality of 'personality' that is virtually his signature.

Jarinyanu created this sense of personality through the construction of figures mostly in frontal presentation, with minimal faces revealing only the eyes and a mouth of white teeth surrounding the tongue. Solemnity is achieved by painting unsmiling open mouths and staring eyes, sometimes showing a dominant white inner core, seemingly highlighting social distance. These contrast with shy or gleeful smiles, and eyes dominated by black centres, implying social involvement. The figures generally have upraised arms which, combined with subtle body asymmetry, suggest individual inflection and interrupted movement. Jarinyanu had an uncanny memory for the detail of body poses, and his figures undoubtedly include elements of portraiture. From his repertoire of such observations he distilled a unique body-signature for each character. He also possessed an innate elegance — the ability to construct sublime body lineaments from a few simple brushstrokes that seemed to come directly from his own body-language mix of occasional awkwardness and the transcending graceful gesture. As a result, his images have a startling immediacy, heightened by an intensity of focus and a display of sometimes heroic proportions — sharply contrasting with his own slight stature. But grand though these paintings undoubtedly are, they are all but a pale after-image of the strength and fragile beauty of their creator. The memory of key dance gestures, a few words of singing, is infinitely more powerful — and haunting.

Being able to sketch the human form with such fluent ease, the activity of painting appeared to give Jarinyanu satisfaction in itself, and the question as to who, where and why — though clearly in his mind at the time of painting — was secondary, so that he often had difficulty identifying his characters after a few weeks. This could cause some distress, and once, when no record was made of an unusual image at the time of painting, he later described the work as 'lost', emphasising that the total image is both the painting and the sung Story-verse which inspired it. His hunger for the simple activity of painting often expressed itself in the reworking of a finished painting to something less, obliterating the casual purity of line and leaving it somewhat wooden. This may have occurred simply because he was still in the mood to paint and had no new canvas. Ideally, he preferred to paint two

canvases at once, creating related but differently inclined figures — having a strong aversion towards replication. Sometimes his 'amendment' compulsion took the form of overpainting elements of the image with those changes that occur in the next 'frame' of the Story-cycle. But then again, a few 'awkward' strokes could sometimes bring that magic of personality to a too perfect figure. For example, he might later find the ring-style 'lifesaver' eyes he had painted too symmetrical, and fix this with a few circling slashes to 'small'im'.

The Dreaming heroes that Jarinyanu painted can also be described as paintings of the 'country' that each one embodies and represents. Painting them allowed long-distance contact with his country and helped maintain some sense of self as being constituted by that country. 'Yapurnu!' he would announce in respect of a looming figure conjured out of the canvas — 'My Country!'. Perhaps as much landscape as portraiture, these paintings challenge the distinction between such categories. Less frequently, he painted explicit 'map' images of his country. These generally employ more naturalistic imagery than their Central Desert counterparts, although Jarinyanu does occasionally include symbolic elements. This kind of painting tends to hover ambiguously on the boundary between the forms being symbolised and their symbolic representation.

Any overview of Jarinyanu's images leaves us with a vision of the artist as religious syncretist preaching the oneness of man. His images are authorised by sung verses from *Ngarrangkarni* Story-cycles, from references to the Bible, and from personal experiences, with symbols and ideas from all sources collapsing into each other with astonishing ease. And overriding all this remains Jarinyanu's abiding concern to conjure forth a single, coherent unity — expressed at the social level by his simple ambition to 'make him whole lot one family'.

Jarinyanu first started using his own Aboriginal name when his career as an artist gave him a real choice, following an involvement with Walmajarri literacy classes. The name David Downs had been given to him by one of his station bosses. Southern Kimberley people tend to hide their Aboriginal name behind their Western name, keeping it quite restricted to guard against possible misuse by enemies. But not Jarinyanu. 'Name from mother — "Jarinyanu" — from beginning! He gotta go front. And *kartiya* [white] name after — "David Downs".' Jarinyanu felt so confident about his developed identity that he was happy for this detail to be known openly, and dismissive of the risks involved. Jarinyanu showed no interest in using his skin-name — Jangkarti — in any formal Western way. This contrasts with the art industry-inspired convention of showcasing 'authenticity' by transposing skin-names as surnames, or second forenames.

From 1986, Jarinyanu signed his works with his three names. In 1994 he chose to add a fourth. Over the years Jarinyanu endured cataract removal and implant operations in both eyes and had been hospitalised a number of other times. In early 1992 he had resigned himself to death. But a much improved quality of life slowly materialised from these interventions, leading him to revise this decision. By 1993 a total transformation had occurred, mirrored in particularly creative artworks. Then in early 1994 he had a dream in which God told him he'd had enough hospital operations with general anaesthetics. From now on he would not have to 'die' again. To mark this circumstance, he would take the name Pirlajangka, meaning 'from the dead'.

Jarinyanu was always unique, being fearless where others of his background and generation are cautious and circumspect. This quite confrontational directness was also present in his speech. 'He'll tell you straight out!' Kimberley people would exclaim in bemused wonder. Everyone who knew him valued the intensely personal quality he brought to any interaction — a disturbingly direct innocence. This same direct quality is the essential feature of his paintings, which is perhaps why they seem to stand for him physically to such a powerful degree. This was particularly apparent in Berlin in June

1995, where the unexpected sight of posters of *Kuruṇgaiya* staring out impassively at street corners and every underground railway station was initially quite shocking. And finally comforting.

DUNCAN KENTISH

NOTES

1 The plural form is favoured by Kimberley people, though the singular is used where context suggests.
2 'Story', 'Law' and 'Ancestor' are rendered with capitals, acknowledging religious respect.
3 See W. Caruana, *Aboriginal Art*, World of Art Series, Thames & Hudson, London, 1993, p. 157, for a reproduction of *Moses and Aaron Crossing the Red Sea*.
4 See J. Hudson & E. Richards et al., *The Walmajarri: An Introduction to the Language and Culture*, Summer Institute of Linguistics, Australian Aborigines Branch, Darwin, 1976, pp. 16–21, for Jarinyanu's description of such an encounter.
5 See also E. Kolig, 'Noah's Ark Revisited', *Oceania*, No. 51, 1995, on the location of a Noah's Ark site in the Kimberleys.
6 See J. von Sturmer, 'Aborigines, Representation, Necrophilia', *Art and Text*, No. 32, March 1989, pp. 133, 144, on the singularity of personality in Jarinyanu's works.

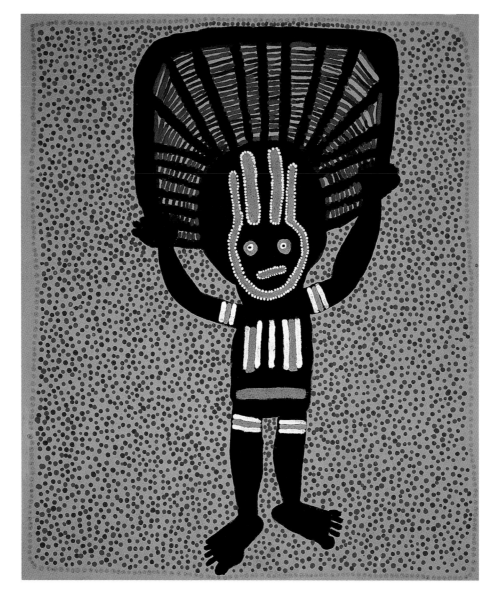

YULKAN 1990
EARTH PIGMENTS AND SYNTHETIC POLYMER ON LINEN
91 x 71 cm

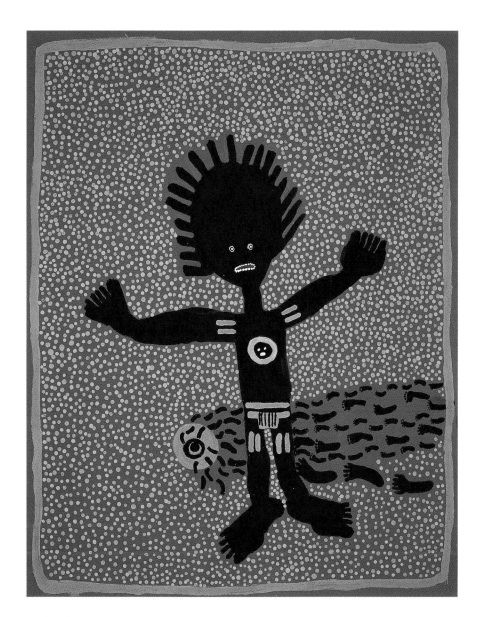

JANGKARRA 1990

EARTH PIGMENTS AND SYNTHETIC POLYMER ON LINEN

107 x 84 cm

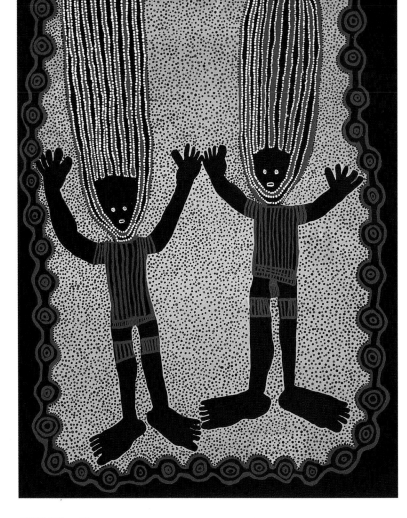

MINIJARTU 1988
EARTH PIGMENTS AND SYNTHETIC POLYMER ON LINEN
152 x 106 cm

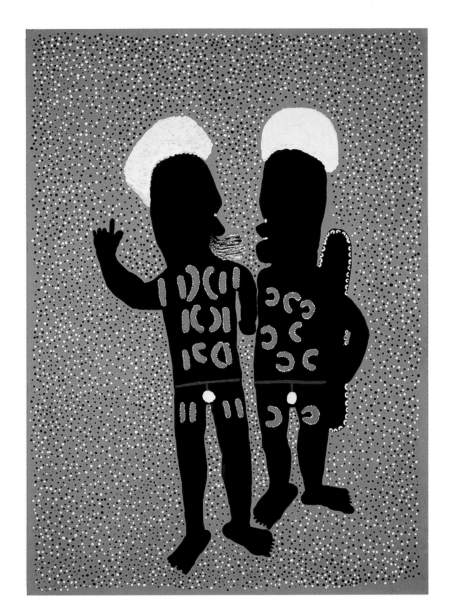

KURTAL AND JAPINGKA PARTING AT NGARANJATI 1989

EARTH PIGMENTS AND SYNTHETIC POLYMER ON LINEN

168 X 122 cm

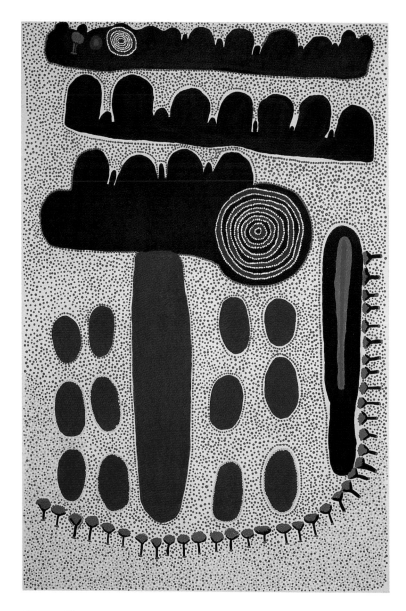

JITIRR 1988
EARTH PIGMENTS AND SYNTHETIC POLYMER ON LINEN
183 x 122 cm

MOSES BELTING THE ROCK IN THE DESERT 1989

EARTH PIGMENTS AND SYNTHETIC POLYMER ON LINEN

152 x 106 cm

KURUNGAIYA 1988

EARTH PIGMENTS AND SYNTHETIC POLYMER ON LINEN

152 x 106 cm

S T O R I E S

J A R I N Y A N U D A V I D D O W N S

Y U L K A N

Yulkan is a representation of a particular kind of unseen malicious force. Jarinyanu takes up the Story:

This is a man devil devil — named Yulkan. He's like Ranjipirri or Jinikan people. We can't see him — he's like a wind. He's holding a Yumpu — like a spider web. Well we can't see that Yumpu — that spider web. When we go travelling — walkabout — well, sometimes Yulkan will chuck that Yumpu in our face and hurt us. When we go back home — might be pain all the way. 'Ah! I'm pain! Too much I been go long way. That bugger devil devil kill'im me!'. [*Malicious spirit beings found in mysterious country to the south-west of Jarinyanu's country.]*

J A N G K A R R A

Jangkarra represents a fearsome ogre from the *Ngarrangkarni* or Dreaming. Jarinyanu has related Jangkarra Story as follows:

Jangkarra is a giant of a man who would eat many kangaroos at a single feast. He would also eat people if he was lucky enough to catch them. Here he has found the tracks of a family group. This made him happy and he opened his arse in readiness and danced — singing 'Ah! my tucker!'. His large footprints show him following the people, but one of them was a* Maparn *or Doctor Man who could see the trouble threatening. The Maparn opened a hole into bare flat rock, and when they had all descended he closed it again and they escaped underground. Jangkarra arrived where their tracks finished and tried to dig out an opening, but he couldn't dig through the solid rock. He then stood for many nights and days with his hands held up in bewilderment and rage at not being able to pursue his tucker. [* Defecated to make room for his next feast.]*

Jarinyanu has recorded this sense of dumb rage in Jangkarra's flexed arm muscles writhing with frustration, while his head of natural 'dreads' or *wawuuru* whip the air. The face on his chest is the 'devil in his heart' urging him to eat the people.

M I N I J A R T U

Minijartu represents two Lizard Men from the *Ngarrangkarni*, wearing striped body-paint designs called *purnarra*. These Minijartu travelled from the west to Wajangari. When they arrived, they stood near a tree and sang, asking themselves why they had come to a place which has a circular red ochre design when they themselves were wearing striped body-paint designs. The Minijartu are shown expressing their dismay at being in the wrong country, and they are swearing obscenely. To return home, they jumped into the river flowing through the two Wajangari ranges. They transformed into lizards as they travelled, with their tails then breaking off from the force of the current. Similarly, the tails of contemporary lizards also break off easily.

The youthful awkwardness of the Minijartu is emphasised by the outsize proportions of their feet, contrasting with their delicate ankles. This innocence is further realised through unusually open body language, including the full-lipped open wonderment of teenage mouths.

The image was painted shortly after the artist received supplies of a rare black South Australian ochre. Jarinyanu often worked with local ochres when in Adelaide, initially assisted by visiting German artist Nikolaus Lang with site information and ochre collection.

KURTAL AND JAPINGKA PARTING AT NGARANJATI

This painting represents the meeting of Kurtal and Japingka, two Rain Men from the *Ngarrangkarni* or Dreaming. Kurtal's home is in Jarinyanu's country, while Japingka is the Rain Man from the country of fellow artist Peter Skipper. Both artists are strongly associated with their respective Rain Men and paint works related to them. Ngaranjati is where the two Story-cycles intersect, and in choosing to paint this event, Jarinyanu is also highlighting his and Skipper's co-equal status as important men — and their implicit rivalry.

In his Story-cycle, Kurtal visited other Rain Men associated with the regions he travelled through, making gifts of food and receiving in exchange powerful gifts to take with him. Sometimes, like other Rain Men, he acquired such precious valuables through trickery and theft, robbing the sites and owners of their former power. At Ngaranjati, on the edge of Jarinyanu's country, he met Rain Man Japingka, also away from his country. Hiding his most important 'gear' behind his back, Kurtal asked him where he was going. 'I'm going home to Japingka', he replied, heading south-west to his country. 'Me too', lied Kurtal. 'I gotta go back home to Kurtal.' He headed south, but then doubled back to actually camp at Ngaranjati, now free of the worry of being robbed as he slept.

Jarinyanu frequently emphasises the short stature and devious side of Kurtal, which he clearly identifies with, and this chosen moment in the Story-cycle gives him full scope.

Kurtal is shown on the right, awkwardly trying to hide his loot behind his back, and lying through his teeth to the straight-up-and-down Japingka. The contrast is nicely reflected in their body language, but also in the body-paint designs. Both are wearing the horseshoe form *wirlan* motif, symbol for an aroused state of weather. Kurtal's weather energy is considerably aroused and clearly aimed at Japingka, whose own designs are more formally stated and contained by *kijiwirr kijiwirr* — meaning 'parallel bars'. Both men wear pearl-shell *jakuli* hanging from hair-string belts, and possess imposing heads of white cloud-hair — features indicating their status as fully initiated senior men. Japingka alone reflects Skipper's condition of then being full-bearded.

The work is unusual in showing the heads of the two figures in interactive profile rather than as a frontal study facing a witnessing audience — emphasising that the cautious relationship between Kurtal and Japingka is uppermost, and that the painting is equally about Jarinyanu's perception of himself and Skipper. This identification of Jarinyanu with Kurtal and Skipper with Japingka is given further elaboration in the placement of the two figures. Jarinyanu–Kurtal is much shorter than Skipper–Japingka, which Jarinyanu faithfully records, but at the same time he has artfully positioned his own character slightly above that of Skipper.

JITIRR

This painting presents an interesting formal combination of both landscape and aerial perspective. It represents country which, according to the artist, belongs to all the Walmajarri mob. This collectively

owned place is known to Walmajarri as Jitirr Mataji. In the upper half of the painting are three ranges of hills or *parma*. In the *Ngarrangkarni* or Dreaming, the Tingarri Men travelled through these hills. A big fight broke out and raged throughout the lower ranges. Large rocks were smashed and many men were killed. The long oval shape adjacent to the hills represents a high sandhill in aerial perspective. It can be seen from a great distance together with the highest hills in the adjoining range. The six oval shapes on either side of the sandhill represent the large rocks smashed from the hills. In the upper left range of hills, there is a *marrapanti*, or rock fig, laden with fruit. These trees provide good tucker in season and plenty of shade. Next to this, a rockhole with good water is shown, located inside a nearby cave.

In the right of the painting there is a lake surrounded by marshlands, where a species of yam grows in abundance. The line of trees forming a curve similar to that of a boomerang refers to the considerable tree population in this country, particularly suitable for making boomerangs.

The profile of alternating large and small hill-forms in the upper half of the painting is one of Jarinyanu's recurring design features, and it has also been employed to represent banks of cloud in Kurtal paintings. The work was painted in Adelaide and directly inspired by trips to the Adelaide Hills, which Jarinyanu declared to be similar, though smaller, to those of Jitirr.

MOSES BELTING THE ROCK IN THE DESERT

Moses Story-cycle paintings first surfaced in response to Jarinyanu's experience of attending a Bar Mitzvah in Adelaide, inspiring his image of *Moses Leading the Jewish People Across the Red Sea* — later highly commended in the 1988 Blake Prize for Australian religious art. This was immediately followed by the present work. Jarinyanu's account of the Story follows:

After crossing the Red Sea, Moses was leading all the Jewish people in the Desert. Everyone became thirsty for water. Lots of people were close to dying. Alright, Moses came up to a big rock and belted it with his stick — broke it open. Inside was a spring — a living water. All the thirsty people drank and went away with Aaron — Moses' younger brother. A little bit later, they made the gold bull and took off all their clothes. Moses went a different way — up the mountain to work with God and get the Ten Commandments.

Jarinyanu represents the people in their thirst-dazed condition with a somewhat chaotic display of footprints. This contrasts with the more ordered representation of their tracks following their renewed vigour after drinking.

The image characteristically shows every stage of the Story-cycle, tracing Moses' journey and that of the people, and including the wielded stick and flowing rock with the people arrayed around the base drinking their fill.

KURUNGAIYA

This work is Jarinyanu's first representation of the Kurungaiya-Jyulpa Story-cycle. These two were brothers from the *Ngarrangkarni* or 'Early Days'. They travelled south-west from Kaningarra (Well 48 on the Canning Stock Route) down to Jigalong near Marble Bar to attend the initiation of young boys. Both men were *Maparn* or 'Doctors', and Kurungaiya carried with him special 'gear'. On the return journey home from Jigalong, Jyulpa went on ahead, while Kurungaiya followed more slowly, killing *Pantapanti* (small goannas) and *Mingajurra* (Golden Bandicoot).

Kurungaiya is shown heavily weighed down by a massive coolamon of food, emphasising his proper concern to provide abundantly for his family. He is also being attacked by wild dingoes, leaping up and biting his legs and lower body, intent on devouring both him and the game. But these are no ordinary dingoes and Kurungaiya is no ordinary man. He dodges and weaves among them and finally throws a 'special' stone at their leader, shown on the far right of the painting, killing him outright. After the other dingoes realised who they were dealing with, they retreated back to their own country.

In this painting, Kurungaiya is wearing a large pearl-shell pubic covering or *jakuli* indicating his status as a fully initiated senior man. The *jakuli* is hanging from a *tungkurl* or hair-string belt, spun from kangaroo, possum or human hair. The body-paint markings on his chest are simply decorative. There is a corroboree or ceremonial dance celebrating this Story, in which the dancer carries a coolamon and weaves around as he represents Kurungaiya trying to avoid the snapping dingoes. Jarinyanu sang and danced this Story painting at the opening of his first Melbourne exhibition.

Eubena Nampitjin and Wimmitji Tjapangarti

The power of Eubena and Wimmitji's paintings struck a chord in me in late 1989 when I organised a large exhibition of Balgo art in Sydney. As I unrolled Eubena's painting of *Nyilla* I was moved by an extraordinary sense of presence which I had not experienced in Aboriginal desert painting before. Intricacy and textural richness — seemingly spontaneous outpourings of dotting, and myriad surface treatments — were controlled in a single powerful composition. Wimmitji's painting of *Kurra* was similar in its plethora of internal contrasts and textures, minute details organised into a subtle, soft unity. Here were master artists, a husband and wife, working in a very similar style, quite different from that of any of the other Balgo painters.

It was Eubena's painting in particular that for me embodied the spontaneity, variety and intense aliveness of Balgo painting and sparked my desire to research contemporary Balgo art. In 1990 I travelled to Balgo in the Great Sandy Desert of Western Australia to gather paintings for another exhibition. When I visited the Art Co-ordinator, Wimmitji was waiting outside the Art Co-ordinator's house. Frail as well as physically small, his eyesight appeared to be failing. In conversation he was intense and excitable and, for myself and most *kartiya* (white people), very hard to understand. A few months later when I consulted the Balgo women about my interest in documenting Balgo painting and was allotted a place in the kinship system to structure my relationship with the community, Wimmitji became a father for me. Eubena, tall, quiet, unassuming, immensely capable, became one of my mothers. As the physically stronger of the pair, her life in Balgo is busy, looking after their physical needs, carrying out responsibilities towards her large family, and hunting for bush food as well as painting.

Eubena and Wimmitji are elders of the Wangkajunga people and as such members of one of the smallest linguistic groups in Balgo (Wirrimanu community). The Wangkajunga people in Balgo were for a long time identified with their western neighbours, the Kukatja, who dominate the population and therefore the affairs of Wirrimanu. The two languages are closely related, though there are a number of significant cultural differences which result in Kukatja people living in the Top Camp in Balgo and Wangkajunga and Walmajarri people living in the Bottom Camp. The Wangkajunga are now increasingly stressing their separate identity and different interests from the Kukatja, Kukatja-Warlpiri, Ngarti and Djaru people living in the Wirrimanu area.

Eubena was born at Yalantjirri, north of Kiwirrkurra some 300 kilometres from Wirrimanu in approximately 1929. Her country extends down the Canning Stock Route to Nyilla, Kaliyangku, Kaninkarra, Tinnu Rockhole, Yikarra and many other sites in the area near Well 33, some 650 kilometres from Wirrimanu. This sand-dune country is probably one of the most remote and inaccessible areas of present-day Australia. Wimmitji was born at Kutakurtal in about 1924. His country centres on Lirrwarti, near the Stansmore ranges between Balgo and Lapi Lapi, approximately 150 kilometres south of Wirrimanu community. He also has links to the country to the south and west, in the area of the Canning Stock Route and Jupiter Well, some 350 kilometres from Wirrimanu.

European Australians first started to have an impact on the lives of Aboriginal people in this area in the 1850s to 1870s when explorers traversed the region. Permanent settlement began with the establishment of cattle stations in the Kimberley in the 1880s, with some Aboriginal people moving to live and work on these stations. Others moved to the church missions which were also springing up. In 1906 Alfred Canning travelled through the lands of the Walmajarri and Wangkajunga to find a route for droving cattle to southern markets. According to people now living in Balgo and to accounts from the time,[1] Aboriginal people helped him to find water. The subsequent fencing off of the waterholes and installing of pumps made the water inaccessible to Aboriginal people and increased resource pressures on them. Though many Aboriginal people did not see white people until the 1940s or even later, nonetheless changes wrought by the introduction of cattle, the disruption to social and ceremonial life caused by population movements to the stations, and difficulties in continuing to move and hunt freely in their land, affected their lives.

Despite the many traumas of contact between Aboriginal people1 and *kartiya*, many of the Wangkajunga and Walmajarri began moving from their traditional lands to the pastoral properties to the north, as did their northern neighbours, the Kukatja, Ngarti and Djaru. In order to lessen the effects of this movement, a Catholic Mission Station was set up on the outskirts of Halls Creek in 1939 by a German Pallottine priest, Father Ernest Worms. Father Worms and the Aboriginal people gathered around him later moved south to Old Balgo Mission.

Eubena was a young woman in the early 1940s when she saw *kartiya* for the first time at Kinyu Well on the Canning Stock Route. There were only men — stockmen taking bullocks to the well to drink. She thought they were ghosts and was afraid they might take her and her baby away. Due to mounting pressure from the cattle industry on their traditional homelands, Eubena, her first husband and their children, came to Balgo in about 1948 with a number of Walmajarri people. Wimmitji's first encounter with white people was in the late 1940s at Balgo Mission. All of his relatives had moved to the mission as a result of similar pressures on their lands, and it had become impossible for him to remain living on his traditional country.

The Perth-based anthropologists Ronald and Catherine Berndt began to visit Balgo in the 1940s. Wimmitji and Eubena later became their informants. As a *mapan* (traditional healer), Wimmitji is one of the most knowledgeable and ceremonially important members of Wangkajunga society in

Wirrimanu. Dreaming stories Wimmitji told to Berndt in 1960 are included in the Berndts' *The Speaking Land: Myth and Story in Aboriginal Australia* (1989).

Like most old people in the area, Eubena and Wimmitji are multilingual. When Father Anthony Peile, a Pallottine priest with wide scholarly interests, came to the mission, Wimmitji was one of the people who taught him to speak Kukatja. Wimmitji also helped Peile to compile the Kukatja dictionary, as well as various articles on medical subjects which he published during his lifetime. Eubena taught Kukatja in the school and later in the Adult Education Centre. She also worked with Catherine Berndt. After the death of her first husband, Eubena married Wimmitji, and no doubt contributed to his work with Father Peile on the dictionary. She seems to have spent much of her time in the 1950s on trips to her country and in the Jigalong area so as not to 'sit down' at Balgo all the time. In the 1960s the growing institutionalisation of the Balgo Mission made it more difficult for her to travel and maintain links with her country.

In late 1971 a group of Pintupi people from Papunya travelled to Balgo for the ceremonial season. They told their relatives there about the painting movement they had initiated in conjunction with the schoolteacher Geoffrey Bardon, through which they were transferring their traditional images onto boards and canvases. The Balgo elders were cautious about following their initiative. This was no doubt because of the dangers of representing imagery connected to secret–sacred ceremonies in permanent media which then entered the public domain. In the years 1973 to 1975 this issue was to create serious social and ritual problems for the Papunya artists. While the Balgo elders debated these issues and whether or not they should paint for the art market, some Balgo men painted privately for Ronald Berndt to assist him with his anthropological work. The Catholic Church also encouraged painting as a medium of communicating Christianity to the local people. By the late 1970s, paintings, probably produced by the younger men, were appearing for sale in the Balgo community store.

In 1980 Warwick Nieass, an Adelaide artist, came to Balgo as a cook. He developed a rapport with some of the senior men and began going out into the bush with a number of the old men and their wives to produce stone sculptures and tools. These stone sculptures were based on a local tradition of carving children's toys, while carvings representing aspects of Ancestral Beings were also used in ceremony. Production of the sculptures ceased in the early 1980s with the death of the old man who had begun making them for sale. Men were painting traditional designs on canvas boards at this time but, while they were happy to produce carvings in conjunction with their wives, they were full of reservations about women and children seeing their paintings, as they considered them to embody *kuruwarri* (Ancestral Power) more strongly than the carvings. The men worked out of sight of the main community and told Nieass, whom they asked to record the works, to be careful of his photographs. Eventually the artists asked Nieass to seek funding for an art centre for Balgo and in 1981 he served briefly as the first Balgo Art Co-ordinator. The old men, however, were still not ready to show their traditional paintings. When the very first Balgo art exhibition was held at the Shinju Matsuri Festival in Broome in August 1981, only the stone carvings, traditional artefacts, and a few landscapes in a Western style were on display.

The Wangkajunga people were less involved than the Kukatja, Ngarti and Kukatja-Warlpiri people in the beginning of the contemporary art movement during Nieass' stay in the community. They were also less involved than these other linguistic groups in the painting 'classes' which Sister Alice Dempsey held at the St John's Adult Education Centre after Nieass' departure in 1982. The rapport which Sister Alice established with women in the community, and the approval given by the senior men for the women to join in the painting movement, eventually resulted in Eubena and

Wimmitji's involvement in these developments. Gradually the male and female artists began to work on their paintings in the same room. Initially the space was divided by cushions to respect the Ancestral Power of the paintings produced by each of the genders. Over time, this division diminished and the artists interacted with each other, adapting from each other's work at high levels.

Eubena was teaching Kukatja in the Adult Education building in 1986 and she began to join in the art 'classes' at this time. In that year she painted three canvases which reflect the influence of the Adult Education Centre. In these works, elements of Western pictorialism and colour were 'blended' with traditional designs and the ochre colours. One of her canvases was included in 'Art from the Great Sandy Desert', an exhibition held at the Art Gallery of Western Australia in Perth from December 1986 to January 1987. This major exhibition, mounted by the Adult Education Centre with assistance from the University of Western Australia's Anthropology Museum, launched Balgo as a new painting community within the contemporary Aboriginal art world.

When a new co-ordinator, Andrew Hughes, was appointed to take over the art centre and develop a new professional art organisation, Warlayirti Artists, Eubena and Wimmitji took a more active role in the painting movement. The artists now started to paint in their own camps instead of at the Adult Education Centre, and it is probable that Eubena and Wimmitji began collaborating on their paintings at this time. (Unlike the Kukatja and the Ngarti, who view it as dangerous for a woman to work on her husband's *Tjukurrpa* (Dreaming) paintings and vice versa, Wangkajunga and Walmajarri men and women often paint together. Authorship of these works is usually attributed to the partner who is the owner of the Dreaming or stories depicted in a particular work.) In this way they developed the shared aesthetic that is unique to their work.

Eubena and Wimmitji's paintings developed and flourished under the new Co-ordinator, Michael Rae, who was appointed in the second half of 1988. At first they worked primarily in brown, highlighted with areas of white dotting or lines. In 1989 they experimented with mixing soft floral colours, pastel greens, pinks and yellows. The complex dotting and compositions that characterise their work became delicately beautiful and opulent. Later in that year a new shade of red and yellow arrived at the art centre. These colours seem to have struck a chord in Eubena and Wimmitji as vibrant Western equivalents of the traditional ochre colours. From that time until the second half of 1993 they worked primarily in red, yellow, white and black, using other colours such as blue, green or pink as subsidiary elements in their paintings. In these works, rhythmic relationships set up between the major visual elements are frequently offset by delicate traceries of white dotting (indicating paths of the Ancestors' movements). These in turn interact with subtle textural fields created by large expanses of monochrome dotting over the ground colour. From late 1993, the palette of red, yellow and pink apparent in *Tapulla*, 1990, characterised Eubena's work. (Pink and red are grouped under the same classification in local colour concepts.) In a development involving a number of other artists in the community in 1993 to 1994, the individual dots Eubena uses have increased in size.

Eubena, now increasingly painting on her own, continues to support her large family and to undertake her duties as a custodian of Wangkajunga women's Law. Her role, as a classificatory mother, in supporting me personally during my stay in Balgo, was immensely important to the successful completion of my research on Balgo women's art.

Eubena and Wimmitji are now among the most famous artists in the Balgo community. Their works appear in major art collections around the world. Although Wimmitji can no longer paint as profusely as in earlier years, when his imagination was gripped by the newness of painting in acrylics and the Dreamings seemed to literally pour from his being onto canvas, he will remain a dominant figure in the art history of the Wirrimanu community for years to come. The mark which Eubena is

making on Balgo painting and on the Australian and international art world is continuing to grow, and is likely to take some years to appreciate fully.

CHRISTINE WATSON

NOTE

1 Peter Biskup, *Not Slaves, Not Citizens: The Aboriginal Problem in Western Australia, 1898–1954*, University of Queensland Press, St Lucia, 1965, p. 82.

AUTHOR'S NOTE

Yakki Gimme, Patricia Lee Napangarti, Magda Lee Nakamarra, Warwick Nieass, Geoffrey Bardon, John Stanton and Michael Rae have all provided information used in this essay. Funding for my fieldwork in the community was provided by the Australian Institute of Aboriginal and Torres Strait Islander Studies.

EUBENA NAMPITJIN

NYILLA ROCKHOLE 1989

SYNTHETIC POLYMER ON COTTON DUCK

75 x 98.5 cm

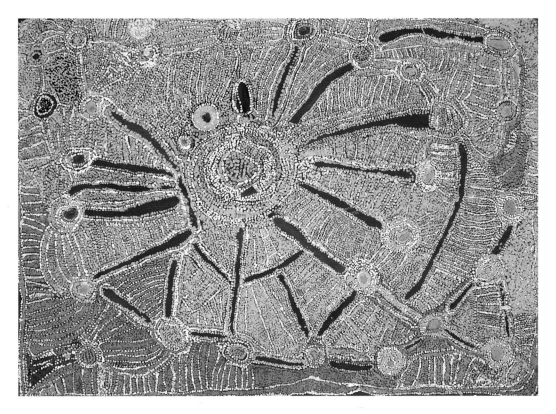

EUBENA NAMPITJIN

TAPULLA 1990

SYNTHETIC POLYMER ON COTTON DUCK

85 x 120 cm

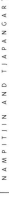

EUBENA NAMPITJIN

MINYULPA 1991

SYNTHETIC POLYMER ON COTTON DUCK

120 x 60 cm

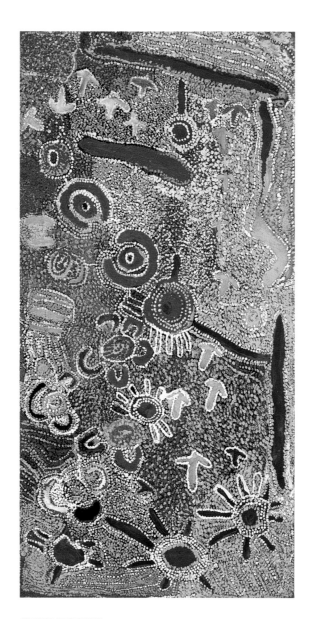

EUBENA NAMPITJIN

YIKARRA ROCKHOLE 1991

SYNTHETIC POLYMER ON COTTON DUCK

120 x 60 cm

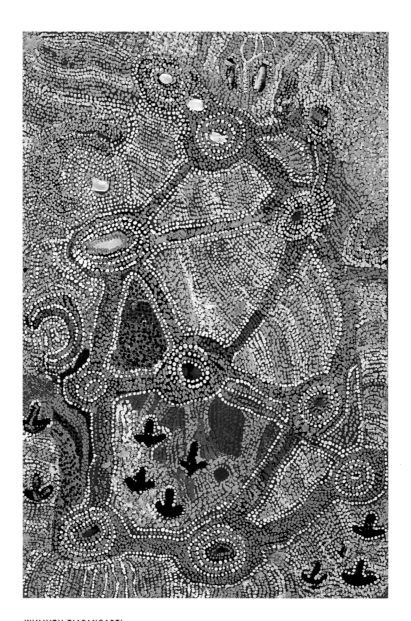

WIMMITJI TJAPANGARTI

KULILLI 1990

SYNTHETIC POLYMER ON COTTON DUCK

90 x 60 cm

WIMMITJI TJAPANGARTI

NYILLA 1991

SYNTHETIC POLYMER ON COTTON DUCK

100 x 50 cm

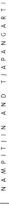

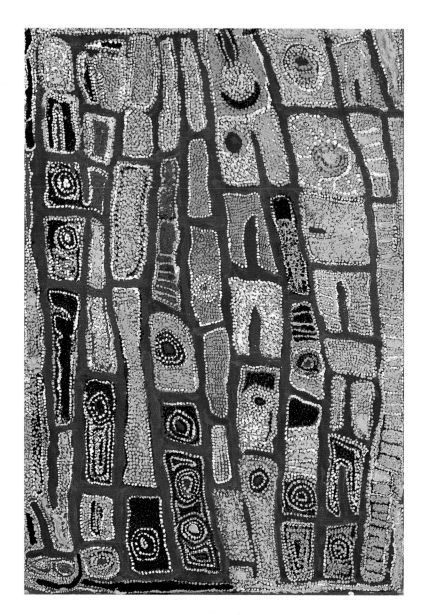

WIMMITJI TJAPANGARTI

MARRANGU 1991

SYNTHETIC POLYMER ON COTTON DUCK

108 x 74 cm

S T O R I E S

EUBENA NAMPITJIN

NYILLA ROCKHOLE

Nyilla is an area in which the artist grew up. This country was formed in the *Tjukurrpa* (Dreaming) by an old man travelling. Illiyarra Creek, shown by the serpentine line, was created as he dragged his spear along the ground behind him as he walked. The three roundels below the creek are the rocky outcrops formed where he knelt. The roundel above the creek depicts Nyilla Rockhole. To the left of this is the old man's campsite, boomerang and digging stick.

TAPULLA

Tapulla Waterhole (the central roundel) is the story-site for an old man called Inyaru. At Tapulla, he was very tired and could not move any further. He decided to stay by the waterhole and is still there today. Two other waterholes are shown on the upper-left of Tapulla Waterhole. The reddish line to the left of these is Inyaru's *nulla nulla* (club). The artist, who grew up in this area, recalled Tapulla's shady mantilla trees which are represented by the spoke and circle configurations radiating out from the central roundel. She also referred to the bush foods there, including *mungil* seeds for making damper. The area around the waterhole is *jilji* (sandhill country), indicated by the long reddish line on the right of the painting.

MINYULPA

Minyulpa is an area in the artist's country in which there are a number of rocky hills. There are caves and other sacred places in these hills, and several waterholes with links to the activities of Tingarri Beings in the *Tjukurrpa* or Dreaming are also located in this area. There are signs in the land, such as sacred trees, which tell people today of these things. This is where the artist spent the first part of her life and she knows of all these matters intimately. The two uppermost roundels are Partawinta and Yarlatjirri waterholes. The reddish area along the top edge of the painting represents hills. The roundels shown lower centre and lower right also depict hills.

YIKARRA ROCKHOLE

The subject of this painting is another area where the artist spent much of her early life. It represents country that was formed by powerful Tingarri Ancestors, including *Kipara*, the Brush-turkey, who travelled around lighting bushfires as he went. His camps and other signs of his activities can still be seen in the landscape by those initiated into these matters. Ceremonies which re-create these Dreaming events are looked after by the ritually senior custodians.
The red bands across the top of the painting are hills. The red roundel in the centre is Yikarra Rockhole. To the lower left, the circles enclosed by curved u-shapes, are Kipara's campsites. The roundels with radiating lines are the bushfires he lit. Brush-turkey tracks are depicted.

KULILLI

This painting depicts part of the Tingarri story-cycle, specifically the travels of a Kipara (Brush-turkey) Man and his family. The story elements which are able to be identified in the painting are Kulilli Rockhole (the centre roundel); the boomerangs and spears (upper left) used by Kipara for hunting and in ceremonies; and his tracks. There are many water sources in this country and he stayed at all of them. It is possible that the circle line configuration represents these camps. Today his travels are recounted in songs which tell of the powers that he has imparted to each of these sites. Wimmitji is the senior custodian or 'boss' for these places.

NYILLA

The painting represents another aspect of the Tingarri story-cycle. The Tingarri Ancestors camped at many different places on their travels and each is recorded in songs that senior male custodians like Wimmitji maintain. The story-site represented here is Nyilla Rockhole, which is in the vicinity of Jupiter Well in Western Australia. The artist lived here when he was younger; the footsteps shown belong to his grandmother. Nyilla Rockhole is shown by the red circle above the lower right footprint. The distinctive enclosure shapes in the upper-right area of the painting represent the many small salt lakes or *yaparnu* which mark the region. The country around Nyilla also has many sources of food and water.

MARRANGU

Two men of the Tjakamarra sub-section were travelling through these parts in the *Tjukurrpa* or Dreaming. This work depicts a specific story-site for the Wati Kutjarra, two men of the Tjakamarra sub-section whose extensive travelling took them through this country in the Dreaming. Their presence is indicated by the two small circles partly enclosed by the dark curved line on the lower left of the painting. The Wati Kutjarra's activities are re-created in songs and ceremonies; they left signs to be read in the land. Wimmitji, who is one of the senior custodians of this story (Law), says that there are many sacred rocks here. When he was younger, his family camped near these places; there were always plenty of bush foods to be collected.

R o v e r T h o m a s

R over Thomas went to live in Warmun, an Aboriginal community at Turkey Creek in the east Kimberley, in 1975, when he was forty-nine years of age. He had spent the previous thirty-odd years working, mainly as a stockman, sometimes as a labourer.

Thomas was born a long way south of the Kimberley, in the Great Sandy Desert at a place near Gunawaggi (Well 33) on the Canning Stock Route. His mother was a Kukatja woman and his father Wangkajunga; he was 'grown up', in the Aboriginal way, by two fathers, Lanikan Thomas and Sundown. His first experience of migration was as a young boy of ten when his family left the Gibson Desert and walked some 500 kilometres north to Billiluna Station.

Billiluna lies north-west of Balgo, in the Great Sandy Desert, a little over halfway between Well 33 where Thomas was born and Warmun where he has lived for the past twenty years. It was at Billiluna that he first worked with cattle and it was there, in the early 1940s, that he went through initiation. Around this time, in his twenties, Thomas set off for Wyndham with a European fencing contractor with whom he also worked in the Northern Territory. After a couple of years he returned to Western Australia where he worked again as a stockman, initially on Bow River Station in the north-east Kimberley. This is when he married for the first time. He next worked for nine years on Texas Downs Station before moving on to Lissadell Station and later Mabel Downs. He met his second wife, Rita, when he returned for a time to Texas Downs.[1]

Thomas belonged to the generation of pastoral workers who became casualties of both bad economic times in the cattle industry and the 1969 Federal Pastoral Award, which legislated equal pay for Aboriginal workers in the industry. Up until this point there had been an uneasy accommodation

between Aboriginal employees and some station owners. In return for labour, stockmen and their extended families were able to camp on station properties, and were to some extent tolerated and provided for. This paternalistic arrangement enabled many people who were legally exiled from their traditional land to live at least in proximity to their country and maintain their ceremonial culture. In the late 1960s this situation changed; the net effect of the equal pay ruling was unemployment, eviction and migration to the fringe communities which grew up as a consequence. Rover Thomas was among the displaced and, at the beginning of 1975, he arrived at Warmun, where an auspicious sequence of events started him on a second career — one which has made him famous.

In 1974, close to Christmas, one of his relations was critically injured in a car accident on a flooded stretch of road near Warmun. The woman, whom Rover called 'mother', was taken to Wyndham and flown to Perth by the Royal Flying Doctor Service. She died during the flight and is said to have passed away as the plane flew over a whirlpool off the coast near Derby. This whirlpool is an important site for the Rainbow Serpent, an immanent power and presence in the indigenous cultural landscape of the region and one particularly identified with the dramatic, elemental forces of the wet season.

The spirit of the deceased woman visited Rover in a sequence of dreams and 'gave' him a corroboree known as the Krill Krill.[2] Dreams can be a powerful medium of communication in east Kimberley culture, acting as pathways across the layered continuum of past and present, living and dead, and the Dreaming and now. The Krill Krill is structured around the songs that the woman imparted to Rover in her dream visitations. Their short verses narrate the journey of her spirit back from the west where she died, to Warmun where the accident occurred, and then north to Kununurra where her journey finished. From Kununurra, accompanied by a spirit companion, she witnessed Cyclone Tracy and the destruction of Darwin on Christmas Day.

Dreams have led to the creation of other corroborees in the Kimberley and have also been a powerful source of individual creativity. In the singular case of Rover Thomas, a number of momentous events occurred virtually simultaneously – the death of his 'mother', Cyclone Tracy, his move to Warmun and the gift of the Krill Krill – setting him off on a new course. The Krill Krill gave him authority and ritual status in his adopted Gija homeland – there was consensus that this corroboree 'belonged' to Rover, which in turn empowered him in relation to Gija country and culture. The Krill Krill gradually became popular at Warmun,[3] developing a significance beyond its original sociocultural setting, and Rover Thomas in particular channelled the gift of the Krill Krill into the wider cultural domain of contemporary art:

Before, no nothing. When that house bin put up in Turkey Creek, me and Jaminji bin start off. We drawing all the way. We bin know something now. I'm all over now. We bin sending little bit by little bit. And so gadiya [whitefellas] he like 'em me. I don't know what for.[4]

It was Mary Mácha, a Perth-based art consultant, who was instrumental in nurturing the fledgling art movement at Turkey Creek and getting the works of Paddy Jaminji and Rover Thomas 'little bit by little bit' into important public and private collections. When Thomas began to paint on a regular basis for the art market, he was solely represented for several years by Mácha. It was through her that The Holmes à Court Collection acquired its substantial holdings of his early works. She has also been an important figure in the development of an equally substantial collection in the National Gallery of Australia as well as other public collections.[5]

Mary Mácha has had a long association with Aboriginal arts and crafts in Western Australia. From 1971 to 1973 she was a project officer with the Western Australian Native Welfare Department,

the State body responsible for all matters pertaining to Aboriginal people, including health, housing and art. Its charter was to preserve, develop and maintain traditional arts and crafts. In this era there was in fact little 'art' to be marketed, although people in remote Western Australian communities produced a steady supply of traditional artefacts such as spears, shields and weapons as well as less traditional items like carved boab nuts. The purchase and marketing of these items was handled through the Native Trading Fund. The department's offices in remote towns such as Wyndham, Derby and Kununurra always had money from the fund on hand to purchase items that the locals brought in to be sent on to Perth to be marketed.

With the election of the Whitlam Labor Government in 1972 and a new era of policies and strategies for Australia's Aboriginal community, a Federal marketing body, Aboriginal Arts and Crafts Pty Ltd, was set up. In 1973 Mácha became manager of the new State agency, Aboriginal Traditional Arts, which continued to represent Nyungar artists and others in 'remote' areas. She maintained the system that had worked well under the old Native Welfare regime which included three field trips each year to Warburton, Cundalee (outside Kalgoorlie) and the Kimberley to talk to the people who were making artefacts. Mácha kept up the old system of payment although, with the closure of the Native Welfare Department's regional offices, she had to extend her network and use the services of trusted local people to pay the artists and forward their work to Perth.

Paddy Jaminji was the only person carving artefacts for sale when Mácha was visiting Warmun throughout the 1970s. It was Jaminji who executed the first Krill Krill boards under Rover's guidance. The boards generally depicted a single icon relating to the songs 'given' to Rover and were held, supported on the performers' shoulders, as they danced the corroboree. Mácha conjectures that Jaminji's involvement might be connected with the fact that he was the only 'visible' artist at Warmun around this time. It also possibly relates to the fact that he was, in kin terminology, the 'classificatory' brother of the deceased woman and would therefore have held some authority in relation to her corroboree.

It was on one of her visits to Turkey Creek that Mary Mácha first saw Paddy Jaminji's paintings of the Krill Krill stored in the tin shed where he lived. This particular set was not for sale at the time, as the ceremony was still being taken around and the boards were required. On a later trip Jaminji was ready to sell them and, at his request, Mácha sent him replacement materials so that new works could be painted for the Krill Krill. In this way three sets of these paintings came onto the market after having first been used in ceremony.

These exchanges between Mácha and Jaminji attracted the attention of others in the community. In places like Warmun, where the only income was social security, or 'sit down' money, the prospect of being able to earn money from painting was especially attractive. In this way Mácha came to provide additional materials to others who wished to paint for the art market, particularly Rover Thomas. Mácha initially supplied marine ply boards of the same dimension as the works sent down by Jaminji until she had a request for larger sizes. Around the mid-1980s Mimi Arts and Crafts in Katherine sent canvas across to Turkey Creek and the painters subsequently indicated their preference to Mácha by also requesting canvas from her, although they have since occasionally painted on hardboard.

In 1983 Mácha left Traditional Aboriginal Arts. She was disenchanted with the views of the Federal Aboriginal Arts Agency, which was not confident that there would be a market for the work, even though two sets of Krill Krill paintings had by then entered major collections.[6] She decided to become an independent agent and consultant, representing Rover Thomas, Paddy Jaminji and other Aboriginal artists from Western Australia.

As the Krill Krill gained in local popularity it also 'toured' to places outside the Kimberley, including Arnhem Land, Victoria River Downs Station and Hooker Creek (Lajamanu) in the Northern Territory. The length of the ceremony and the total number of songs and paintings varied. What appears to have been the most 'condensed' version of the corroboree, involving only one painting done on cardboard, was performed on Victoria River Downs Station. The first performance before a non-Aboriginal audience was staged during the 1983 Festival of Perth. Rover Thomas has proudly spoken about travelling his corroboree:

I can go anywhere, take this corroboree, Krill Krill,
I can go Perth, from there to Melbourne, anywhere. Darwin.
I bin take 'im to Darwin last year, oh, the year before, year before, y' know.
Yirrkala, Maningrida
and us mob, maybe bin go to Hooker Creek, long way,
Northern Territory, Northern Territory,
Other side of Victoria [River Downs] ...
and anyway we bin have a good dance in Hooker Creek
come back all the way along,
all the way to Wattie Creek.
From there right back to Turkey Creek.
And next time I bin take 'im to Perth
all over the place,
dancing there all over the city ...[7]

If Rover Thomas had become an artist in the country of his birth and traditional affiliations, his art would no doubt have developed along quite different lines. If he became a painter at all, he would probably have been drawn to Warlayirti Artists Co-op at Balgo with its concentration of Kukatja painters. Balgo artists also have close cultural and aesthetic links with the Pintubi artists at Kintore and Kiwirrkurra far to the south in the Gibson Desert. Both Kukatja and Pintubi use representational symbols, such as circles, u-shapes and dotting, as key features of their compositions – one aspect of many shared visual and story traditions. The Gija style of Rover's adopted country is quite different, having a figurative orientation influenced by regional rock art and ceremonial body-paint designs. While Rover Thomas mainly paints subjects and stories belonging to Gija country, his imagination draws on both Western Desert and East Kimberley styles, creating a highly individual synthesis that is rare in the work of 'bush' artists.

Rover's early work was strongly influenced by Jaminji, the Gija artist who painted the first visual interpretations of the Krill Krill and with whom he occasionally collaborated.[8] Gija painters generally depict land, plants and animals in silhouetted forms of eloquent simplicity against a plain background. Some of the artists who emerged after Jaminji and Thomas have elaborated the interiors of these outlines in very innovative ways, notably Jack Britten in his rendering of geological strata in his paintings of the Bungle Bungle Ranges. Thomas has not followed this path; his works depend for their effect on a boldly articulated, minimalist simplicity. Other Warmun painters, such as Freddy Timms and Queenie McKenzie, have been more influenced by Rover's style than Jaminji's.

Although he does occasionally include figurative elements and topographical profiles in his paintings, Rover Thomas primarily adopts a plan or aerial perspective typical of Western Desert art. This map-like approach is integral to his vision, whether he is representing a loosely topographical

image of place or more geometrically ordered symbolic landscapes. Dotting, a key compositional element in Western Desert paintings, is literally marginalised in Rover's work. Dots serve only to create emphases – for example, around the border of the picture or as an outline around internal shapes – and appear to be the artist's only concession to decorative effect.

Dreaming stories from the east Kimberley, the Krill Krill and, to a lesser extent, his first country along the Canning Stock Route have provided Rover Thomas with most of his themes for painting over the past fifteen years. From time to time he has painted secular stories, landscapes with personal, autobiographical associations, as well as 'exotic' or unusual subjects which caught his imagination. But there is another important category of stories that forms a major part of his œuvre. These stories reference 'the killing times', a period of massacres between the 1880s and the 1920s which was a brutal feature of Aboriginal experience in the east Kimberley. Racism was a vicious ingredient in these events, which were the consequence of intense pastoral development, competition over resources and the lethal societal mix on the Kimberley frontier. These atrocities were investigated and documented by a Royal Commission in 1922.

Although the killings on Texas Downs, Ruby Plains and Bedford Downs took place before Rover was born, his vivid accounts testify to the way remembrance of these events has been preserved in oral histories.[9] There are also allusions and references to these incidents in the Krill Krill cycle; some of the killings took place on stations where Rover Thomas had worked.[10] Rover has taken these shocking stories, locked into the country like the Dreamings they rest beside, as the subject matter of many of his paintings. Perhaps because time has brought some emotional distance, Rover's verbal accounts are told in a graphic but matter-of-fact way. Nor is there any apparent change in mood in his paintings on these themes; they are imbued with the same eerie serenity and detachment that pervade his other work.

Thomas' public profile did not really begin to take shape until the late 1980s when he also began to paint for Waringarri Aboriginal Arts, an organisation established at Kununurra in 1986 to cater for the emerging art movement centred around Warmun. While continuing his association with Mácha, Rover Thomas's reputation grew as his work gained wider commercial exposure through Waringarri's commercial exhibitions. Towards the end of the decade he began to be noticed by art institutions. In 1989 he was included in the Art Gallery of Western Australia's exhibition 'On the Edge: Five Contemporary Aboriginal Artists'. In 1990 he represented Australia at the Venice Biennale along with Trevor Nickolls, from Adelaide, and was also awarded the John McCaughey Prize for the best painting hung that year in the Art Gallery of New South Wales.[11] In 1994 Thomas was involved in his landmark retrospective 'Roads Cross: The Paintings of Rover Thomas', mounted by the National Gallery of Australia . As Thomas' reputation has grown and his work has become more sought after, the number of agents and galleries representing him has increased and he is currently represented by several. However, his age and poor health place him at odds with the intense current interest in his work.

In September 1995 Rover and members of his extended family travelled back to his birthplace in the vicinity of Well 33 on the Canning Stock Route accompanied by Kevin Kelly, manager of Waringarri Arts. Rover, who is these days physically quite frail as a result of serious illnesses, had expressed a desire to see his country again. He spent two weeks there revisiting sites of personal and totemic significance, including the places where his mother, father and brother are buried. Rover seems only rarely to have painted stories from his father and mother's country before this visit, although *Ngarrangkarni*, 1984, is one of a number of exceptions. But on his return to Kununurra, he painted an impressive body of work inspired by his sojourn in Kukatja country.[12]

Rover Thomas has created some of the most beautiful and subtle tonal effects in Australian painting, using a relatively narrow range of ochres, pipeclay and charcoal. It is his lyrical and expressive use of natural pigments to put down his unique vision of country which distinguishes him among his contemporaries. Although many of his paintings have sublime surfaces, some of his pigment and binder mixes have been experimental and, from a conservation point of view, quite unorthodox. While Thomas generally mixes his pigments with bush gum, a natural resin obtained from native bloodwoods and kurrajongs, he has created more than one surface that has proven to be a delicacy for insects by using sugar and other unknown substances. Yet friable and eaten surfaces, missing dots, paint splashes, dog prints and other spills are accidents of materiality and process that beguile connoisseurs jaded by technical virtuosity. And in their own way, these quirks in painting are just like those which fascinate us in nature and take their place as intriguing embellishments. These earthy painted surfaces are one of the keys to the wide appeal of Rover Thomas' art.

<div align="right">ANNE MARIE BRODY</div>

NOTES

1 See R. Thomas et al., *Roads Cross: The Paintings of Rover Thomas*, exhibition catalogue, National Gallery of Australia, Canberra, 1994.

2 Variant spellings of Krill Krill are Gurirr Gurirr and Girr-Girr or Grill-Grill.

3 W. Christensen, 'Paddy Jaminji and the Gurirr Gurirr', in J. Ryan & K. Ackerman, *Images of Power: Aboriginal Art of the Kimberley*, exhibition catalogue, National Gallery of Victoria, Melbourne, 1993, p. 33. Christensen remarks that when Rover Thomas first found the Krill Krill, he could not get anyone to sing it and that several years went by before it was performed in its entirety.

4 J. Ryan, 'Bones of Country: The East Kimberley Aesthetic', in Ryan & Ackerman, op. cit., p. 42.

5 Mácha was a contributor to Thomas et al., op. cit. The references pertaining to Mary Mácha are based on an interview conducted in early 1995.

6 The two sets referred to went to the Berndt Museum of Anthropology, Perth, and the Lord McAlpine Collection, Perth.

7 Thomas et al., op. cit., p. 24.

8 ibid., p. 27.

9 ibid., pp. 40–56.

10 At least twelve killing sites within a 150 kilometre radius of Warmun (Turkey Creek) have been documented. ibid., p. 40.

11 The painting was *Blancher Country*, 1989, which was loaned by The Holmes à Court Collection to the exhibition 'Abstraction', curated by Victoria Lynn at the Art Gallery of New South Wales in 1990.

12 See S. Neales, 'Vibrant Images from an Arid Zone', *Age*, 16 November 1995, p. 19. These paintings were exhibited in 'Well 33 Revisited' at the William Mora Galleries, Melbourne, in November 1995.

DUMORUNJI 1986

EARTH PIGMENTS AND BUSH GUM ON PLYWOOD

60 x 90 cm

NGARRANGKARNI 1984
EARTH PIGMENTS AND BUSH GUM ON PLYWOOD
90 x 180 cm

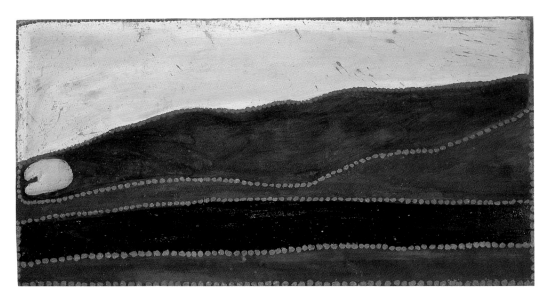

BARRAMUNDI DREAMING 1985

EARTH PIGMENTS AND BUSH GUM ON PLYWOOD

90 x 180.5 cm

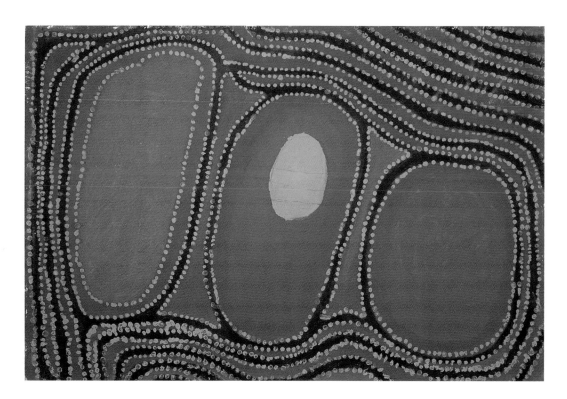

BARRAMUNDI DREAMING 1986

EARTH PIGMENTS AND BUSH GUM ON PLYWOOD

60 x 90 cm

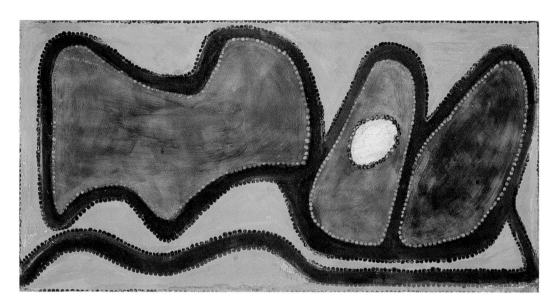

JUMBALA HILL 1985

EARTH PIGMENTS AND BUSH GUM ON PLYWOOD

90 x 180 cm

S T O R I E S

D U M O R U N J I

Dumorunji is a *Ngarrangkarni* man who travelled from the Dunham River to the east in the Dreaming.
When the Rainbow Snake sings out you can hear Dumorunji reply like an echo. He is represented by
the red oval form. The white areas show spinifex grass which turns this colour in the dry season.

N G A R R A N G K A R N I

This painting represents a women's corroboree from the *Ngarrangkarni* (Dreaming). The story belongs
to Wangkajunga country along the Canning Stock Route, possibly Kaningkara. The following
'fragment' is the only documentation provided with the painting: The dog ran along the cliff and
chased the emu.

B A R R A M U N D I D R E A M I N G 1 9 8 5

The painting depicts a Barramundi Dreaming site on the Dunham River. The white mark is where the
Jabiru dropped fish poison (made from freshwater mangrove) in the wrong place. When the poison fell
onto the ground instead of the water, the Barramundi made his escape. As he squeezed through the
fishtrap made by *Ngarrangkarni* people he left the white mark that can still be seen on the side of the hill.

B A R R A M U N D I D R E A M I N G 1 9 8 6

This painting represents a Barramundi Dreaming site on the Dunham River.
 In this version (c.f. no. 2) the Barramundi which lived in a deep pool on the Ord River made a
giant leap. As it was flying through the air some scales and fat from its belly were scraped off on a
rocky ridge. They can be seen in the form of a large white patch on the hillside. The Barramundi
landed in a small pool at the headwaters of Smoke Creek.

J U M B A L A H I L L

This painting is of Jumbala, a big hill near Jail House Creek on Dunham River Station. Aboriginal
prisoners were locked up in a cave in this hill for a week or two while the police rested their horses.
The policemen camped at the mouth of the cave, represented by the white circle, and the prisoners
inside were tied to each other with chains.

E m i l y K a m e
K n g w a r r e y e

In the course of a conversation in Alice Springs at the house of her niece, Barbara Weir, Emily Kame Kngwarreye talked about her life on Utopia and the paintings which have made her the most widely known and discussed contemporary Australian artist.[1] The conversation went on for about four hours in the middle of a hot desert day. We talked in a mixture of languages including English, Kriol (a uniquely expressive Aboriginal–English dialect) and Anmatyerre, Emily's first language and one that is also spoken by her niece. Our conversation was patched together in a way that reminded me of conversations in foreign places, where the need to communicate often requires some unusual linguistic accommodations. But this is not a foreign country and I, like the majority of white Australians, do not speak Anmatyerre or any other Aboriginal languages.

At the time of her death Emily Kame Kngwarreye was one of the oldest painters in the contemporary Aboriginal art scene. She was also the most famous. Within her community, she is a woman of seniority and experience. The idea of doing a biographical portrait of Emily had interested me for some time, as her art had attracted a lot of attention, yet so little seemed to have been published about her life. I had read that she had worked on pastoral stations and that she had ridden horses. At one point, when rivalries between her agents were intense, some of the scant biographical details which surfaced seemed mainly to support proprietary claims. At the time she did her first painting on canvas, Emily was represented by only one agent and one gallery. By 1996 she had at least three agents 'on the ground', in and around Alice Springs, and multiple representation by dealers and galleries in capital cities. An indication of the competition surrounding Emily Kame Kngwarreye, and the widespread benefits of her success, can be gleaned from one gallerist's comments in 1992:

'Its fabulous. She's kept this gallery open'.[2] Among the biographical 'facts' in circulation about Emily Kame Kngwarreye, there are many references to her extraordinary personality and sense of humour – part of the legend of Emily is that she was a character.

Some of the stories that Emily recounted during our interview stretched back to early childhood and she recalled these distant events vividly, with the sharp long-term memory of the elderly. She told me that her family used to have a camp in a little creek running off from Alhalkere. This is her country, where she was born and grew up. There was a soakage in this dry creek which lay in between sandhills. In documentation for the Utopia Land Claim, Alhalkere is shown by a roughly circular outline lying just outside the north-west boundary of Utopia. Situated within Mt Skinner pastoral lease, a large portion of Alhalkere is subsumed under an Aboriginal excision set aside for the traditional Anmatyerre owners

Emily was in the vicinity of her family's camp when she first saw a white man. On this day she and a friend were digging for yams when they saw a man on horseback 'sneaking up'. They both bolted, ducking and running down the hill, thinking it was the devil come to kill them. The man, most probably a policeman, would have been following the dry creek line looking for sources of water. There was a second horse tied to the first, carrying an Aboriginal man, a prisoner wearing clothes and chains, including an iron collar. The whitefella had a whip and his horse was white and Emily had never seen a horse before either. The men didn't speak and she and her friend ran for the hills where people were camped. They were just young girls, about to become women, when they had this encounter. She recalled the incident vividly and laughed about the way they had run away. This was sardonic laughter – she could see the ridiculous side of being scared of a white man.

Emily lived with her family at this soakage at Alhalkere for a long time. Sometimes they walked north-east to Ngkwarlerlaneme where there was a big camp; they went there on social visits and for ceremonies. She particularly mentioned a social visit she made to Stirling Station when she had grown up. This was after 1924, when Sonny and Trott Kunoth were on Utopia, so she knew whitefellas. She later went to work on Woodgreen Station where she looked after farm animals, mainly nannygoats. She remembered looking after Bob Purvis, the current owner of Woodgreen Station, when he was a baby, rocking him to sleep in his pram. When I asked if this was where she rode horses, she laughed disparagingly and said that she never rode horses but she did ride camels. At the mention of camels, she gave a marvellous impression of the way a camel moves its head as it walks along.

Emily remained a single woman for a long time and says that she played hard to get. 'You don't catch me' is what she used to say; but then her promised husband came and got her. She was first married around the time that Barbara Weir, her niece, was born, just over fifty years ago. This promised husband was an 'uncle' who already had a wife. Emily went with him to work at Bushy Park Station. They also worked between Alcoota and Mt Riddock stations as one of the husband and wife couples 'employed' to take camel teams and supplies from Alcoota to the mica mine on Mt Riddock Station. Like many Aboriginal people in the area, they also worked around the mine; everybody says that this work was hard. Emily did not stay long with her first husband, because he wanted to take another wife; they had no children. She later married again. She was older than her second husband and someone else was promised to him in the traditional way, but they loved each other and were married anyway.

Barbara Weir was 'grown up' by Emily from when she was very young. Among the different incidents that Barbara recalled was one memorable occasion when they went hunting and ran out of water. Emily had to carry Barbara, sick from the heat, a long way home, as well as a kangaroo she had slung over her shoulder. While reminiscing about near escapes, Emily told an extraordinary story

about how once, when she was out by herself digging for honey ants, she was attacked and nearly killed by a big mob of feral cats. The most poignant event she and Barbara described that afternoon concerned the day, in 1955, that Barbara was taken by 'welfare' from their camp. This was the era of assimilation policies when Aboriginal children born to white Australian mothers or fathers were forcibly removed from their Aboriginal families, supposedly for their own good, to be raised as whites. Welfare agents were vigilant in carrying out their assignments and, like many other children in this situation, Barbara was hidden whenever they were in the area. But one day, when Emily sent her to fetch some water, Barbara was grabbed and taken to St Mary's, a home for half-caste children in Alice Springs. Emily and everybody else from that time on believed she was dead. They chucked away the billy that Barbara was carrying that morning, as happens with things that belong to the deceased. Barbara Weir did not return to Utopia until 1968.

Emily was among the group of Utopia women who learned various art and craft techniques, including tie-dyeing and batik, as part of an Adult Education program organised in 1977 by Jenny Green,[3] on behalf of the Institute for Aboriginal Development (IAD) in Alice Springs. Two years later Utopia women played a key role in the Land Claim Hearing which resulted in the community gaining permanent legal title to the leasehold on the former pastoral property. For cultural reasons, they gave their evidence separately from the men, presenting their claim through the performance of *awelye* (women's ceremonies), which demonstrated their ownership of country, stories and Dreamings. With the return of Utopia, the Anmatyerre and Alyawarr custodians moved back onto their clan lands, dispersed across the former pastoral lease, living the traditional way in extended family groups.

Throughout this period and the 1980s the Utopia women were producing distinctive batiks. Even though there were clearly a number of outstanding artists in the Utopia Women's Batik Group, their work was largely perceived and marketed within a craft environment. This perception attached itself to their work at the same time as the painters from the Western Desert, represented by the Papunya Tula Artists Co-op, were making substantial inroads into the fine art market. It was not until the batik group started painting in acrylics on canvas that this perception changed and these women, as painters, breathed new life into the desert art movement. Many of the original members of the batik group — in particular, Ada Bird Petyarre and Gloria Tamerre Petyarre — have gone on to establish successful solo careers as artists. But right from the start the brightest spotlight was trained on Emily Kame Kngwarreye and has remained there ever since.

This new direction for the Utopia Women's Batik Group came about in 1987, when the women came under the management and marketing umbrella of CAAMA Shop, the visual arts 'branch' of the Central Australian Aboriginal Media Association. The shop was located a little way out of town, down at the Gap. The Utopia women were the first bush 'collective' that CAAMA Shop had taken on. At the outset, its manager and arts co-ordinator, Rodney Gooch, showed a preference for working with these artists on challenging group projects. It was his way of getting to know the women in the group, their stories and their capabilities, as well as providing a basis for nurturing individual talent. The first of these projects, 'Utopia – A Picture Story', mapped the women's stories in striking pictorial images in batik on silk. Some six months later Gooch initiated a second major project, taking out 100 primed and stretched canvases to be worked over the summer break. Emily was one of eighty Utopia women who painted their first works on canvas over December–January 1988–89. Only four months later, due to a fortuitous accident of scheduling, this collection, under the title 'A Summer Project', went on exhibition at the S. H. Ervin Gallery in Sydney. Emily's first painting was featured on the cover of the small catalogue that accompanied the show. Immediately following the public

appearance of this painting there was a flurry of requests for her work. Suddenly there was intense competition and a queue for her paintings.

In the meantime, a Utopia-based artist-in-residence project managed by CAAMA Shop and funded by The Robert Holmes à Court Foundation had been established. The idea was to fund two artists to work, uninterrupted by commercial pressures, for a period of twelve months. An important aspect of the project was the principle that it would be based on Utopia and work within the framework of traditional culture. Two younger artists were initially selected but the focus changed to ritually senior people when that approach didn't work out. Finally, Emily and Louie Pwerle were invited to participate and the grant was taken up in mid-1989. By this time Emily was not painting just for CAAMA Shop and, as a consequence, the project exhibition, held at the Perth Institute of Contemporary Arts (PICA) a year later, was not an inclusive record of all her work from the period. One glance at her curriculum vitae gives a good idea of the active and demanding environment in which she worked thereafter.

Public collections appear to hold few of Emily's works in batik from the 1980s. An exception is the National Gallery of Australia, which has an early batik as well as a large piece, executed in 1981, which is hand-painted in fabric dyes on cotton sheeting. There are stories that Emily's batik style, her broad bold handling of lines, dots and structure, was considered by her fellow artists to be 'over the top'. When I asked Gloria Tamerre Petyarre whether these stories that had filtered through were true, she said that everybody laughed about Emily's work. But she was also quick to point out that it was just good-natured banter — 'We were only joking'. Emily's individualism as a painter fitted in with all the other stories about her being an exceptional and intrepid woman. Clearly, she was always very confident about her approach to painting, represented stories her way and did not feel pressured to conform or change her style. In fact, with her phenomenal success, the opposite began to happen.

Emily's painting in 'A Summer Project' was based on a loose, linear structure overlaid with dots, and the images which followed were similar compositions. Within a few months she had produced a series in which the surfaces were densely packed with dots and the underlying linear structure had 'disappeared'. In these works there were generally smaller dots inside the larger ones. This change signalled a pattern of working which Emily maintained throughout her seven-year painting career. She tended to produce a series of works in a similar style and then shift direction. The size of these series is variable and some of her stylistic shifts appear quite radical, at least to Western eyes. One of the most dramatic occurred when she began to use large brushes in order to cover the canvas quickly. She found that working this way was less time consuming and exhausting. On the other hand, some of her paintings from this period are the largest she ever produced. In works from one series from this 'large dot' period, *Alhalkere (I)*, 1992, being a good example, Emily worked the dots into solid patches of colour. In another area of this work you can see strong lines of dots, one following the other, where she 'dragged' the brush in a particular direction. A subsequent series was dominated by structural imagery formed by this technique. Emily showed me how she did this and, as she did so, her body moved in a way that evoked women's dance. The way these dots follow each other to form lines also echoes ceremonial dance formations where women move in single file to the punctuated rhythm of song chants.

After eighteen months of being an artist, Emily told me that she wanted to stop. She had come to Perth for the opening of the CAAMA/Utopia Artist-in-Residence Project at PICA. She said that painting caused her too much worry and thought that her family (sisters and nieces) should take over from her. Emily repeated this statement when interviewed four years later (and no doubt many times

in between) when she travelled to Canberra to receive her Australian Artists Creative Fellowship Award. This award is intended to support artists financially in their ongoing creative endeavour but it was clearly Emily's view that she had received this money in recognition for her hard work as a painter and that now she could retire. At the time, her remarks attracted a lot of comment in the press. The reality was that it was virtually impossible for her to stop painting. Apart from her genuine creative absorption in her *métier*, and the pleasure she derived from painting, Emily had the burden and responsibility of maintaining a large group of people. The extent to which Emily has provided not only for her immediate family but also for 'arts business' beyond her community is another fascinating chapter of her story. But as for the possibility that others could take over from her – this was not something that the art market would readily countenance, even though her reasoning had an impeccable logic from an Aboriginal perspective.

The focus on individual creativity which is integral to Western art is culturally at odds with the traditional Aboriginal view that images and stories belong to country and are collectively owned. People are the custodians of the Dreamings and have rights in relation to them, according to their ritual status and obligations within a network of kinship obligations. In the same way that the ritual mantle of 'boss' is passed to another, a 'senior' artist like Emily Kame Kngwarreye should have been able to delegate the work of painting. But the art market is primarily interested in the originator, less so in the studio or the school. The fact that many works not by Emily have already found their way into the marketplace and collections under her name is therefore ironic. Rumour and controversy about the authorship of paintings even led some agents to get her to sign her works. Yet there are well-known precedents in contemporary Aboriginal art which indicate that a signature is not necessarily a guarantee of the artist's hand. Aboriginal artists might well be indifferent to this type of proof.

Authorisation, the culturally sanctioned right to paint stories, is a central issue for traditional artists, whereas authenticity, in the sense of individual authorship, is not a priority within the culture. If works of art are signed, it is most likely because the artist has been accommodating. Signing is a bit like saying yes to a question because that is what you think somebody wants to hear. It is doubtful whether the legal and commercial ramifications of signing a picture are adequately explained to Aboriginal artists. And it is equally clear that the marketplace is not properly educated about Aboriginal artists' views on the value of a signature, on what the market deems to be a proof of authenticity. For an Aboriginal artist it is not a personal, handwritten label but the image, the story and the right to represent it which are the signature.

During our conversation Emily expressed her concern with the way outsiders got things wrong. She was angered that some of her paintings had been given titles (and stories) that were wrong. Important issues of authorisation and Law were involved and outsiders' errors, however they came about, placed her on difficult ground. It was not goanna eggs, as one caption stated – this story did not belong to her, she had painted yams.[4] While it was easy to imagine how this mistake might have happened, Emily was adamant that the record be set straight.

When we had finished talking, I had some more facts, an expanded but still, by Western standards, sketchy biography. We agreed that there was a lot more to be said and that perhaps we should also go out and look at some of the places we had talked about. Clearly, for any would-be biographer of Emily Kame Kngwarreye, 'country' is a good place to start.

ANNE MARIE BRODY

NOTES

1 The interview took place in December 1994.

2 See D. Guinness, 'Kngwarreye Colours the World', *Australian* (The Arts on Friday), 11 December 1992, p. 10.

3 Jenny Green, arts writer and linguist, was living on Utopia in the late 1970s. Green saw the need for an IAD program and was the founding coordinator of the batik group.

4 This matter arose when I asked Emily to comment on two works published in A. Brody, *Contemporary Aboriginal Art from The Robert Holmes à Court Collection*, exhibition catalogue, Heytesbury Pty Ltd, Perth, 1990, pl. 40, p. 62.

AUTHOR'S NOTE

I would like to thank Emily Kame Kngwarreye, Gloria Tamerre Petyarre, Barbara Weir, Rodney Gooch and Marc Gooch for making possible the interview on which this essay is based.

UNTITLED (BODY MARKINGS) I–II 1994

SYNTHETIC POLYMER ON POLYESTER

(I) 184.5 x 68.5 cm (II) 185.5 x 70.8 cm (irreg.)

UNTITLED (BODY MARKINGS) I-IV 1994
SYNTHETIC POLYMER ON POLYESTER
152 x 61 cm (irreg.)

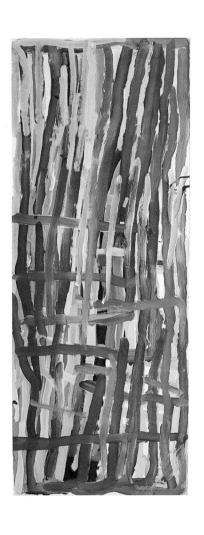
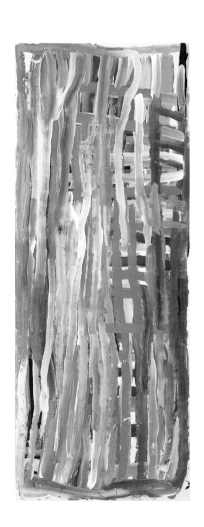

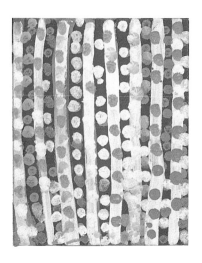 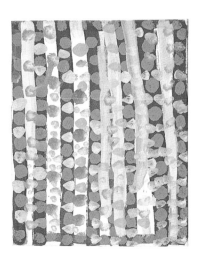

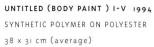

UNTITLED (BODY PAINT) I–V 1994
SYNTHETIC POLYMER ON POLYESTER
38 x 31 cm (average)

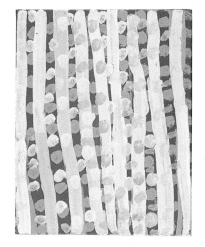 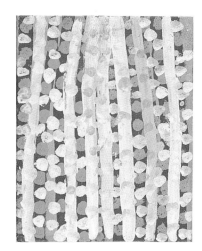

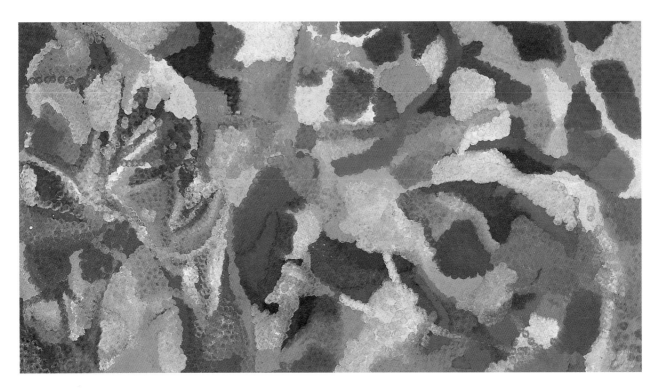

ALHALKERE (I) 1992

SYNTHETIC POLYMER ON POLYESTER

163 x 297 cm

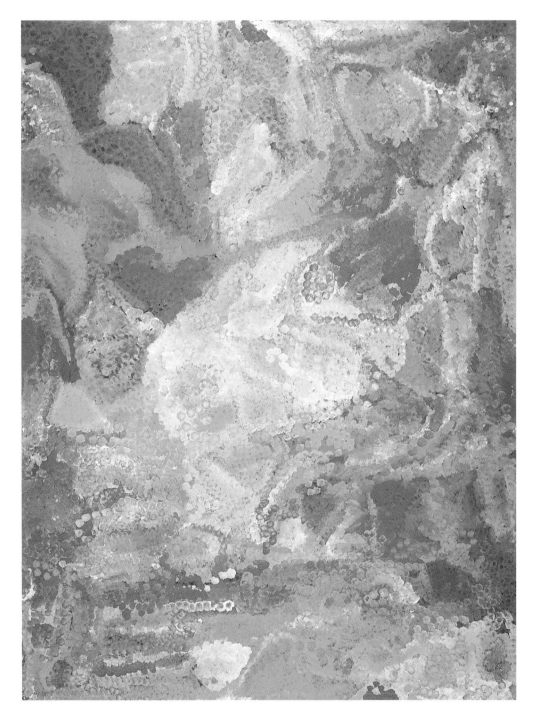

ALHALKERE (II) 1992

SYNTHETIC POLYMER ON POLYESTER

226.5 x 169.5 cm

S T O R I E S

E M I L Y K A M E K N G W A R R E Y E

When asked about the stories for her paintings Emily Kame Kngwarreye stated that her works represent the 'whole lot, that's all, whole lot Awelye—my Dreaming'. The main stories that she represents are Pencil Yam (*Arleyteye*) Kame (the seed of the pencil yam) and Bush Potato. Many of her paintings include structural forms which represent phases in the life cycles of these plant forms such as seeds and root systems.

Her paintings also include or solely represent the ceremonial designs associated with these Dreamings, most notably the striped body-paint designs women painted on their breasts and upper chests. The artist also stated that some of her linear images represented scars, fine lines or marks made with stone knives, as a symbol of mourning or 'sorry business'.

Maxie Tjampitjinpa

The mystique persists that Western Desert paintings encapsulate some kind of artistic 'first contact' experience — as if the painters just walked out of the desert into a remote settlement one day and picked up their brushes. Maybe some did, but as a child of the settlements Maxie Tjampitjinpa is a long way from this romantic primitivist image. He was born at the Lutheran mission outpost of Haasts Bluff, where his Warlpiri parents had settled more or less permanently after he was born in the mid-1940s. At the end of the 1950s the family was transferred with the rest of the local Aboriginal population to the new government settlement at Papunya where Maxie went to school.

Maxie seems to have spent a large part of the early 1970s away from Papunya. He did a health workers' course in Darwin and worked at various kinds of labouring jobs in Darwin, Maningrida and Port Keats. He was also at Snake Bay on Melville Island. When he returned to Papunya he worked on the settlement as a tractor driver, bus driver and police tracker. By the time he took up painting in 1980, he had broad experience of mainstream Australian culture as well as life in various Aboriginal settlements. He was also familiar with the new acrylic medium, having observed the founding generation of Western Desert artists at first-hand after his return to Papunya in the mid-1970s. He was probably at that time of his life more familiar with their painted versions of the Dreamings than with the ceremonies from which they were derived. In his mid-thirties, he was one of the youngest acrylic painters in the Western Desert — too young to know what the older men knew of these things. But he knew as well as anyone what it meant to be a Papunya Tula artist, painting high quality canvases for the collector's market.

Maxie produced his first works at Papunya under the keen eye of Old Mick Tjakamarra, one of the custodians of the Honey Ant Dreaming at Warumpi. Old Mick had authorised the painting of the Honey Ant designs on the Papunya school wall in 1971 and helped set the art movement in motion. Throughout the 1970s, Old Mick applied his profound knowledge of Dreaming stories and designs to canvas with a tireless enthusiasm which made him Papunya Tula's most prolific artist as well as its most senior. Maxie Tjampitjinpa was his first pupil, part of a new generation of painters poised to explore the artistic possibilities of the mature Papunya style under the careful supervision of the older artists.

Maxie's first experience of fame in the art world was not a particularly pleasant one. The thrill of the announcement that his painting *Happenings at Mt Leibig* had won the 1984 Northern Territory Art Award, the Territory's major annual prize for contemporary art, was overshadowed by a controversy between the organisers and some of the unsuccessful competitors over whether the winning entry, and for that matter Papunya paintings in general, were even eligible to be in the contemporary art section of the award. 'It is folk art, not fine art', observed one disgruntled 'local' (i.e. non-Aboriginal) artist to a reporter. Not only did the envious 'locals' consider themselves 'excluded' from Aboriginal art competitions, they now saw 'outside' judges from the southern States giving Aboriginal artists all the prizes in open competitions too. They demanded that Papunya art be treated like 'American Indian art or European folk art' and placed in a different section of the competition. Judge Nancy Underhill hit back with the view that Papunya art was generally of a higher standard than the work of 'local artists', whom she considered 'not in a creative state', and local art collector and 'sand painting expert' Hinton Lowe was quoted belabouring Maxie's critics for their 'completely ignorant misconception of the art form'. The furore subsided as suddenly as it had arisen — though not without its impact on the quiet man at the centre of the storm.

One of the ironies of the 1984 incident at the Northern Territory Art Award was that Maxie, of all the painters, should have been the one singled out for dismissal as a folk artist. His work, perhaps more than anyone else's at that time (as now), exemplifies the movement of Western Desert art *beyond* these parameters of judgment. So there was poetic justice in Maxie Tjampitjinpa's name being singled out again by James Mollison when, as Director of the National Gallery of Australia, he put the case for the admission of Aboriginal art to the category of *fine* art to European art audiences in his essay 'De Tiepolo a Maxie Tjampitjinpa' in the catalogue which accompanied 'L'été australien à Montpellier', an exhibition of 100 'masterpieces' of Australian art shown in France in 1990.

These battles for the acceptance of Aboriginal art as 'Art' are now ancient history in Australia. The step that came after involved the process of differentiating artists within the collectivity of (say) 'Papunya Tula Artists'. It had already been taken by the pioneer Western Desert painting company as early as 1984. Papunya Tula mounted its first exhibition featuring artists as named individuals at the Adelaide Arts Festival in that year. The company's management did this rather reluctantly, because of the complications it would introduce in their dealings with other artists, but they saw the move as a necessity if Papunya paintings were to continue making inroads into the fine art market. Solo exhibitions of the company's leading artists followed in the late 1980s, and the trend has accelerated in the 1990s to the point where some of the most illustrious individual careers in Australian art have started in the Western Desert.

Less than a year after his controversial art award, Maxie Tjampitjinpa painted *Flying Ant Dreaming*, 1985, his first canvas entirely devoid of the design elements which until recently were the defining feature of Western Desert art. It was as though he had responded to one observer's suggestion that what confused the 'locals' about the status of his painting as art was the derivation of its forms and images from ceremony. This work consisted entirely of layers of yellow, red ochre and white

stippling against a black ground to represent the winged termites swarming around their nest after rain. Though a radical departure in anyone's terms, the painting was nevertheless not an isolated phenomenon in Western Desert art of this period. There was a diminishing interest in the depiction of ceremonial or narrative imagery in the work of most second generation Papunya painters. Younger artists were more reticent about disclosing the details of the Dreaming narratives and spelt out less and less of the stories iconographically. As the decade progressed, Papunya paintings in general were moving away from the complex design work and intricate infilling of backgrounds which characterised the late 1970s and early 1980s, towards a simpler, bolder look strongly focused on land and vegetation. However, Maxie's *Flying Ant Dreaming*, 1985, did not so much illustrate the progressive reduction of narrative content as go straight to the extremity of that progression, to the point where the cultural connection between the painting and the land rested only on the capacity of the painted surface to evoke the Dreaming for which it is a sign.

After producing paintings in slightly less minimal variations of this style for about twelve months, Maxie seems to have terminated his initial exploration of its possibilities. *Flying Ant Dreaming*, 1985, predates by six years the artist's extended excursion into layered fields of colour. He was spending more and more time in Alice Springs, taking advantage of the greatly increased opportunities to paint that were opened up for serious painters and uninspired copyists alike by the thriving local trade in 'dot paintings'. Art companies and galleries were springing up all over town, and canvas and paint were freely available from these sources to any of Papunya Tula's established artists.

Under the 'boom' conditions that prevailed in Alice Springs in the late 1980s, anyone else in Alice Springs who showed interest was also encouraged to paint. This nurtured the talent of town-based painters, some of whom had been struggling for years in isolation to emulate the success of the Papunya artists. Two important women painters who emerged from this context were Eunice Napangati and her sister Pansy Napangati, whose work strongly influenced Maxie's over the same period, and with whom he still paints and exhibits. However, the influences usually went the other way, as the inexperienced or less imaginative painters began freely incorporating other artists' ideas into their work. One of the most popular (because of the speed with which one could finish off a painting using it) was Maxie's stylistic invention, the flicked dotting technique — or 'phone booth' style as it was irreverently dubbed at the time after its resemblance to the graffiti-proof interiors of public telephone boxes in Australia.

Maxie continued to use stippling on his own carefully worked backgrounds — to represent the wings of flying ants, heat haze, the dust kicked up by dancing feet, fires at night, and so on — but always in combination with the basic elements of Western Desert iconography and dotting in his distinctive manner, very precise and deliberate. If you want a 'profile' of Maxie Tjampitjinpa, you will find one in the catalogue *Tjukurrpa*, which the Centre for Aboriginal Artists published in 1988 about the painters working in its backyard studio. Maxie appears side on to the camera, sitting cross-legged before a canvas, a picture of silent concentration, enclosed in the space of his own activity. A yellow bandanna is tied around his unkempt hair, which falls forward over his face as he looks down at the point on the canvas where he is adding another dot to the patterning. His paint-spattered left hand is poised in a delicate gesture above the painting as if to direct the brush he holds upright in his right hand to the precise position he has planned for it in his mind's eye.

Although he was well placed for success by his curriculum vitae and still as prolific as ever, Maxie Tjampitjinpa was, for some reason, not among the high-fliers of desert art in the 1980s. A documentary called *Sons of Namatjira* (1974) may hold an answer. This film deals with the conditions under which the second generation of Hermannsburg watercolourists worked in Alice Springs. In a

memorable scene, Keith Namatjira's dealer tells the landscape artist to 'paint something different next time — not always this same tree in that same place on the left'. Wordlessly, Keith takes the canvas and returns to his camp, sits down under a tree — and starts painting the same white gum tree in the same place on the left hand-side of the painting. It was the same story for the 'sons' of Papunya Tula Artists in Alice Springs in the late 1980s—except that Keith Namatjira *was* able to continue producing his infinite variations of the same place. But Maxie was part of a different kind of painting movement and there were no shortage of artists only too happy to step in and paint something else if that was what was wanted. The only thing most of the latest crop of hungry-eyed gallery owners along the Todd Mall knew about any kind of art was that they wanted 'something different' every time.

Ironically enough, in the run-up to major exhibitions of individual artists' work which Papunya Tula mounted during this period, solo shows were also usually explained to the painters as requiring the production of many paintings 'all different' from one another. The concept was modelled on the company's group shows of the 1970s and early 1980s, in which the wide range of styles and subject matter among the different artists had enhanced sales by providing a varied and interesting display. As yet, no-one involved in dealing directly with the artists had enough experience of mainstream contemporary art to conceive any differently of solo exhibitions for Western Desert artists. However, once the principle of conceptual coherence routinely applied to the shows of their non-Aboriginal contemporaries is accepted here too, the possibility of making one's paintings all 'the same', instead of submitting to market-drive demands for innovation, begins to open up. It was the opening Maxie needed to explore again the minimalist direction he had first taken in 1985.

When Maxie Tjampitjinpa came into Papunya Tula Artists in August 1991 with three near identical small canvases depicting the effects of bushfire in all-over stippling (yellow and red for flames and burning embers, white for ash and smoke, and black for the charred areas after the fire had passed over a red ochre ground), he may not have known what reaction to expect. As it happened, Papunya Tula's Sydney agent Chris Hodges was so impressed with them that he immediately offered Maxie an exhibition of his *Bush Fire* paintings. The artist set to work painting with equal enthusiasm and in May 1992 the first of his 'Bush Fire' exhibitions in Sydney announced a bold new direction, one which he has pursued with ever-increasing subtlety and finesse since then. Hodges' gallery was originally established to provide an outlet for the work of the Utopia artists. As the main gallerist for Emily Kame Kngwarreye's work in the first years of her meteoric success, Hodges was ideally placed to appreciate the potential of Maxie's minimalist style. The two artists' later works are in many respects similar: their paintings are sensuous, abstract-looking fields of colour, which contain no elements of Western Desert iconography or even conventional dotting, but rely on painterly effects to evoke the Dreaming forces in the artist's country.

In his *Bush Fire* series, Maxie depicts the ancestral bushfire in all the different phases and places it passes through as it sweeps over the desert plains: sparks and clouds of smoke, or brush fire raging out of control, or burning itself out to leave a charred, smoking landscape which the rain will regenerate. The fire is also depicted in changing lights — by night, or the softness of early evening, or harsh afternoon shadows. The paint is applied layer on layer, building up complex atmospheric and spatial effects across the surface.

What is this Bush Fire Dreaming that Maxie Tjampitjinpa continually paints? It seems unlikely that it is the ancestral fire from Warlukurlangu which has been the subject of so many paintings by so many Western Desert artists — despite the annotations of his recent *Bush Fire* series suggesting that it is. His parents' Dreaming countries of Warntunguru and Kunatjarrayi lie much further to the west around Waite Creek. Earlier documentation from Papunya Tula's file of Maxie's Bush Fire Dreaming

paintings talk of a fire which travelled through Mt Leibig and Browns Bore and finished at a place they call Impalu, west of Waite Creek. In some accounts, a large group of old men carries a bushfire with them on their Dreaming journey through these and other sites further to the south. Perhaps these are all confused references to the same ancestral event, or perhaps there are many different fires in Maxie's Dreaming. These paintings convey a reverence for their subject matter which renders the information — for once — almost superfluous. That it is unavailable will serve to draw attention to the obvious: that this has not been Maxie Tjampitjinpa's own story of his life in art. *That* is a tale still in the making.

VIVIEN JOHNSON

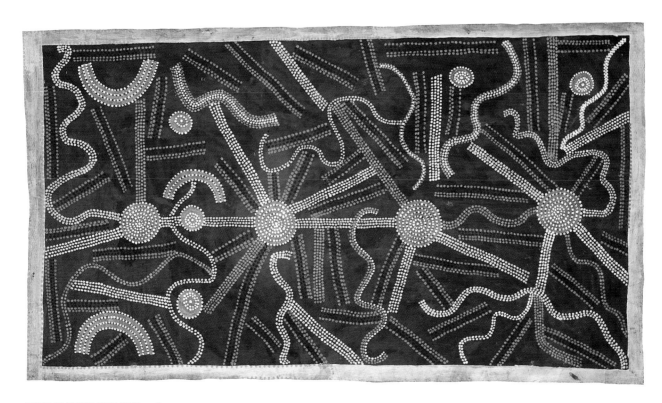

TJIPALPA WATER DREAMING 1982

SYNTHETIC POLYMER ON TARPAULIN

150 x 262.8 cm

FLYING ANT DREAMING 1985

SYNTHETIC POLYMER ON COTTON DUCK

132.5 X 97.5 cm

FLYING ANT DREAMING 1987

SYNTHETIC POLYMER ON LINEN

150 X 185 cm

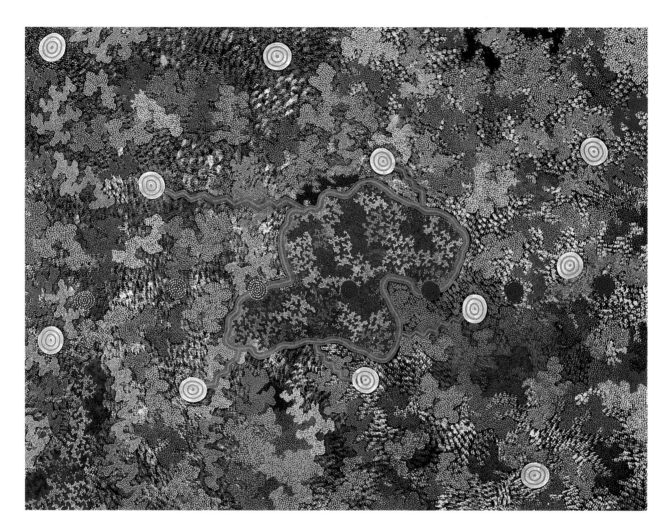

WATULPUNYU DREAMING 1988

SYNTHETIC POLYMER ON LINEN

213.5 X 279.5 cm

BUSH FIRE DREAMING 1994

SYNTHETIC POLYMER ON LINEN

183 x 122 cm

S T O R I E S

MAXIE TJAMPITJINPA

TJIPALPA WATER DREAMING

Tjipalpa is a Water Dreaming site on the western side of Central Mt Wedge, north-west of Papunya. The different sized concentric circles, some of which are interconnected, represent large and small rockholes. The sinuous lines represent bolts of lightning and the arcs are rainbows.

FLYING ANT DREAMING 1985

The stippled surface of this image represents flying ants (*watanuma*) swarming after the rains. The white flecks are the wings they shed.

FLYING ANT DREAMING 1987

The designs in this painting are associated with the Flying Ant Dreaming (*Watanuma*) at a site called Wantungurru. The central circle represents an ant-bed and the area contained within the white arcs is where the ants live. The sinuous white line shows where these *watanuma* emerge from the ground and swarm after the rains. These design elements are based on body-paint designs worn during the ceremonies associated with this site. The short parallel bars on either side of the concentric circle design represent bunches of leaves carried by dancers in ceremony. On either side of the central design, the underground chambers of the ants' nest are shown. The white diagonal chamber stippled in pink depicts the eggs of the *watanuma*.

WATULPUNYU DREAMING

Watulpunyu is a Water Dreaming (*Kapi*) site near Mt Wedge, which is located south-east of Yuendumu. The circle-site designs linked by a grey line represent water. The pink inner line is lightning. The inner area enclosed by this configuration contains the dead bodies of *Watulpunya*, Flying Ant Ancestors struck down by lightning. The stippled grey areas throughout the painting depict clouds.

BUSH FIRE DREAMING

Various aspects and effects of the ancestral bushfire are shown. The yellow and red stippling represents flames and embers; the white is for ash and smoke, and the black for charred areas after the fire has passed through.

A b i e J a n g a l a

Abie Jangala, now in his late seventies, is one of the few Aboriginal artists to have had an account of their life published. His story was one of nine short autobiographies published by the Northern Territory Department of Education in *Stories from Lajamanu* in 1977, some eight years before he became a painter.[1] In reading through this modest account of his extraordinary life, one gains the impression of a man who was always there, as observer, participant and philosopher.

Abie Jangala has lived at Lajamanu in the Northern Territory since the early 1950s and is a strong and highly respected elder in this Warlpiri community. He is a man of great ritual authority, ceremonial boss for water–rain–cloud and thunder *Jukurrpa* (Dreamings) centred on widely dispersed sites in the Tanami Desert. Although he was born into one of the strongest of the desert groups, he grew up in an era of trauma and hardship for his people. A severe drought from 1925 to 1929 forced the Warlpiri to come in to frontier outposts such as mining camps, pastoral stations and police ration depots to obtain food. And in 1928, in retaliation for the murder of a white man, an entire clan was massacred where they were gathered for ceremony. This infamous event, known to historians as the Coniston massacre, is referred to by the Warlpiri as 'the killing times'. By 1955, just over twenty-five years after Coniston, two-thirds of the Warlpiri community were living on settlements.

Virtually around the same time that he started his initiatory journey into manhood according to Warlpiri traditions, Abie Jangala was also being initiated into the ways of white society, which first appeared on the margins of his world and then increasingly came to marginalise it. As a young boy of about twelve he first saw white men at the copper mine at the Granites. He later worked there for eighteen months and was there again, working on building projects including roads and airstrips, after

he was picked up and drafted into the army. He recalls that there were 'about 4000 Aborigines and 4000 Europeans working in the army there'. He found it to be 'a good life, a bit rough. We had to work hard and were pushed around, but still I liked it'. After the war he worked on the establishment of the Warlpiri settlements at Yuendumu and Lajamanu. While many others left Lajamanu and returned to be closer to their traditional country, Abie Jangala stayed and helped build it into the strong community that it is today.

Abie was born in the bush in the vicinity of Thompson's Rockhole about 350 kilometres south of Lajamanu. This was where, when his time came to be initiated, his father and other men 'made him a young man'. His father, with whom he evidently had a close relationship, told him:

This is your Dreaming country and mine. When I die, you will take my place and be in charge of that Dreaming. You will have your own corroboree that you can show to your children when they are going to be initiated or you can teach this to your younger brothers, who will in turn teach it to their children. So you don't have to dance somebody else's corroboree, you have your own.

It was Abie's father who took him to visit the Granites and the copper mine where there were white people. They went bush again after a few days. When Abie was around sixteen, his father took him back to Thompson's Rockhole for further initiation:

My father thought I should learn more, because I was a bit older now, already a young man, but I still didn't know very much and my father was worried about that. He showed me all the different ceremonies and then said to me: 'I have shown you everything now and I think you are old enough to go on your own. I don't think I can teach you any more. But if you still need me to teach you, you can always come back'.

Abie maintained this pattern of journeying, returning to see his father and visiting his country, going off on his own and learning more about ceremonial 'business':

because I would be in charge of our Dreaming country and its sacred places when my father passed away. According to our Law other people could not come to my Dreaming country, just as I could not come to theirs. That is why I always went back to the same place.

After the war he went to Yuendumu, an Aboriginal reserve created in 1946 by the Native Affairs Branch of the Northern Territory Administration specifically to accommodate the increasingly displaced Warlpiri population. Government policy at the time favoured centralised settlements as the means of dealing with the societal crises faced by indigenous people in the wake of white settlement. Abie joined his family, who had been moved to Yuendumu from the Granites when he was in the army. Warlpiri country covered a huge area and Yuendumu was located in the heart of Ngalia, southern Warlpiri territory. Within a short time feuds and health problems developed among this concentrated population living in an artificial settlement environment. The official solution was to establish a second Warlpiri settlement at a place called Catfish, 600 kilometres to the north.

When the road was completed, Abie was one of twenty people randomly 'drafted' by officials to move to Catfish: 'We were not asked, we were simply told to go'. They travelled beyond Supplejack through places that Abie had never been. Their destination lay in country belonging to the Gurindji, neighbours of the northern Warlpiri, and many of the travellers were uneasy about the whole idea.

Along the way they camped a little distance short of Catfish, at a place called Hooker Creek. He says that this place didn't look 'too bad' and the officials asked if they were willing to stay there instead of going on:

There was nothing in Hooker Creek apart from … one bore. There was no windmill for pumping the water, it had to be done by hand. We had to get some bushes and build humpies for ourselves and then we had to start building a shed that could be used as a garage to repair trucks. First this shed only had a roof, no walls, as we were short of building material. We built a house on the place where the big house behind the mechanics workshop stands now, and when that was finished the government people stayed there. We also built a store, on the place where the school library is now.

Abie remained at Hooker Creek for about eighteen months and then returned to Yuendumu to see his family:

My father was getting old now and I saw him in Yuendumu for the last time. He said to me: 'I am old and sick now and I will die soon. You can take care of yourself. You don't need anybody to look after you any more, or to teach you. You can go now and don't have to come back'.

He stayed at Yuendumu for about a year until the government embarked on the first major relocation to Hooker Creek in 1951. This time a group of around 200 people were ordered to move and Abie went back with them, one senses out of empathy, to help them start a new life. But this was not their country and many old people in particular were unhappy. While many left 'walking back all the way to Yuendumu, Mt Doreen and the Granites', Abie Jangala stayed. Hooker Creek was renamed Lajamanu in the late 1970s when it was transferred to community ownership. At one point in his life story, Abie reflected on his long association with this place:

Since I came here for the first time, Hooker Creek, or Lajamanu as it is called now, has changed a lot. Many houses have been built, bore holes have been dug and many people live here now. Children have been born here and that means their Dreaming place is here, so we have started to think of Lajamanu as our country now. The Europeans who live here are also better than those we had before; we are not pushed around any more as we used to be. We can speak to them now.

Abie began to paint on canvas in 1986. Three years earlier he had been initiated into contemporary art issues and environments when he travelled to Paris as one of a group of twelve Warlpiri men participating in the exhibition 'D'un autre continent: L'Australie le rêve et le réel' at the Musée d'Art Moderne de la Ville de Paris. This was the first international exhibition in which Aboriginal artists had shared the stage with other contemporary Australian artists. The position taken by the Warlpiri towards their involvement in the exhibition is of great interest, particularly in view of subsequent developments at Lajamanu. The catalogue contains a statement they issued in connection with their installation. It reads in part:

We did not do this ground painting in Paris to seek out praise or honour. We only want the world to accept and respect our culture. We only want recognition that we have a culture, and that we remain strong, as Warlpiri people, in Australia. We do not want to be venerated as 'special'. We just want to be recognised as part of the human race, with our own traditions, as we always have.

We Warlpiri present you here in Paris not with a 'showpiece'. We are not, and do not ever want to become, professional painters.

Instead, we present you with a glimpse of the way we venerate the sacred Heroes who have given us our identity, so that Europeans can have some understanding of what we are, and how strongly we feel about being allowed to remain ourselves.

We will never put this kind of painting onto canvas, or onto artboard, or onto any 'permanent medium'. The permanence of these designs is in our mind. We do not need museums or books to remind us of our traditions. We are forever renewing and re-creating those traditions in our ceremonies.[2]

By the end of 1985 the Lajamanu community had moved on from the position outlined in the Paris declaration and had begun to paint in permanent media.[3] This decision to become professional painters and join the contemporary painting movement was the outcome of a meeting of senior men, including Abie Jangala, who gave their approval for public paintings to be made. The fact that the Warlpiri community at Yuendumu had recently (in 1985) formed a cooperative, Warlukurlangu Artists Association, would have been an influential factor in this decision. Also, after Paris, Lajamanu artists had participated in art events in London and the United States as well as in Australian cities, adding to their experience of the art world. At home they could see the impact that Western Desert art was beginning to have on other Australians. Moreover, painting had the potential to bring about many of the positive aims stated in the Paris declaration. Art could represent a Warlpiri perspective in far-off places and build respect for their culture and identity. The other important consideration was that painting would provide people with an income.

The meeting paved the way for a Traditional Painting course taught by the community's adult educator, John Quinn. This was welcomed because people had little experience of Western art materials.[4] Abie Jangala was among the first group of men who enrolled. Using acrylics and tins of housepaint, the men worked on large pieces of composition board and discarded building materials. Abie's first painting, *Emu and Water Dreaming*, consists of *kuruwarri* — graphic motifs comprising circles, curved and straight lines and bird tracks — set out in a formal symmetrical design against a field of mostly white dots.[5]

This painting was among a group of forty works which the National Gallery of Victoria purchased in 1989. This acquisition was negotiated by Sharon Monty, at that time director of the Dreamtime Gallery, Perth. The occasion marked the beginning of a brief professional association between Monty and Abie Jangala, whom she represented for a period of some eighteen months until she closed her gallery in 1992.

Sharon Monty first saw Lajamanu works on a visit to Katherine in June 1988 at Mimi Arts and Crafts. She was excited by what she saw, in particular photographs of the men's first paintings, which were still in storage at Lajamanu. In August, Monty went to the Aboriginal Sports and Culture Festival at Barunga, south-east of Katherine. She took the photographs of unidentified Lajamanu works she had in Perth and approached a group of Warlpiri people who named the artists for her. A month later she went to Lajamanu. She caught the mail plane and remembers the tarmac being surprisingly busy — there were many other small planes in for a big Land Council meeting.[6]

Monty waited around until there was a break in the meeting and then approached the old men, telling them that she had come about the special collection of men's paintings. As a stranger and a woman asking senior men about these things, Monty was naturally very hesitant — there was the possibility of her breaching protocol. The response was to pass over her enquiry and suggest that she might be interested in buying current work. Monty persisted with some trepidation and then floated the idea of selling these special works to a museum, a place where they would be looked after. It emerged later that several people had talked about buying the collection but the negotiations had

never progressed very far. Monty realised that the men had been testing her commitment: 'This is an Aboriginal way of negotiating. You pick it up, put it down, toss it around, shake it out and leave it'. The men eventually took her over to the Adult Education Centre and showed her the paintings she had come such a long way to see.

Back in Perth, Sharon Monty began to negotiate the sale of the first painting collection to the National Gallery of Victoria. She also wrote to each artist about the sale with details of their payments and the copyright arrangements. At the same time she started to receive phone calls from the artists with the news that they had been busy painting for her — 'big mob … you'd better come'. In December she returned to Lajamanu accompanied by a Perth television film crew, who documented the handover of the Lajamanu collection to the National Gallery of Victoria, which was represented by its curator, Judith Ryan.

Abie Jangala had been on an extended visit to Tennant Creek at the time of Monty's first visit. But he knew about the sale and was back by the time she returned and approached her with a roll of paintings under his arm. She found him to be 'fairly awesome, impressive … an imposing presence'. Monty told Abie Jangala how much she admired his painting in the Lajamanu collection and when he then intimated that perhaps she could sell his work, she agreed to represent him.

In 1989 Abie expressed an interest, through the Lajamanu Arts Co-ordinator, in coming to Perth. Monty made all the arrangements for his trip in 'pretty fractured' conversations by radio telephone. At the last minute one of the connecting flights was cancelled and she had to break the news to Abie and his travelling companion, Ronnie Lawson Jakamarra. He was very disappointed but was back on the phone within half an hour: 'We've fixed it, Nungala'. They flew the long way round and spent three weeks in Perth. In March 1990 Abie returned with Kenny Walker and stayed for six weeks. This second visit was made possible through the assistance of an artist-in-residence grant funded by the Western Australian Department for the Arts. The artists' 'studio' was a spot beneath a large shady tree in the grounds of the Perth Institute for Contemporary Arts (PICA) where people were welcome to sit, observe and ask questions.

Abie's temperament, his inner calmness and strength, made a lasting impression on Sharon Monty, as did his patience in explaining things and answering her questions. She was also captivated by his great sense of humour and liking for 'horsing around'. On one occasion, when she asked about the Frog Dreaming, one of the stories he paints, he responded by cavorting around the kitchen 'like a frog'. Abie nearly always sang the songs for his Dreamings as he painted. He did this when he was alone, but especially when in Warlpiri company.

From time to time Sharon Monty and Abie Jangala discussed painting. He expressed the view that 'the proper way' to paint was not to use too much colour and stated that he paints what his father tells him to paint: 'He comes to me in dreams'. Monty believes that Abie was continually striving to re-create the simplicity of ceremonial ground paintings in his works on canvas. When she asked what he felt about painting, Abie replied: 'That it's the truth'.[7]

The isolation of the Lajamanu community and the lack of accessibility to the centres of marketing have meant that this community of artists has not become as established as other desert painting groups, particularly those within range of Alice Springs. Abie Jangala is the only artist within the community to have had solo exhibitions and a steady career. It would seem that he was marked for this attention from the start or perhaps he sought it out. Abie Jangala seems always to have placed great value on the cultural interaction that art makes possible.

ANNE MARIE BRODY

NOTES

1 The autobiographical references and extracts are taken from 'Abe Jangala', in *Stories from Lajamanu*, 2nd edition, Northern Territory Department of Education, Curriculum & Assessment Branch, Darwin, 1984, pp. 1–9. (Abe is a variant spelling of Abie.)

2 L. Bennett, 'Aboriginal Participation', in S. Pagé, *D'un autre continent: L'Australie le rêve et le réel*, exhibition catalogue, ARC/Musée d'Art Moderne de la Ville de Paris, Paris, 1983, p. 49.

3 See V. Johnson, *Aboriginal Artists of the Western Desert: A Biographical Dictionary*, Craftsman House, Sydney, 1994, pp. 36–8.

4 See J. Ryan, 'Paint Up Big: The Lajamanu Adventure in Art', in J. Ryan, *Mythscapes: Aboriginal Art of the Desert from the National Gallery of Victoria*, exhibition catalogue, National Gallery of Victoria, Melbourne,1989, p. 84.

5 ibid. This work is illustrated on p. 89.

6 The material in this section of the essay is based on an interview with Sharon Monty.

7 For a slightly different version of Abie's statement on painting, see S. Monty, 'Abie Jangala: Despite Trucking and Resettlement Still Boss of the Water', *Artlink: Contemporary Aboriginal Art*, Vol. 10, Nos 1 and 2, autumn/winter 1990, p. 15.

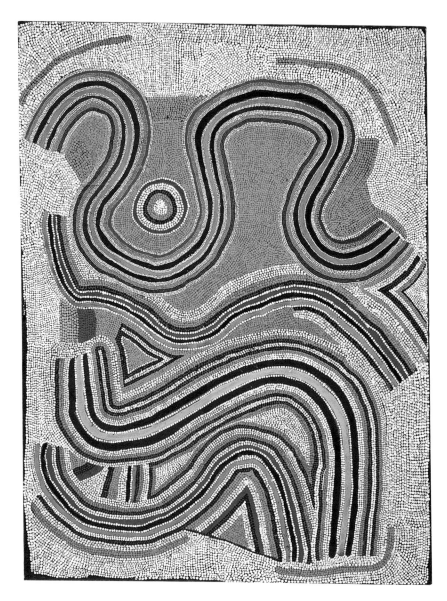

WATER DREAMING 1987

SYNTHETIC POLYMER ON COTTON DUCK

122 X 91.5 CM

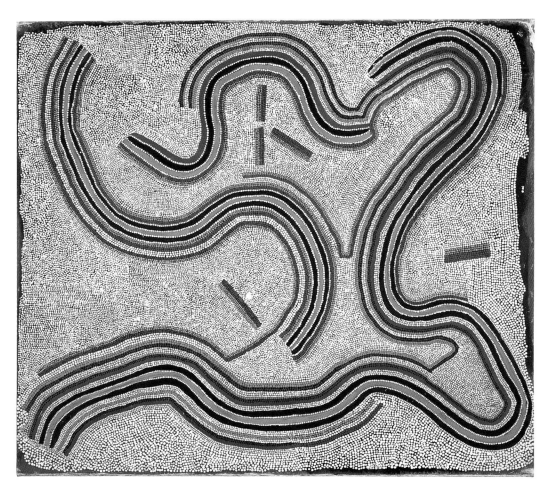

WATER DREAMING 1987

SYNTHETIC POLYMER ON COTTON DUCK

119 X 139.5 cm

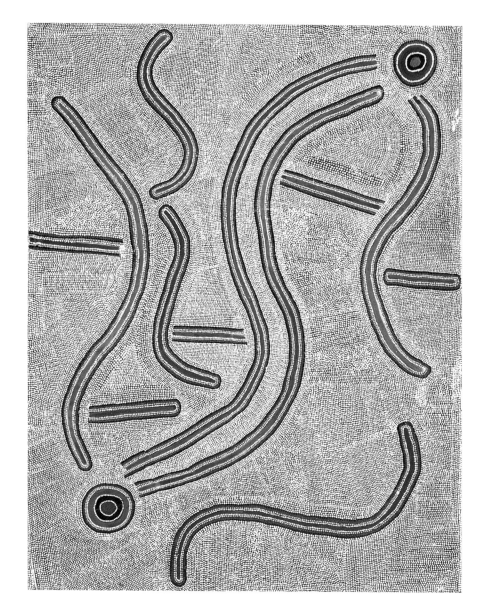

WATER DREAMING AT PAPINYA & KURDILPARNTA 1989

SYNTHETIC POLYMER ON COTTON DUCK

169 x 136 cm

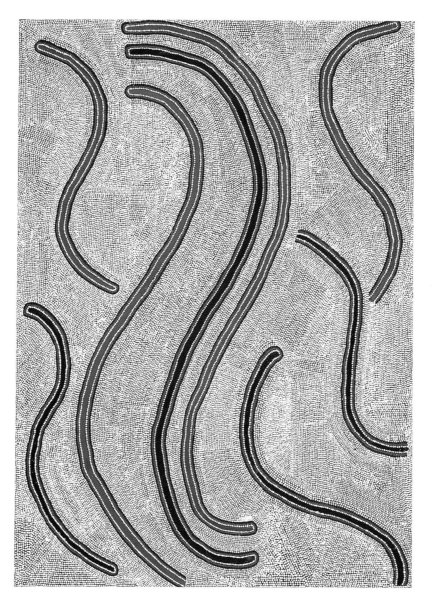

MUNGURLARRI WATER DREAMING 1989

SYNTHETIC POLYMER ON COTTON DUCK

163 x 118 cm

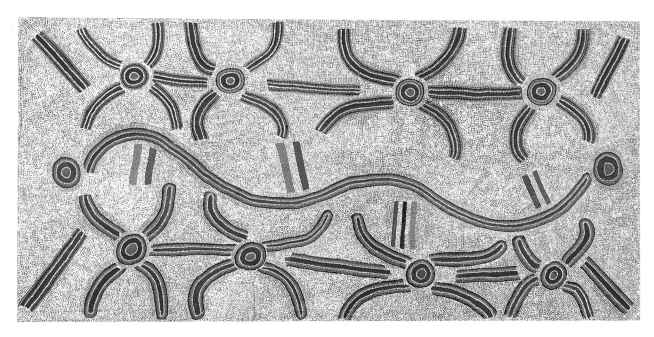

WARRARANGI (GREY TOADS) 1990

SYNTHETIC POLYMER ON COTTON DUCK

119 X 252 cm

STORIES

ABIE JANGALA

The main complex of stories about Abie's country are to do with the Water Dreaming. Abie is a rainmaker himself, and his stories refer to: the creation of waterholes and springs by the *Kilkilangi* (the Whistling Eagle); the throwing back, to seed the clouds, of water from the permanent spring at Kurpurlunu; the bringing in (singing) of the rain in 'hard times' and the action of the rain itself in various places in his country.

Kilkilangi came from the south (from Mikanji and Puyurru) with his son; they were Jangala and Jampitjinpa. Kilkilangi carried the rainbow (*Wanera*) on his head. He flew down at many places (Jiyakang, Punjarri, Papinya, Mungurlarri) and left waterholes 'all the way'. At Kurpurlunu, the rainbow fell off his head and made the spring water, Kaninjarra. Kilkilangi said: 'I'd better pick him [up] and put him on my head'. So he wound the rainbow round his head and flew off. The bird kept going, ending his travels in Abie's country. Kurpurlunu is a place where there is always good water, even in times when all other waterholes have dried up.

There is another story which tells why the water is good at Kurpurlunu. The Jangala and Jampitjinpa Ancestors–men were sitting down at Kurpurlunu. They were watching a fire, far away at Winki, in the east. This had been started by two men, a Jakamarra and a Jupurrula, who were hunting the big Euro (*Karrngarla*). They tried to make a fire with a fire stick (*jimpana*) but no fire came. 'Where's the fire?', they asked. Then they saw the fire come out of the ground. The two fellows grabbed spinifex, set it alight and ran off, Jupurrula one way and Jakamarra the other, to flush out the Euro (wallaby). Everybody was chasing him and the fire spread everywhere. They caught the Euro and ate him. Afterwards it rained and the water was spoiled by the smoke and debris from the fire (*warlu*). At Kurpurlunu, the Jangala and Jampitjinpa saw the smoke and covered their soak over to keep it good. This is why the water at Winki is no good (salty) and the water at Kurpurlunu, just under the topsoil, is good.

During the fire, Jakamarra and Jupurrula nearly died from the smoke, but Jangala and Jampitjinpa saw this and rescued them, bringing them back to life.

Kurpurlunu was visited by *Walpadjirri* (Abie's bush name), the greater bilby, who came from the north-west, from Jillajin (Christmas Creek). Walpadjirri 'pinched' (stole) something at Kurpurlunu and then went back home. *Wulwarna*, the green frog from Kamira, also visited Kurpurlunu. He swam or travelled up the floodwaters as they surged down from Kurpurlunu. Wulwarna is the frog who knows or senses the coming rains, and comes out of hibernation to sing them in. He is the focus of Jardiwampa ceremonies which are held in the early wet season. His countryman, *Warrarangi*, the grey toad, is slower to respond.

The cycle of rainmaking (the seed of which was the spring made by Kilkilangi) is continued at Kurpurlunu. When the people came in from dry areas, they collected water and threw some at the clouds to seed them. Wet season storms mass big and come to Kurpurlunu.

Kurpurlunu became an important men's business place. It is a big place, but according to Abie 'no *kartiya* find him' — no white men know where it is.

The ancestral Jangala–Jampitjinpa man was a great rainmaker. He cut down the *Wirrkali*, bloodwood tree, stood the trunk upright and sat beside it to sing the rain. The rain came from a place in the south called Puyurru (about 400 kilometres north-west of Alice Springs, NT). It travelled to Jiyakangku and then to Wanimbilgi. The rainmaker travelled, and the rain came, all the way to Kurpurlunu. Rainmaking rituals are performed in 'hard times' to bring on the rain in places where there is no permanent water.

At Puyurru the rain went two ways. One lot of rain travelled to Kurpurlunu and another through a more westerly path to Kamira. The floodwater built up at Kurpurlunu and flooded across to Kamira. The rains kept going past Kurpurlunu and Kamira in a northerly direction into other people's country, travelling towards the salt water.

Warrarangi, grey toads, hibernate all through winter. They bury themselves in the mudholes, one on top of the other. When the monsoonal weather breaks, their countryman, the bright green frog called Wulwarna, hears (senses) the monsoonal clouds and begins to sing and dance (just as the people do during Jardiwampa ceremonies held in late October–November). Wulwarna is quick and alert, but Warrarangi is slow and stays in his hole a bit longer. Finally, the toads know the rain is near and push their way up, one after the other. Warrarangi is good tucker.

The circles in Abie's paintings typically represent soaks or springs; the long sinuous lines are the rains (*ngapa*) and the smaller sinuous lines are lightning (*wirnpu*); short barred lines are clouds or rainbursts — these are also body-paint designs. In *Warrarangi: (Grey Toads)*, 1990, the frogs are depicted coming out of their holes in response to the massing clouds. The latter are shown by the stripes — yellow (full of sun), black (full of storm) and red (sunset–sunrise). The brightest green stripe is for Wulwarna and the grey is for Warrarangi.

Ginger Riley Munduwalawala

A puzzled Ginger Riley, responding to a group of vocal London reporters, tried to make sense of their probing questions about the Dreamtime, totemism, spirituality and other stereotypes. The occasion was the opening preview of 'Aratjara: Art of the First Australians' at the Hayward Gallery, and Riley's questioners were searching for the expected (ochres, dots, cross-hatching, symbols), but had instead run up against his monumental, mainly blue, figurative landscape. His painting was, of course, a complex religious narrative like the other 'more Aboriginal-looking' works in the exhibition. For Ginger, a true colourist, his joyful application of paint and colour in his portrayal of landscape said it all. His painting expressed the powerful sentiments he felt for his country, story and Ancestors. 'See my blue, my country is very beautiful' was his reply to the journalists. It was all there if only you could see.

Ginger Riley Munduwalawala was born around 1939 in Mara country in the Limmen Bight region on the western side of the Gulf of Carpentaria. His birthplace, a few kilometres north of his outstation, is in his mother's country. The area is marked by rolling hills and the Limmen Bight and Roper River systems that flood the coastal plains and hinterland during the annual monsoons. The Four Arches, a group of rocky hills, are a prominent feature of the landscape and Riley's paintings. They were formed by the Snake Ancestor in his twin guises as Garimala and Wawalu. These two snakes came from the south (*garimala*) and the south-east (*wawalu*) into Ginger's mother's country where they made the Four Arches. Ginger rarely paints any story other than the creation epics (Dreamings) belonging to his mother's country.

Ginger Riley's mother died when he was a baby and his father took the family north-west to the

Anglican Roper River Mission Station, which had been established by the Church Missionary Society (CMS) in 1908. In the early 1970s the station was handed over to its Aboriginal residents and administered by their Ngukurr Community Council from which the small township takes its name. Many people from different parts of Arnhem Land have settled at Ngukurr, which these days numbers around seven different language groups among its population.

Ginger was sent by his father to be educated at the mission. But, bored by repetitious learning and despite his father's efforts to keep him attending, he shunned the white man's schooling. He says that he used to leave by the back door around the same time as his father left by the front. He is quick to comment, however, that he became 'a proper bush Aboriginal'. Ginger's European surname comes from a police officer called Riley who was stationed in the Ngukurr area. It was once a common practice for those in positions of authority over Aboriginal people to bestow European names on them. The source of the name Ginger he did not explain.

In the early 1950s, as a young teenager, Ginger went to work on Nutwood Downs Station, which was owned by the London-based Vestey pastoral group. Working as a ringer, Ginger joined the numerous, but largely unrecognised, Aboriginal stockmen and stockwomen who contributed their skills to the developing pastoral empires of the outback. They were extremely underpaid, if paid at all, for their services. My own father took to the stockman's life when he left school in the 1920s. Though he worked further south in New South Wales, like his northern brothers, he was paid only in kind, not in wages. A generation later, Riley himself says: 'We only got food — not money'. This economic slavery continued until the mid-1960s when Aboriginal workers began to agitate for change with the support of left-wing trade unions. At Wave Hill, another Vestey-owned property to the west of Roper River, Gurindji stockmen and their families, led by Vincent Lingarri, walked off the cattle station to their nearby homeland at Wattie Creek.

Although Riley was not directly involved in the politics, these changes formed the backdrop to his years of work in the cattle business and eventually affected him personally. One of the adverse outcomes of the 1967 equal pay legislation was unemployment for many Aboriginal workers. But, like many others who suddenly found themselves out of work, Ginger warmly remembers this period of his life and is extremely proud of his stockman's skills. When the work ran out, Riley headed to Darwin and other places in the Top End, including Groote Eylandt, doing different labouring jobs.

The extensive travelling and experience involved in his long working life have contributed a lot to Ginger's self-confidence and sophistication, as was evident on his visit to London. During a taxi ride across the city, the driver recommended a 'taxi drivers' eating house to Ginger and his agent. They took his advice, and everything was fine until another customer leaned over their table and said 'Welcome to my country' in a patronising way. The man backed off when Ginger replied, 'It's my country too! My Queen is here and my Church is here'.

Ginger's first experience of painting occurred in childhood when he watched his father and grandfather apply ochres to utensils and weapons. They also applied paint to their bodies for ceremonies. The community seems to have done very little painting for the outside tourist market, although the late Willy Gudabi, a Ngukurr artist many years older than Ginger, said that he produced such works from time to time and Ginger himself probably tried his hand, like most people, at producing artefacts for sale to the local market.

Ginger Riley covered some vast distances during his time in the cattle business. It was on a long round trip with his white station boss, from the Gulf to Alice, that he met Albert Namatjira, the Arrernte artist famous for his watercolours of Central Australia. Paintings by Namatjira and his descendants are generally known as the Arrernte School, named after the language group of

Namatjira and his followers, or the Hermannsburg School, because the art movement originated at the German Lutheran Mission at Hermannsburg, south-west of Alice Springs. Namatjira's images have recently undergone a serious reappraisal by the art establishment, which ignored them for decades in spite of (or perhaps because of) their huge success with the public. Interest in the work of these Arrernte artists has increased since people became aware that these stylistically Western landscapes are also representations of the artists' Dreamings. The watercolours are gradually being revalued and appreciated as accomplished and 'authentic' images of the desert which make their own distinctive contribution to the strong landscape tradition in Australian art.

Namatjira had his first sell-out exhibition in Melbourne in 1938, the year before Ginger Riley was born. Riley was greatly impressed by Namatjira when they met, probably in the mid-1950s. He admired and respected Namatjira for the recognition he had achieved for himself and his people through painting. Riley was also greatly inspired by Arrernte paintings, in particular their colour, and returned to Nutwood Downs motivated to take up painting. However, his first attempts appear to have been unsuccessful, perhaps because he could not match the intensity of Namatjira's palette using only ochres, which were all that would have been available. He says of this time, 'I began to think there was something wrong with my painting'.[1] Some thirty years were to pass before he tried his hand again.

By the mid-1980s Ginger Riley had returned from the Top End and was again living at Ngukurr. During the period that he had been away from his country, the artists of the Central Desert to the south had begun to paint for the art market, transforming elements of their traditional ceremonial art into images painted in acrylics on canvas. Their activities created a debate within the white art world about the ideological and aesthetic merits of this move. From the beginning of the desert movement in the early 1970s until well into the 1980s, many commentators were sceptical. There was much hypocrisy and paternalism in critics denouncing the commercialisation of what they defined as 'traditional art'. Such uninformed, prejudiced views about Aboriginal art equated tradition, purity and authenticity in an unacceptable way. They sought to deny Aboriginal artists the right to use their aesthetic traditions and talents in response to contemporary circumstances and, by implication, denied them the right to sell their work in the art market. But by the middle of the 1980s Aboriginal art had arrived and was here to stay.

Ngukurr was one of the last of the communities to take up painting in the 1980s and its art again challenged the reactionaries. The first Ngukurr works were markedly different from anything being done in Aboriginal art at the time. Ngukurr artists did not use the ochres or the designs of bark paintings, their closest tradition, nor did their work reflect the mature compositions of the desert painters. Instead of refinement, there were free, imaginative drawings, uninhibited compositions and bright colours — fluorescent pinks and electric blues. Despite the recent acceptance of contemporary Aboriginal art, certain reservations, reminiscent of the debates of the past, hung around this new work and fleetingly questioned its authenticity.

The Ngukurr painting movement started like many others under the auspices of the community's Adult Education Centre, which initially offered printmaking courses. This was part of an endeavour coordinated by Brian Burkett, an adult educator, to establish commercial enterprises that would provide people with an income. An old hall, which housed the screenprinting workshop, was named 'Beat Street' after the graffiti on its front wall. Ginger did not produce any prints but in 1986 he and Djambu Barra Barra painted with printing inks on thin lawn fabric which was then turned into curtain material and displayed for sale in the Ngukurr Council Office. The fact that they did not sell was discouraging and Ginger again gave up painting until the arrival of a visiting art teacher, John Nelson,

a little while later. Nelson brought canvas and acrylic paints and these revived Ginger's interest. His first paintings depicted sea creatures or were realistic landscapes or animal studies.

In 1987 Burkett introduced art materials and painting courses. In September of that year, Ginger's and Djambu's paintings were the most impressive among a small but distinctive group of four Ngukurr entries in the National Aboriginal Art Award at the Museums and Art Galleries of the Northern Territory in Darwin. The Ngukurr 'wall' startled many viewers; it was perhaps too contemporary for some people.

Ginger's first paintings tended to focus on isolated images floating in a field of flat colour. There was often a border of triangular forms, possibly a ceremonial design, although he has described this motif as simply decorative. In the beginning he consistently used it to 'frame' his pictures, although less often in the large-scale works he began to paint in 1988. Ginger also quickly developed his subject matter, moving away from the motif–field structure of his first works into landscapes. At the same time he was developing his mature painterly style and technique.

There is still the memory of Namatjira's early inspiration in Ginger Riley's paintings in so far as Ginger's work also invites stylistic comparison with Western landscapes. But Ginger's 'scenes', with their unique approach to perspective and intense colour, sometimes painted raw, straight from the container, are a world away from Namatjira's comparatively soft watercolours. Riley's brushwork is vigorous and energetic, and it is this expressive technique which makes him one of the rare painterly innovators on the contemporary Aboriginal art scene. Like Namatjira, Ginger Riley paints his country in a representational style, but Namatjira and his followers gave no visual 'clues' to the story. With Namatjira's images, you have to be able to 'read' the landscape in order to know which trees or rocks are sacred and to whose country they belong. The landscape is presented at face value, virtually as scenery; only an Arrernte custodian could read its deeper cultural meanings. Ginger Riley, on the other hand, reveals the story in the landscape in an open, figurative display. Narrative and landscape come together through his use of colour, the emotive medium through which he expresses his profound feelings for his country.

When he finally found his style and success, Ginger Riley was strongly motivated to continue painting. Having lived for some time in a socially marginalised way at Ngukurr, at 'bottom camp', the income from painting enabled him to move back to his mother's country. He hopes that one day he will be able to buy the outstation that he currently leases and stock it with his own cattle and horses. Ginger is proud of the self-sufficiency that the income from painting has brought him, in contrast with the dependency that was part of working in the cattle industry, when Aboriginal people were paid only in food rations and board: 'I really like to get the money. I reckon it's good because I didn't have any money all my life in the bush'.[2]

Painting is Ginger Riley's work now. He has achieved wide recognition and success in recent years and won two national art prizes. In 1992 he won the Alice Prize and in the following year the Australian Heritage Commission Award. In 1993 his work was chosen by Australia Post for inclusion in their special stamp issue to mark the Year of Indigenous People. Ginger will become only the second Aboriginal artist to enjoy a major retrospective when his achievements over the past decade will be on exhibition at the National Gallery of Victoria in June 1997. Ginger Riley will no doubt enjoy the recognition. There is a hint of this in his exchange with a reporter who interviewed him about a commission he executed in 1992 for the Australian Embassy in Beijing. Thinking that he might one day go to Beijing, Ginger remarked: 'People will know me next time I go to China. People will say, "That is Ginger Riley's painting and here's the bloke now". That's the way I want it'.[3]

<div align="right">DJON MUNDINE</div>

NOTES

1 Quoted in K. Merrigan, 'Picturing the Land of Our Diplomats', *Sunday Age*, 23 February 1992.
2 ibid.
3 ibid.

AUTHOR'S NOTE

Some of the material in this essay is based on an interview with Ginger Riley Munduwalawala at Ngukurr in November 1994. I would also like to thank the following people for their assistance and comments: Margaret West, Curator of Aboriginal Art, Museums and Art Galleries of the Northern Territory; John Avery, Aboriginal Areas Protection Authority, Northern Territory; David Dalrymple, Katherine Aboriginal Legal Services, Northern Territory; Gael Duell and Brian Burkett, Adult Education Officers, Ngukurr, Northern Territory, 1987–89; and Beverley Waldegrave-Knight, Alcaston House Gallery, Melbourne, Victoria.

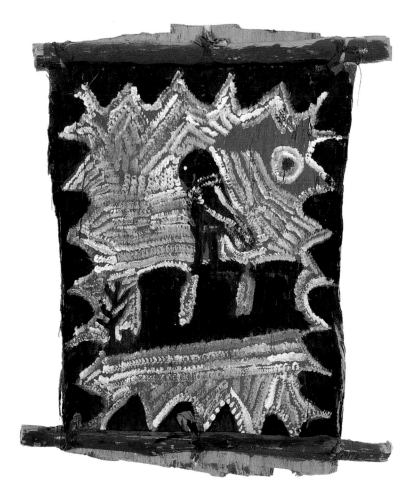

NGAK NGAK AND THE ARCHES c. 1987

EARTH PIGMENTS ON BARK

60 x 40 cm

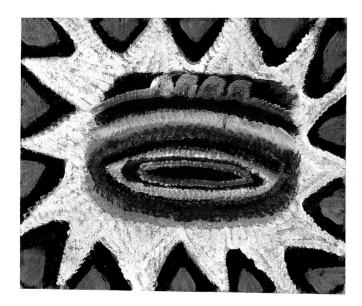

ARTIST'S COUNTRY I 1989

SYNTHETIC POLYMER ON PLY BOARD

36.1 x 43.7 cm

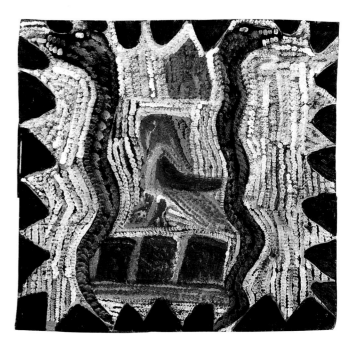

ARTIST'S COUNTRY II 1989

SYNTHETIC POLYMER ON PLY BOARD

60.5 x 64.5 cm

GINGER RILEY MUNDUWALAWALA

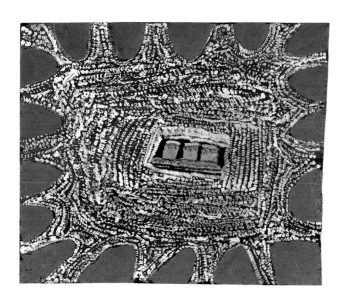

ARTIST'S COUNTRY III 1989

SYNTHETIC POLYMER ON PLY BOARD

41 X 49.9 cm

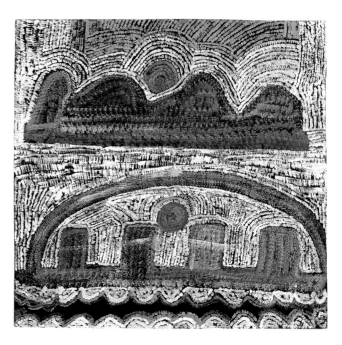

ARTIST'S COUNTRY IV 1989

SYNTHETIC POLYMER ON PLY BOARD

62.5 X 65.1 cm

ARTIST'S COUNTRY V 1989

SYNTHETIC POLYMER ON PLY BOARD

33.3 x 58.5 cm

ARTIST'S COUNTRY VI 1989

SYNTHETIC POLYMER ON PLY BOARD

43.3 x 61.8 cm

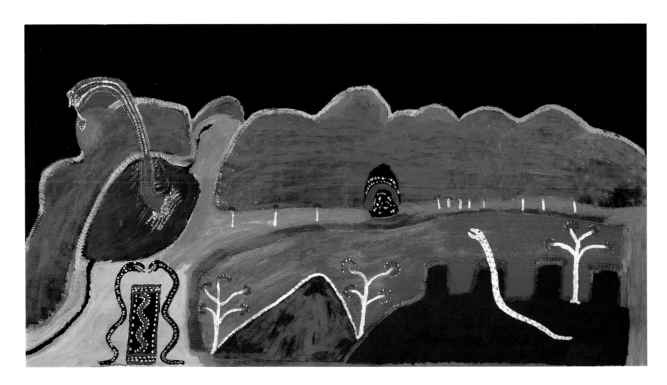

GARIMALA AND BULUKBUN 1988

SYNTHETIC POLYMER ON COTTON DUCK

176.9 x 326.3 cm

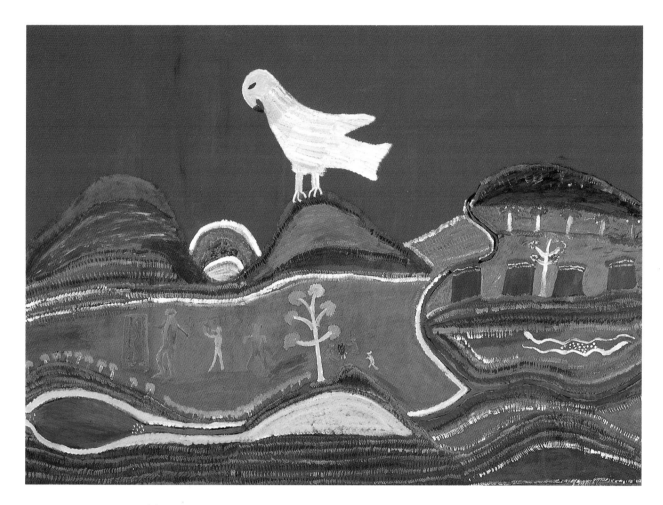

GARIMALA AND NGAK NGAK (1) 1989
SYNTHETIC POLYMER ON COTTON DUCK
168.5 x 234 cm

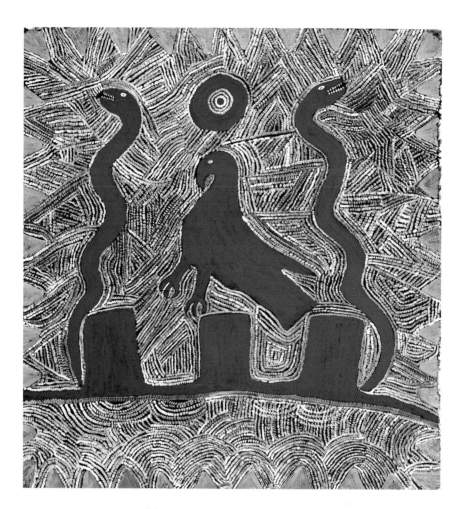

GARIMALA AND NGAK NGAK (2) 1989
SYNTHETIC POLYMER ON COTTON DUCK
178 x 168 cm

S T O R I E S

GINGER RILEY MUNDUWALAWALA

This group of paintings represents aspects of the Creation Story (Dreaming) belonging to the artist's mother's country. The varied association of elements of this story in different paintings is explained by the artist as 'same story — different country'. These differences sometimes appear to be seasonal, diurnal (night and day versions) and possibly perpectival, that is, looking at the story from a different angle or place. Ginger Riley Munduwalalawa is *jungai* (guardian) for his mother's country. The story encompasses aspects of both women's and men's Law and is therefore sacred and not to be discussed.

Garimala came into this country from the south and the south-east. He was really two snakes: Garimala (or Kurramurra) and Wawalu.

Where they rested four rocky outcrops were formed. These are referred to on standard maps as the Four Arches. The two snakes are generally shown in association with the Four Arches: 'I've been drawing those two snakes there beside the hill (the arches) … but really they didn't stay there. They left their eggs there and kept travelling'. The eggs they laid somehow didn't become babies … I don't know why … maybe they were too heavy'. Garimala is still present in the landscape — you can see the bubble in the water.

In the early days these snakes were 'cheeky', meaning dangerous. They used to hurt people, but then they changed. Ginger used to talk to them, suggesting that they are now 'quiet' and not dangerous. Bulukbun, a dragon-like creature who massacred many people, is possibly the malevolent incarnation of Garimala–Wawalu. The more aggressive Bulukbun becomes, the more he raises the spines on his back. There is a story about a boy who killed a flying fox and was pursued by Bulukbun to a place known as San Vidgeon where there was 'a camp of Mara and Waliburru people — woman and man, dog and child'. Bulukbun smelled them and massacred them all. Their skeletons are inside a nearby cave; these bones form part of another group's story. Bulukbun lives on under the water and parts of his enormous body are shown emerging in different parts of the landscape.

Among the figurative elements which recur in Ginger's paintings are the ancestral Gori-y-mar people. Sometimes they are dancing the first ceremony or else going about their daily lives. In some paintings there is a board decorated with designs which is shown guarded by two snakes or occasionally men. This board, or 'message stick', is an invitation to ceremony; the guardians are keeping the message secret. The tree (or trees) which figures in most paintings is the liver tree, so called because the shark gave his liver to create it. This tree is sacred. *Ngak Ngak*, the sea eagle belonging to men's ceremonies, is an important figure in the paintings. He appears to have the role of watching over things, possible country or Law; he is generally shown looking at something. In the beginning Ngak Ngak flew over the mouth of the Limmen Bight River, creating Yumunkuni (Beatrice Island) which is part of Ginger's mother's country.

GINGER RILEY MUNDUWALAWALA

125

Jack Wunuwun

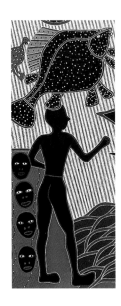

Recently, while flying over Gamerdi outstation in a light plane, I looked down and noticed for the first time that the small road encircling Wunuwun's gravesite and few buildings there formed the shape of a yam leaf (*barrdje*). The yam is an analogue for the Morning Star — Wunuwun's major personal totem. Jack Wunuwun was, until his death in 1990, an important artist and the 'practical' and ceremonial leader of the Dhuwa moiety Gang-ngal clan. This is one of the clans which make up the group known as the Murrungun people; their language is Djinang. The Murrungun are the custodians of the elaborate Morning Star ceremony, a ritual of exchange and diplomacy which also celebrates the cycles of nature through the symbols of birth, death and regeneration.

Wunuwun was brought up on the Methodist mission on Milingimbi Island off the coast of Arnhem Land. He went to Darwin after the Second World War, where he worked as an army cook's helper, and returned to Maningrida in the 1960s. Later, as part of a wider movement in which Aboriginal people returned to their homelands, he went to live on his clan estate (or country). Here he set up home with his brother-in-law John Bulunbulun at Gamerdi, east of the Blyth River.

My first meeting with Jack Wunuwun was early in 1985 when roads between Maningrida and Gamerdi were still flooded after the annual monsoonal rains. This meant a journey by motorised dinghy up the swollen, brown Blyth River, dodging debris being swept down by the floods. Most memorable were the crocodiles slipping silently down muddy banks, and huge cabbage palm trees silhouetted against the sky fringing the river banks and grassy flood plains behind. At Gamerdi landing Jack Wunuwun had himself built a solid wooden structure far above the water level from which, by the use of a plastic bucket and rope, people could wash themselves and their children and

clothes. This was, I found later, a nerve-racking experience and even more so as in time vital planks went missing. The jetty was synonymous with the artist in its ambitious scale and sculptural presence, growing out of sticky, brown mud to enhance the life of his family.

My impression of Gamerdi at that time was one of an artists' community. Wunuwun, John Bulunbulun and other family members were surrounded by paintings completed for sale and work currently in progress. The women had produced beautiful conical baskets and mats dyed with colours from roots and bulbs and painted with ochre pigments. These works of art made a sophisticated and brilliant contrast to the environment and their simple living conditions. It occurred to me then that the slow, meditative and utterly serious process of painting was drawing in stabilising forces and that this scene had significance for all humanity. The *rarrk* or cross-hatching on the bark paintings seemed to reflect the heat haze and light and shadow of the day.

Wunuwun regarded his art as a vital means of reinforcing traditional values in a rapidly changing world, where the encroachment of Western ideas threatened to overrun Aboriginal life. He had been schooled in the techniques and subjects of his art by his two older brothers and in 1968 began his artistic career. While working within the parameters of the Djinang artistic tradition, he became an influential innovator, experimenting with complex compositional devices which held the multilayered meanings of his paintings. On three occasions when it suited his purpose, and he needed a surface large enough to contain the images he wanted to put down, he chose to work on canvas instead of bark, mixing carefully chosen natural pigments to animate the unfamiliarly smooth surface. This experimentation coincided with the period in Aboriginal art in the late 1980s when boundaries were extended and influences were felt beyond the local communities into the wider art world. His son Terry Gandadilla recently told me: 'He always painted from nature or his own mind. He never looked at art books or got ideas from other artists'.

His technical approach to his work was meticulous. Bark was carefully chosen so there was never a twist to it, shaved to just the degree of thickness he preferred, and flattened and proportioned in a way that the blank surface almost suggested the final form and guided his hand in his mark-making. Colour and its bold and brilliant use was his trademark. He selected and gathered ochres according to both personal aesthetic and cultural criteria. For instance, only recently did I discover, during a discussion with Terry Gandadilla, that his first use of the colour green could be dated to mid-1982 when he noticed Terry, then a student teacher, mixing blue and yellow acrylic paints to make green. Working within the constraints of his culture, Wunuwun improvised and produced a beautiful rich green with charcoal and yellow ochre. His other distinctive colour, *raitpa*, an iridescent purple-brown, often effectively contrasted with velvety flat red ochre, is represented by a circle in the small painting of two *derrka* (stringy-bark canoes) in the 'Morning Star' series. According to his son:

raitpa represents [the island of] Galiwin'ku, because that's where they both come from [in creation time]. It's a name for my father, too, or you can call it Gunbimia. He had to put raitpa in his paintings. That colour takes us back into the past and to a place. If I were to go there now people would know why I was there [to get colour].

I've heard the song for *raitpa*, *derrka* and salt water repeated hypnotically all night at an initiation ceremony. Wunuwun would hum this and other songs from the Manikay song-cycle as he was painting.

In the Maningrida art community there is a complex mix of personalities differing widely in their reasons and needs to make art — from the occasional flash of brilliance to the dedicated artists completely involved in their work-in-progress. For Jack Wunuwun art was inextricably tied to his

desire to communicate and educate at the highest level and as widely as possible. The *Barnumbirr Manikay* series in this exhibition grew out of this ideal and embodies these elements.

During a social visit to Gamerdi on New Year's day 1986, while lunching with the family under a shade tree in front of a large tin shed which was their storage and sleeping place, I noticed an envelope with numbers listed and images drawn beside them. Wunuwun told me that this was to instruct his children and grandchildren in the songs and visual representation of the Barnumbirr (Morning Star) Manikay (song-cycle). He particularly focused on the traditional education of his young daughter Sherron — who was constantly with him from when she was a baby — as he painted, conducted meetings and socialised. This was his response to the knowledge that she would be growing up in a fast-changing world.

I was fascinated by the drawings on the paper, as this was an unexpected and unusual teaching method for an Aboriginal man of Wunuwun's era, and retrieved the envelope from the dust. In our talks that day we discussed the form of a possible artwork which would encompass all those elements of the song-cycle separately, each making a strong and distinct statement, and together, on a large canvas with the single songs–images interconnected in a way that would help the viewer to a more complete understanding of his complex story.

Wunuwun was ready to make a significant statement through his art and to help him achieve this we applied to the Aboriginal and Torres Strait Islander Arts Board for funding so that there would be no financial pressures while he painted the series. While waiting to hear from the board, I suggested that Jack might like to enter a work in a local art prize to try to get some cash coming in. He agreed. The rivers rose as the monsoon set in and radio contact became spasmodic but messages were filtering through that a large painting was nearing completion and that it would not fit in the door of our local light plane. The rain eased and we were able to drive to the western bank of the Blyth River, having arranged an appropriate meeting place. We waited, willing a rain storm to hold off, when a small yellow fibreglass canoe, paddled by Wunuwun, came into sight. His two wives were holding aloft a large, blue tarpaulin-wrapped parcel. The handover was swift because of the threat of rain, crocodiles and fading light. The large bark only just fitted into the Toyota tray. As we raced ahead of the threatening deluge the truck headlights failed. Speeding, guessing the potholes and other road hazards, the effects of this nightmare drive were instantly forgotten when we unwrapped the extraordinary bark painting back in Maningrida. The painting far exceeded the value of the acquisitive prize money we had been hoping to win and, under Wunuwun's instruction, because of its size and the serious intent of its subject matter, was offered to the National Gallery of Australia and purchased by them. Meanwhile, its reputation spread within the community and pilgrimages of family groups came to gaze at the already legendary work. Unfortunately, an annual wet season plumbing problem inside the Maningrida Arts and Crafts centre meant the visitors had to splash through ankle-deep water before they stood to gaze in wonder at the beautiful artwork.

This extraordinary painting also resulted in a morning of extreme tension for Jack and me. There were problems of 'ownership' of parts of the imagery. These were only satisfactorily resolved after long discussion at a meeting of clan leaders. We found later that destruction of the work was a possibility. Eventually, in a proud moment some months later, we were able to stand in front of his masterpiece hanging at the National Gallery and savour the moment. This painting was a forerunner to the *Manikay* series, inspired by our discussions. The National Gallery was later, in 1990, to purchase what was really his final painting and another major work, *In the Beginning of Time*, which is a diptych depicting a narrative of the birth of the sun and Morning Star and the creation of the moon, who lifted the sky to let light and life into the world.

After weeks of intensive interaction with his paintings, Wunuwun would feel, as most artists do, a sense of loss when the work left its 'bush' origin and then Maningrida for outside destinations. This feeling was balanced by the knowledge that his message was carried, through the intricate detail of his imagery, to the public in exhibitions and publications. He told his children and grandchildren, who were closely involved in his art-making, 'One day you might find it [the painting] [reproduced] in a book'.

During the six years we worked together, Wunuwun always gave clear directions as to what he felt he could achieve and the value he placed on his work. Though dealing with such a volatile mix as culture, art and money, we learnt to do business efficiently and satisfactorily, reaching agreement after discussions and suggestions from both of us, even during those isolating months of wet seasons with only a crackling radio for communication. Towards the end, I felt he was pushed beyond his physical capacity in producing his bark images to achieve the level of financial security he needed to provide for his family's needs and I wished for a system as in Japan where he would be revered as a National Treasure.

Wunuwun's intellectual generosity and all-encompassing vision for humanity were revealed in the way he explained the Murrungun Creation Story, which describes the beginning of the world. He held that when the original giant egg burst, leaving the solid yolk as land and clear liquid which became the sea, Aboriginal people remained on land and were subsequently 'cooked' by the newly risen sun, whereas fish and white people travelled to a cold place and stayed there, left in a 'raw' state. However, he remarked that even today, by their will and determination, *balanda* (white people) can find their way back to their home country. This explanation seemed to explain pilgrimages to Gamerdi, journeys which continued even after his death, and the ease and comfort with which people were made welcome.

Among the many visitors to Gamerdi over the years — filmmakers, journalists, art gallery directors and collectors — perhaps the most incongruous were successive individuals and groups of Japanese anthropologists, mostly connected with the National Museum of Ethnology in Osaka. Their research interest was partly to find similarities between the two hunter–gatherer indigenous cultures. The most memorable was a venerable old man, Professor Fujioka (now deceased), a 'clever man' in his culture and a man of great knowledge. The professor made a special visit to Gamerdi after he and Wunuwun had met in Japan, a great mutual respect having developed from that time. The professor, who led a highly disciplined academic and religious life in Japan, found the harsh environment and unfamiliar pace of life demanding. Particularly challenging to him were the enforced hours of silence spent with Jack because of language difficulties, though there were important, more subtle areas of communication they both felt. Fujioka could direct his vital energy or Ki to create heat or cold and Jack was aware of his own ability to harness 'power' and use it in magical ways. He had had the strength to resist many attempts on his life through sorcery. Quite regularly various objects were removed from his body by his personal 'witch doctor' Charlie Mawandunga. Smooth round stones, sharp bones and slivers of wood made an intriguing collection, kept as part of the family's heritage. One, though, a paper clip, which after removal had been slipped inside a drink can for safekeeping, had been inadvertently placed in a garbage bin and all our attempts to locate it by rattling cans failed. Mawandunga was present at Wunuwun's death at Darwin Hospital, working side by side with the doctor during his final hours. At his funeral, a 'clever man' from distant country was flown in to the funeral site to try to shed light on the circumstances and cause of Wunuwun's death.

Wunuwun's death came too quickly, the final diagnosis of lung cancer being made far too late for anything to be done. Every day at his funeral at Gamerdi it rained. Several trucks from Maningrida

had crossed the Blyth River, but there were serious doubts about a possible return journey. Close family and related clan groups gathered and sang and danced each evening over the ten days or so of the funeral. We were privileged to see the exquisite painting by appropriate kin on the coffin lid and told that this image will not be repeated for a long time. Brilliant orange parrot feathers decorated the ceremonial pandanus bags used by the dancers, whose chests were painted with clan designs. White feather strings representing magpie geese and delicate feather 'water lily flowers' were ritually placed near the coffin by Ganalbingu people, the appropriate Yirridja moiety 'mother' group.

On the afternoon of Wunuwun's burial, when preparations were finally complete, a huge downpour made this impossible. Anyone who could fit sat closely under a bough shade close to the coffin waiting for the rain to pass, mesmerically watching the torrent sweep away the carefully sculpted *wanjir* (ground design). I remember wishing it were a normal day and we could cancel the burial and hold him close. Somebody in the huddle to stay dry commented, 'Let's keep him here'.

The ground sculpture chosen was *Wernde* (ant-bed), where the ritual cleansing of those close to the deceased took place after the burial. The significance of this ceremony had previously been explained by Wunuwun in documenting paintings of these designs. The shallow channels formed in the sandy soil by the makers provide a conduit for the spirit of the deceased person embodied in the blood and sweat shed by him and his relatives. These elements await the first seasonal heavy rains which will flush them through to the clan waterhole to join the souls of the unborn.

After Terry Gandadilla and I had spent an afternoon of discussion in preparation for these remembrances, an unusually large, brown butterfly, *bunpa*, tenaciously circled our heads. We looked at each other in silent acknowldgement that the old man had been present and even enjoyed our talks.

DIANE MOON

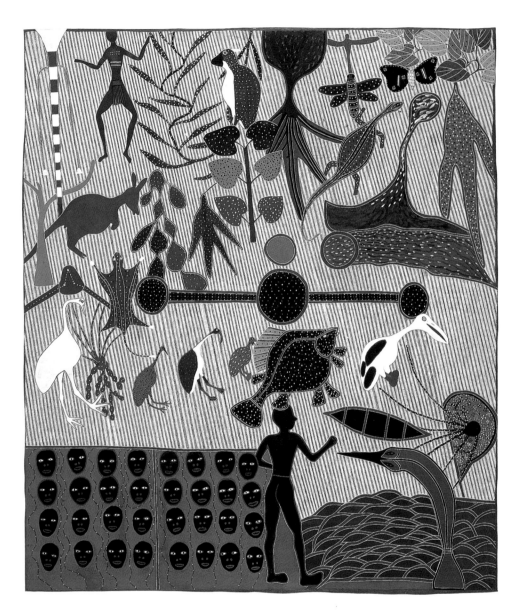

BARNUMBIRR MANIKAY I 1988
MORNING STAR CYCLE
EARTH PIGMENTS AND SYNTHETIC POLYMER ON COTTON DUCK
185 x 160 cm

MALAWARRAWURR —
ANCESTOR/CREATOR

46.5 x 33 cm

MUNDULTJA — SALT WATER

46.2 x 30 cm

DERRKA — CANOE

46.8 x 33.5 cm

LARAJEJE — LONG TOM FISH

45 x 31.6 cm

WUNUWUN — SEAWEED

45 x 25.8 cm

NANJAR — PELICAN

45.7 x 29.3 cm

BARNUMBIRR MANIKAY II (1—30) 1988
MORNING STAR CYCLE
EARTH PIGMENTS ON EUCALYPTUS BARK

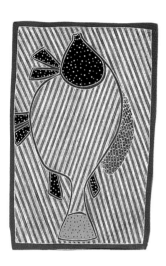

MORRPAN — ARCHER FISH

46.9 x 30.8 cm

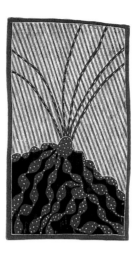

GUNUMBIRRI — SWAMP GRASS

45.1 x 25.5 cm

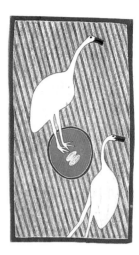

GURURRKU — BROLGA

45.1 x 25.5 cm

BARDARPARDARPE —
CHICKEN BIRD

45.1 x 25.5 cm

GUDIDI — SAND PLOVER

47 x 30.3 cm

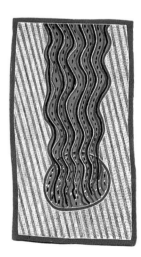

BALMARRK — WET SEASON
WIND

45.1 x 25.9 cm

DUWARR — BUSH FIRE

45.7 x 25.9 cm

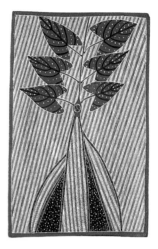

DJARRKA — GOANNA

43.9 x 26.6 cm

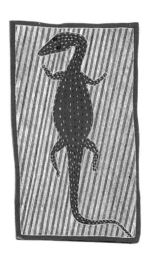

BARRDJE — YAM

46.9 x 30 cm

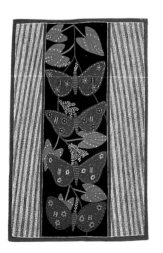

BONPA — BUTTERFLY

45.6 x 29.4 cm

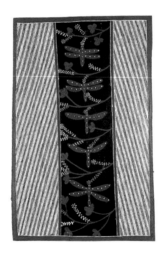

WURRURLUL — DRAGONFLY

46 x 29.5 cm

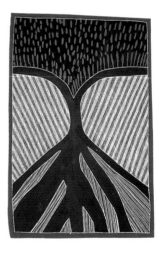

**DJANPA AND GINIPA —
BANYAN TREE AND FRUIT**

45 x 29.8 cm

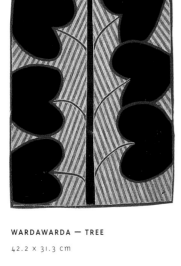

WARDAWARDA — TREE

42.2 x 31.3 cm

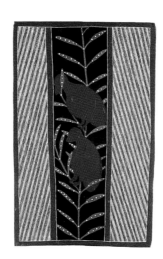

DJURRURTJURRURR — OWL

44.6 x 29 cm

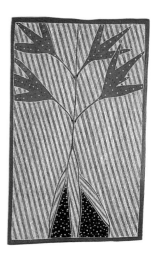

MARRPANDARR — BUSH CARROT

45.2 x 28.2 cm

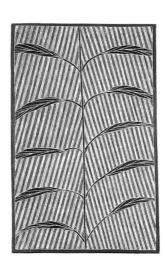

YIRKUDA — YAM POTATO

45.6 x 28.8 cm

BARDAI — VINE

46.5 x 30.2 cm

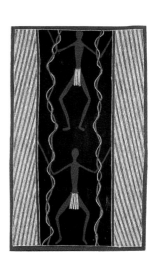

MUNYAL — SPIRIT

45.7 x 28.5 cm

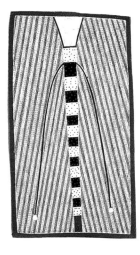

BARNUMBIRR — MORNING
STAR

45.6 x 26 cm

NGARKURR — WALLABY

45.4 x 29.2 cm

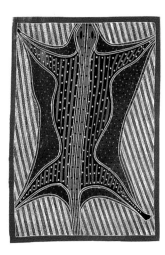

WARRPURR — GLIDER POSSUM

45 x 30.9 cm

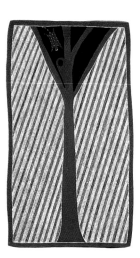

GORRITJE — TREE

45.3 x 26.4 cm

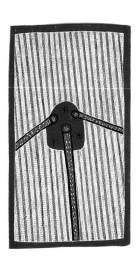

GIYAN — ANTS

44.4 x 25.5 cm

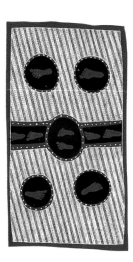

BULAWIRRI — WATERHOLE

45.3 x 25.4 cm

S T O R I E S

JACK WUNUWUN

B A R N U M B I R R M A N I K A Y

This painting and the thirty small works on bark represent the Barnumbirr Manikay or song-cycle of the Morning Star, the principal Creator/Ancestor for the Djinang people belonging to the Murrungun clan.

In Murrungun/Djinang cosmology, the world originated from two giant eggs which burst and spread out. Around this 'time' the Djankawu sisters and Mambu travelled into *Murrungun* country. The Djankawu sisters are important figures in the formation of Murrungun country. Wunuwun described them as 'making the whole lot and growing them up — just like a garden'.

The Djankawu came from the east and are associated with the sun, which gradually warmed (cooked) the liquid egg (the world). The yolk then hardened and dried out, creating the land. The Murrungan/Djinang also compare this period to a time of flood, following which the world was drying out.

The Djankawu sisters and Mambu were followed by Malawarrawurr, another culture hero for the Murrungun people. Malawarrawurr came across the sea in his stringy-bark canoe (*derrka*). He had to wait a long time for the land to become hard before he began travelling on foot. He encountered the long tom fish, shark, seaweed and many other creatures which became important Dreamings. He 'found' the east and west wind and bushfire. He gave all these Beings song and dance.

In the course of his journeying, Malawarrawurr married three wives who became birds. They were Gudirri, Garrala and Bardarpardarpe. They gave birth to Rangu who created the sky and became the moon.

The Murrungun world explored by Malawarrawurr is represented by the centre circle. This circle is Bulawirri waterhole close to Wunuwun's clan lands. Bulawirri means world. Bulawirri waterhole is also called Gathararrara, meaning Australia/Bulawirri — that is, the whole world as it was known to traditional Murrungun society before contact.

In the upper left of the painting, the pole with feather-tasselled strings on either side represents Barnumbirr, the Morning Star. The figure next to the Morning Star pole is Munyil, the Spirit Being who watches out for Barnumbirr. Munyil sings or calls out every evening and spirit people dance for him.

The 'arms' of the Morning Star pole are called *djungan*. One is named *mirringe*, with the extended meanings of cooked, east and Morning Star. The other is *gorringe*, signifying raw, west and Evening Star. According to Wunuwun, 'this one, Barnumbirr, still represents the whole lot. It could be the earth … Australia'.

The centre circles also represent *wandalla* (the sky) as well as Bulawirri (the world). The 'arms' and connected circles signify east and west. Dualities in Murrungun cosmology are again elaborated by another meaning given to the connected circles in the centre of the painting. This structure also represents *wanjir*, which is the sand sculpture or prepared funeral ground. Within the ceremonial space

of the *wanjir*, people 'wash' in a ritual which helps the spirit of a dead person find its way back to the clan waterhole. In performing this ceremony, people are perceived to be washing off their sweat, considered to be a tangible essence of a person's spirit.

This washing ceremony reflects one important aspect of Murrungun views on death: 'bones finish-up' and become dust but blood and sweat 'travel'. It is these essences of spirit, blood and sweat, which after death find their way back through the ground to the 'right' country. The channels which connect the three circles guide the dead person's spirit back to its home from either the 'east side' or the 'west side', from the place or 'country' where they died. The first rains of the wet season are said to wash the spirit of the deceased back through the ground to the clan waterhole, where it waits to be born again.

The faces in the bottom left of the painting represent *yirritja* and *dua* moieties, and the strings on either side of each face symbolise the relationship between them.

Jimmy Wululu

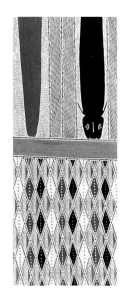

Jimmy Wululu was born around 1936 at Mangbirri, a coastal settlement in Central Arnhem Land. The Aboriginal people of this shoreline, who call themselves Yolngu (meaning 'simply a human being'), have been in the area for tens of thousands of years. Wululu was about sixteen years old when his mother died. He went to school at the mission on Milingimbi, one of the Crocodile Islands group in the Arafura Sea, just offshore from the Arnhem Land coast. This Methodist mission, which was established in 1923, was the major settlement in the area, surviving as an institution for fifty years. In 1973 the Church set up an Aboriginal Council to run the settlement, reflecting a major shift by the Australian Government from assimilationist policies to self-determination for Aboriginal people.

Wululu belonged to the second generation to grow up on the mission, a group often referred to as 'mission boys', because they spent the larger part of their formative years there rather than following a traditional life in the bush. It was generally assumed that 'mission boys' were poorer in traditional skills and ritual knowledge than their 'bush' peers. However most, including Wululu, still went through an intense Aboriginal education, independent of their exposure to Christianity and European ways. Certainly their long journeys on foot to Darwin show they had lost none of their survival skills.

Among Wululu's earliest Milingimbi memories is being told of W. Lloyd Warner, the American sociologist who wrote *A Black Civilisation*, published in 1937, a classic text about the people and culture of the region he visited in the mid-1920s. Wululu recalls that, 'People used to call him Mr Warner. I was only little. My mother showed me a paperbark tree near Yathalamarra where Mr Warner cut [marked] the tree with an axe'. Milingimbi, before the arrival of the missionaries and Warner in the 1920s, was an important meeting place for many Aboriginal groups in the region. This was particularly so towards the end of each dry season when they took advantage of the permanent water source at

Milingimbi waterhole itself and the abundant shellfish in the surrounding mudflats. The waterhole was also an important religious site, a place where the spirit of the Rainbow Serpent resided.

With the establishment of the mission, Wululu's father and many of his extended family, specifically the Guypapuyngu people, had moved from their spiritual homeland Djiliwirri (some 80 kilometres to the east on the western shores of Buckingham Bay) to live more permanently at the mission. Other groups such as the Wongurri and Djambarrpuyngu from the neighbouring coastlands and islands also came in. They were attracted by the prospect of new foods and trade goods which were exchanged in return for their labour — and also their conversion to Christianity. According to Wululu, 'Anything metal like knives, axes. Different languages came in. The mission gave us many good things and many bad things like *ngarrli* [tobacco]'.

In 1929, when the local, now sedentary population had reached about 500 in number, a measles and whooping cough epidemic passed through and killed many children of that generation and some adults. Further sickness occurred in the early 1930s. Local Aboriginal people blamed the outbreak of this disease on the disturbance of a coughing sickness spirit which resided in certain rock formations on the mainland. They overlooked the presence of Europeans in their environment and also the Yolngu people's now more sedentary and urbanised lifestyle at the mission. Cultural disturbances also occurred, including conflict between the missionaries and Yolngu over the traditional practice of polygamy. The concentration of so many different cultural groups around the mission also caused tension. In the past, the coming together of people from different languages and places at Milingimbi had been orchestrated for limited periods of time for religious ceremonies to bring the rains of the wet season and renew the world. Now, with people settling permanently on what was really someone else's country (land), there were many violent conflicts over access to the mission and its resources as well as local food sources, despite the teachings of Christianity. Wululu seems to have been little involved, though his elder brothers and other male members of his family were heavily involved in these skirmishes.

During the Second World War, Wululu and his family lived near Mangbirri, on the mainland opposite the mission. The mission was converted into an Australian Air Force base which was bombed several times by the Japanese. Wululu's older brother, Billy Djoma, describes how they:

waited for the enemy with spears in their hands. Some people ran away … We took to the bush as the enemy were dropping bombs. So there were the Japanese and we were all in the thick bush. We spotted one of our planes, a little one fighting with a Japanese plane … As the enemy planes flew overhead, they looked like grasshoppers with wings outspread, all joined together. They came on the Sunday, Monday and maybe the Tuesday also.

After the war and before his *djapi* (first initiation), Wululu and some friends walked over 600 kilometres west across Arnhem Land to Darwin. This journey was undertaken by many of their generation who were lured by stories of adventure and excitement in the city or, as Wululu says today, 'the action'. Wululu completed this sojourn several times, including once with the Arnhem Land writer–artist Jack Mirritji, who described the adventure in his autobiographical work, *My People's Life*. A journey on foot of this magnitude (roughly the distance from Paris to Hannover) through the tropical terrain of Arnhem Land cannot be underestimated. On his first trip to Darwin, Wululu went to school for a time at Bagot, a Government-run Aboriginal Reserve. On later trips he worked as a manual labourer. He lived a dual existence, working and mixing with white Australians by day and by night being involved in a complex ceremonial life involving large numbers of performers. Although these ceremonies were staged virtually in the heart of town, they went largely unnoticed.

Back in Milingimbi in the late 1950s, Wululu joined a building team that was involved in an

innovative scheme using ant-beds to make mud-bricks with which they built small bungalows for the local population. Building and other jobs were done under missionary supervision:

Alfred Gungupun and I we used to work with a Fijian missionary called Mr Milituki, looking after the piggery. I worked clearing bush for the garden and airport, then building houses, mud-brick houses. Everyone worked on those houses — They were little boys and we showed them how to build. Bob Ingram, a balanda [whitefella] from Tasmania taught us how to build. I also helped with cattle, with David Malangi, milking cows near where the church building is now. I painted then, who was that white man? Alan Fidock, yes. He was like the art adviser then — I sell to him.

Wululu paints in the classic Arnhem Land tradition, using ochres found in the soil and sheets of bark. This medium has largely remained the same since time immemorial. The earth pigments used are red and yellow ochres, a white pipe clay, and ash from fires to mix black. These colours were traditionally ground and mixed with water and a natural adhesive such as juice from the tuber of a native orchid. Nowadays the fixative is generally a commercial product like PVA woodworking glue. Brushes are still made from plucked sedge grass stems or palm leaves, chewed ends of twigs, or human hair. These are used at least as often as store-bought camelhair brushes. Barks are generally 'primed' using a base sealant coat of red ochre, although Wululu often uses black. The basic structure of the image is then drawn freehand. The final part of the painting is the cross-hatching or *rarrk*, which involves the overlaying of grids of parallel lines at acute angles to each other. These *rarrk* designs, their ordering of colours and the number and angles of the lines drawn are taught by a master painter to his pupil. But in the hand of each new artist they effectively become the signature of individual style. The first composition an artist learns is generally the design painted on their body at their first initiation into adulthood.

Boys do not usually take up painting as a 'career' until they are in their twenties, or even thirties, by which time their ritual status, experience and observation of life provide a better basis for becoming a visual artist. Wululu was 'apprenticed' to his father and a brother who 'taught him to paint. Leaves, snakes, any bush fruit. I ask my brother. [He said] "You can stick on with this *ngarraka* [herring-bone] on bark and *dupun* [hollow log] from Gapuweyak and Yathalamarra'". His earliest paintings, from the 1970s, were naturalistic images of turtles and other animal studies. His later works moved directly into minimalist body designs abstracted from nature, a development related to his increased involvement in ceremonial life and the sophisticated visual forms to which his more senior ritual status exposed him.

Wululu's experience in the building trade also had a marked influence on this style. The usual practice for bark painters, and other bush artists, is to create the image in their mind and then execute it freehand. It is extremely rare for an Aboriginal artist to do preliminary drawings of any kind. Wululu is a rare exception. He diligently drafts the image, first outlining his design in pencil. For this he uses the straight edge of a piece of timber or a ruler to make the composition as neat and formal as possible before he starts painting. This feeling for geometry and precision in his work stems from his work as a carpenter. He talks about how he learned:

to use the ruler and draw and measure properly. I use a ruler now with my paintings … I know, I understand from my people how to do this [gestures indicating drawing freehand], but how can I draw straight. I use ruler, timber, a straight edge.

Wululu worked as both a painter and a builder throughout the 1960s and 1970s, travelling back and forth to the mainland. At the end of the 1970s, he took up fishing in a serious way and currently holds a commercial fishing licence. In 1978 he worked with the anthropologist Ian Keen, both as cultural informant and builder.

Two of Wululu's brothers, Johnny Bongawuy and Billy Djoma, were both productive and respected painters. They overshadowed Wululu, who only really began to emerge socially and artistically after their deaths (in 1982 and 1989 respectively). Then, as the oldest male in the family, many responsibilities fell on Wululu's unassuming shoulders: 'I gotta really good story from them and that's why I'm a *bungguwa* [boss]'.

Wululu was one of several artists involved in the Aboriginal Memorial, an installation of 200 burial poles made on the occasion of Australia's Bicentenary in 1988. This collective work, by artists from Ramingining and nearby communities, was conceived as a memorial to those Aborigines who had died defending their land against the colonisers. This large installation of burial poles, inspired by the forests of Arnhem Land, was the only Aboriginal contribution to the 1988 Sydney Biennale 'Beneath the Southern Cross'. This memorial is now on permanent display in the National Gallery of Australia.

Wululu's contribution to the memorial was admired by Jean-Hubert Martin who attended the Sydney Bicentennial. The set of poles in this exhibition were commissioned in 1989 specifically for his landmark exhibition 'Magiciens de la Terre'. In 1989 Wululu travelled to New York with fellow Ramingining artist David Malangi, to attend the opening of the major exhibition 'Dreamings' and participate in related symposiums. A co-effort of the South Australian Museum in Adelaide and the Asia Society Gallery in New York, the display was thematically arranged around images of the body. It was to bring current Aboriginal art practices to the attention of the world — particularly the move to paint on canvas, using modern acrylic paints, by Aboriginal artists of the Central Desert regions of Australia. Aboriginal filmmaker Michael Riley had completed a documentary on the construction of the exhibition, and travelled with the party. Unfortunately, although a huge success in terms of visitors and interest from the press, the project excluded the work of contemporary, urban-dwelling Aboriginal artists. Furthermore, no matter how well the exhibition was presented, the Asia Society Gallery was still regarded by the New York art world as a space connected to traditions of ethnography rather than to the freer realm of contemporary art.

Wululu and Malangi were not overawed by the city, many sites of which were familiar to them from American film and video images. Their most lasting impressions were of the street people and their poverty, people whose complete abandonment and isolation would be inconceivable back in their Arnhem Land home. Malangi was confused by jet lag, but enjoyed the experience of his first real overseas trip nevertheless. My own memory of this trip was capped by a conversation with Jimmy Wululu in Central Park, when he looked about at the trees and open space and remarked rhetorically, 'This was once all owned by Indian people [native Americans]' — not seeing the city as such, but looking for the spirit of the original inhabitants — the spirit of the place.

In 1992 Wululu laid out a traditional sand sculpture as part of a joint exhibition with Phillip Kudthaykudthay at the Drill Hall exhibition venue of the Canberra School of Art.

This productive period came to a sorrowful conclusion in early 1992 when Jimmy and his family were devastated by the death of one of his eldest sons. From that time he gave up painting and moved from his outstation at Ngangalala into the township of Ramingining. He subsequently declined offers to attend the 1993 Düsseldorf opening of 'Aratjara' and also to install a sand sculpture for the 1994 'Havana Biennale'. He also discovered that he had diabetes and he struggled to adjust his life to accommodate this condition. However, when recently discussing the inclusion of his 1989 'Hollow Log' group in *Stories*, he strongly declared that he had passed his time of sorrow and that he was full of energy to get on with his art and his life. Wululu has since completed his 'sand sculpture' in the forecourt of the Northern Territory Legislative Assembly building for Darwin's 1996 Bougainvillea Festival. Back at home he specifically discussed his plans to conduct a Hollow Log Ceremony in the coming year. Despite his remark that 'some *bungguls* [ceremonies] die now', Wululu was excited about conducting this ceremony in order to pass to the next generation that this was 'not just story and painting'.

<div style="text-align: right;">Djon Mundine</div>

HOLLOW LOG POLES 1989

EARTH PIGMENTS ON EUCALYPTUS WOOD

group of twelve, various dimensions

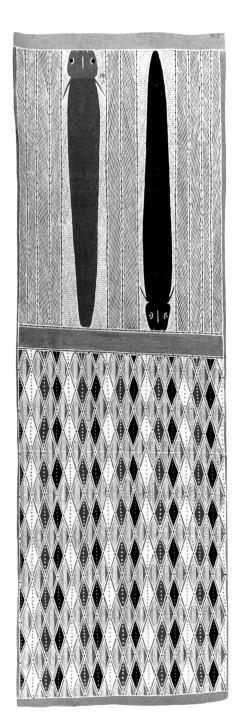

EEL TAIL CATFISH AND YIRRITJA HONEY 1989

NATURAL PIGMENTS ON BARK

212 x 68 cm

S T O R I E S

J I M M Y W U L U L U

H O L L O W L O G P O L E S

The Hollow Log or Bone Coffin ceremony is one of many ancient ceremonies which are still performed in Arnhem Land today. In this mortuary ceremony, the bones of a deceased person are recovered from the grave by relatives and, in a special ritual, distributed to family members. At a time agreed upon by the families involved, the bones are gathered together and a hollow log selected from the bush. The log, which has been naturally hollowed out by insects, is cleaned and prepared for painting. In a major ceremonial performance, in which many related groups play a part, the log is painted with the appropriate clan designs while songs, dances, mime and other rituals are performed. The bones of the deceased are then taken, sung over, painted with red ochre, broken up and placed in the hollow log coffin. The importance of this ceremony was captured in the remark made a long time ago by a Mildjingi man from the Ramingining area to the anthropologist Donald Thomson. He said that if you wanted to know where a person stood in society, and in the world at large, you should heed their hollow log ceremony.

Ceremonial activity has increased in Arnhem Land in recent years, but the Hollow Log ceremony is the least frequently performed. One contributing factor has been the imposition of Western burial services encouraged by Christian churches and also by Government regulation. A Hollow Log ceremony was documented in the late 1970s in the Kim McKenzie AIAS film, *Waiting for Harry*. Another was filmed at Milingimbi a decade earlier in the Cecil Holmes documentary *Djalumbu — Hollow Log Ceremony*. The last ceremony held in the Ramingining area occurred in 1984.

The herringbone design on Wululu's Hollow Log coffins represents the eel-tailed catfish. During the late wet season, from March to April, many fish such as barramundi travel inland with the large incoming tides. When these tides meet the wet season run-off from the land they flood the large coastal plains. During this time it is possible to spear fish by wading across the plains. This is when many fish spawn and new generations are created.

Conditions are good for the young, with abundant insect life and much debris in the run-off water. The *ginginy* (eel-tailed catfish) are translucent when young. At this stage they are about 7.5 to 15 centimetres long and their herringbone skeletons are clearly visible.

A long time ago, close to the beginning of time, a spirit man called Murayana (who was really three people called Mundjilitjili, Guruwirriya and Rrapanangmanang), made the first Yirritja Hollow Log (Djalumbu) and a Marradjiri Pole and Burala, a totemic sculpture representing the diver duck. When they finished, they painted their bodies with catfish designs and threw the log into the sacred waterhole where it sank into the deepest part. Baby catfish are thought of as the souls of the deceased and unborn people. These fish inhabit fallen logs in watercourses and are often caught and carried away by cormorants diving for food. It is thought that just as these birds carry away the fish, death removes the souls of the dying.

PETER SKIPPER

BORN c. 1929 JUWALINY/WALMAJARRI
FITZROY CROSSING, WESTERN AUSTRALIA

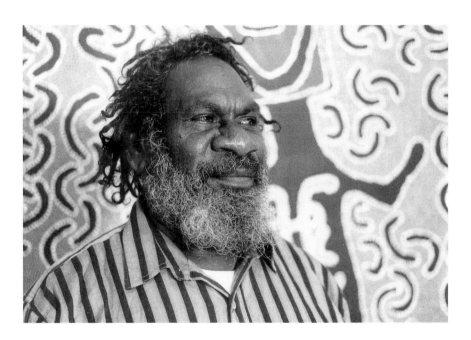

SOLO EXHIBITIONS

1989
'Explorations, Patterns, Dreamings'
— Craft Centre Gallery, Sydney

JOINT EXHIBITIONS

1994
'Peter Skipper and Butcher Cherel Janangoo'
— ArtPlace, Perth
1993
'Parntapi Bilnga: Peter Skipper and Cherel Janangoo'
— ArtPlace, Perth
1992
'Jarinyanu David Downs and Peter Skipper'
— Hogarth Galleries, Sydney
1990
'Jarinyanu David Downs and Peter Skipper'
— The Chesser Gallery, Adelaide

GROUP EXHIBITIONS

1995
'12th National Aboriginal and Torres Strait Islander National
Art Award'

— Museum and Art Gallery of the Northern Territory
— Westpac Gallery, Melbourne
— Brisbane City Hall Art Gallery and Museum, Brisbane
— S. H. Ervin Gallery, Sydney
— Tandanya, National Aboriginal Cultural Institute,
 Adelaide
'Stories: Eine Reise zu den großen Dingen — Elf Künstler der
australischen Aborigines. Werke aus der Sammlung Holmes à
Court, Perth'
— Sprengel Museum, Hannover
— Museum für Völkerkunde zu Leipzig
— Haus der Kulturen der Welt, Berlin
— Ludwig Forum für internationale Kunst, Aachen
1994
'Jarinyanu David Downs, Peter Skipper and Mary Anne
Purlta'
— Adelaide Fringe Festival, Tuldar Gallery, Adelaide
1993
'Tarinoita: Contemporary Australian Aboriginal Art'
— Keravan Taidemuseo, Helsinki, Finland
'Contemporary Aboriginal Art from The Robert Holmes à
Court Collection'
— Moree Plains Gallery, Moree
'Images of Power: Aboriginal Art of the Kimberley'
— National Gallery of Victoria, Melbourne

'Jarinyanu David Downs — Metaphysician with Peter Skipper and Mary Anne Purlta'
— Emerald Hill Gallery, Melbourne
'New Tracks Old Land: An Exhibition of Contemporary Prints from Aboriginal Australia'
— Massachusetts College of Art, Boston (1992–1995), USA
— Touring USA and Australia
1992
'Crossroads — Toward a New Reality: Aboriginal Art from Australia'
— The National Museum of Modern Art, Kyoto
— The National Museum of Modern Art, Tokyo
'Contemporary Aboriginal Art from The Robert Holmes à Court Collection'
— Perth Institute of Contemporary Arts (PICA), Perth
1991
'Aboriginal Art and Spirituality'
— The High Court of Australia, Canberra
— Parliament House, Canberra
— The Waverley Centre, Victoria
— Ballarat Fine Art Gallery, Ballarat
1990
'Balance 1990: Views, Visions, Influences'
— Queensland Art Gallery, Brisbane
'Contemporary Aboriginal Art from The Robert Holmes à Court Collection'
— Carpenter Centre for the Visual Arts, Harvard University, Boston, USA
— James Ford Bell Museum, University of Minnesota, Minneapolis, USA
— Lake Oswego Festival of the Arts, Oregon, USA
—The Forum, St Louis, Missouri, USA
'Abstraction'
— Art Gallery of New South Wales, Sydney
'Tagari Lia; My Family — Contemporary Aboriginal Art 1990: From Australia'
— The Third Eye Centre, Glasgow, Scotland
— Glynn Vivian Art Gallery & Museum, Swansea, UK
— Cornerhouse, Manchester, UK
'South to North: Tandanya Contemporary Art'
— Gallerie la Belle Angele, Edinburgh
'Ngarrangkarni: Jarinyanu David Downs, Peter Skipper and Mary Anne Purlta'
— Roar 2 Studios, Melbourne
'Jarinyanu David Downs, Peter Skipper and Mary Anne Purlta: Paintings and Prints'
— The Chesser Gallery, Adelaide
1988
Dreamings: The Art of Aboriginal Australia
— Asia Society, New York (touring), USA

COLLECTIONS

Art Gallery of South Australia, Adelaide
Art Gallery of Western Australia, Perth
National Gallery of Victoria, Melbourne
Per Grieg Collection, Norway
South Australian Museum, Adelaide
The Duncan Kentish Collection
The Holmes à Court Collection, Heytesbury
University of South Australia Art Museum, Adelaide

PUBLISHED REFERENCES

CARUANA, W., *Aboriginal Art*, World of Art Series, Thames & Hudson, London, 1993, p. 156.
HODGE, B. & MISHRA, V., *Dark Side of the Dream: Australian Literature and the Postmodern Mind*, Allen & Unwin, Sydney, 1991, pp. 93–97 (Skipper's text re-translated from Hudson & Richards, 1976–84, pp. 5–6).
HODGE, B. & MISHRA, V., 'Purist's Attack Exudes Impurity', *Australian*, 3 February 1993, p. 22.
HUDSON, J. & RICHARDS, E. et al., *The Walmajarri: An Introduction to the Language and Culture*, Summer Institute of Linguistics, Australian Aborigines Branch, Darwin, 1976, 1978, 1984, pp. 5–15.
KENTISH, D., 'Peter Skipper', in *Aboriginal Artists of Western Australia*, folder of 16 art posters with story descriptions and biographies of artists, Aboriginal Education Resources Unit, Perth, 1990.
KENTISH, D., 'Fitzroy Crossing', in R. Crumlin, (ed.), *Aboriginal Art and Spirituality*, exhibition catalogue for High Court exhibition, Collins Dove, Melbourne, 1991, pp. 47, 50, 129–131 and 136.
KENTISH, D., 'Peter Skipper', in A. Brody (ed.), *Stories: Eine Reise zu den großen Dingen — Elf Künstler der australischen Aborigines. Werke aus der Sammlung Holmes à Court, Perth*, exhibition catalogue, Sprengel Museum, Hannover, 1995, pp. 17–20, 26–27.
LARSON, K., 'Their Brilliant Careers', *New York Magazine*, 24 October 1988.
LUTHI, B. (ed.), *Aratjara: Art of the First Australians*, exhibition catalogue, Dumont Buchverlag, Cologne, Germany, 1993.
McGUIGAN, C. (ed.), *New Tracks Old Land — Contemporary Prints from Aboriginal Australia*, Aboriginal Arts Management Association, Sydney, 1992, pp. 51 and 56.
MUDROOROO NYOONGAH, 'Turning the Tables on Anthropologists', *Australian*, 27 January 1993, p. 14.
O'FERRALL, M. A., 'What Happened After the Cup Way Out West: Aboriginal Art in the Public Eye', *Art Monthly Australia*, December–February 1992–93, No. 56, pp. 16–18.
O'FERRALL, M. A., in T. Uchiyama et al., *Crossroads — Toward a New Reality: Aboriginal Art from Australia*, exhibition catalogue, The National Museum of Modern Art, Kyoto, 1992, pp. 115, 156.
RICHARDS, E. & HUDSON, J., *Walmajarri–English Dictionary*, Summer Institute of Linguistics, Darwin, 1990.
RUBINSTEIN, M., 'Outstations of the Postmodern', *Arts Magazine*, March 1989.
RYAN, J., 'Art of Fitzroy Crossing', in J. Ryan & K. Ackerman, *Images of Power: Aboriginal Art of the Kimberleys*, exhibition catalogue, National Gallery of Victoria, 1993, pp. 70, 84.
SUTTON, P. (ed.), *Dreamings: The Art of Aboriginal Australia*, exhibition catalogue, Viking, New York, 1988, pp. 100–101, 227.
SUTTON, P. & NEWMAN, J., 'Dreamings', *Art and Australia*, Vol. 26, No. 4, 1989.
TRIGGER, D., 'No Place for Vague Radicalism in Cultural Studies', *Australian*, 20 January 1993, p. 20.
TRIGGER, D., 'Keeping Politics Out of Anthropology', *Australian*, 3 February 1993, p. 22.
WEST, M., *12th National Aboriginal and Torres Strait Islander Art Award*, exhibition catalogue, Museums and Art Galleries of the Northern Territory, Darwin, 1995.

J A R I N Y A N U
D A V I D D O W N S

C. 1925–1995 WANGKAJUNA/WALMAJARRI
FITZROY CROSSING, WESTERN AUSTRALIA

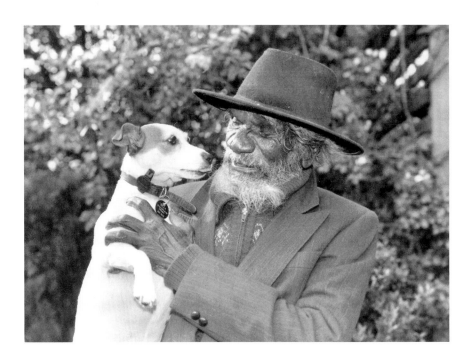

SOLO EXHIBITIONS

1995
'Jarinyanu David Downs: Southern Explorations'
 — Adelaide Central Gallery, Adelaide
'Jarinyanu David Downs'
 — Ray Hughes Gallery, Sydney
1993
'Presentation-performance: Seven Paintings by Jarinyanu
David Downs — Pacific Arts Festival'
 — Tandanya National Aboriginal Cultural Institute,
 Adelaide
1991
'Jarinyanu David Downs'
 — Chapman Gallery, Canberra
1989
'Dreamings from the Great Sandy Desert'
 — Roar 2 Studios, Melbourne
1988
'Jarinyanu David Downs'
 — BMG Fine Art, Sydney
'Jarinyanu David Downs: Print Exhibition'
 — Tynte Gallery, Adelaide

JOINT EXHIBITIONS

1992
'Jarinyanu David Downs and Peter Skipper'
 — Hogarth Galleries, Sydney
1990
'Jarinyanu David Downs and Peter Skipper'
 — The Chesser Gallery, Adelaide
1988
'Jarinyanu David Downs and Mary Anne Purlta: Print
Exhibition'
 — Solander Gallery, Canberra

GROUP EXHIBITIONS

1995
Stories: Eine Reise zu den großen Dingen — Elf Künstler der
australischen Aborigines. Werke aus der Sammlung Holmes à
Court, Perth'
 — Sprengel Museum, Hannover
 — Museum für Völkerkunde zu Leipzig
 — Haus der Kulturen der Welt, Berlin
 — Ludwig Forum für internationale Kunst, Aachen

1994
'This is My Country'
— Artplace, Perth
1993
'Tarinoita: Contemporary Australian Aboriginal Art'
— Keravan Taidemuseo, Helsinki, Finland
'Contemporary Aboriginal Art from The Robert Holmes à Court Collection'
— Moree Plains Gallery, Moree
'On Our Selection: Recent Acquisitions of Contemporary Australian Painting and Sculpture from The Robert Holmes à Court Collection'
— Perth Institute of Contemporary Arts (PICA), Perth
'Contact: Aboriginal Art from the 1980s and 1990s'
— Art Gallery of South Australia, Adelaide
'Images of Power: Aboriginal Art of the Kimberley'
— National Gallery of Victoria, Melbourne
'Jarinyanu David Downs — Metaphysician: With Peter Skipper and Mary Anne Purlta'
— Emerald Hill Gallery, Melbourne
1992
'Crossroads — Toward a New Reality: Aboriginal Art from Australia'
— The National Museum of Modern Art, Kyoto
— The National Museum of Modern Art, Tokyo
'Contemporary Aboriginal Art from The Robert Holmes à Court Collection'
— Perth Institute of Contemporary Arts (PICA), Perth
1991
'Aboriginal Art and Spirituality'
— The High Court of Australia, Canberra
— Parliament House, Canberra
— The Waverley Centre, Victoria
— Ballarat Fine Art Gallery, Ballarat
'Flash Pictures: by Aboriginal and Torres Strait Islander Artists'
— Australian National Gallery, Canberra
— Tandanya National Aboriginal Cultural Institute, Adelaide (1993–1994)
1990
'Balance 1990: Views, Visions, Influences'
— Queensland Art Gallery, Brisbane
'Contemporary Aboriginal Art from The Robert Holmes à Court Collection'
— Carpenter Centre for the Visual Arts, Harvard University, Boston, USA
— James Ford Bell Museum, University of Minnesota, Minneapolis, USA
— Lake Oswego Festival of the Arts, Oregon, USA
— The Forum, St Louis, Missouri, USA
'Jarinyanu David Downs, Peter Skipper and Mary Anne Purlta: Paintings and Prints'
— The Chesser Gallery, Adelaide
'Tagari Lia; My Family — Contemporary Aboriginal Art 1990: From Australia'
— The Third Eye Centre, Glasgow, Scotland
— Glynn Vivian Art Gallery and Museum, Swansea, UK
— Cornerhouse, Manchester, UK
'Works on Paper'
— Joseph Lebovic Gallery, Sydney
'Print Exhibition'
— Gallery Heritage, Melbourne.
'South to North: Tandanya Contemporary Art'
— Galerie la Belle Angele, Edinburgh

'Fields of Dreaming'
— Austral Gallery, St Louis, USA
'Aboriginal Painting'
— The Australia Gallery, Soho, New York, USA
'Ngarrangkarni: Jarinyanu David Downs, Peter Skipper and Mary Anne Purlta'
— Roar 2 Studios, Melbourne
1989
'Aboriginal Paintings and Prints'
— Coo-ee Aboriginal Art, Sydney
'Aboriginal Art: The Continuing Tradition'
— Australian National Gallery, Canberra
'Aboriginal Print Makers'
— Tynte Gallery, Adelaide
1988
'Fremantle Print Award Exhibition'
— Fremantle Arts Centre, Perth
'Recent Aboriginal Paintings'
— Art Gallery of South Australia, Adelaide
'Innovative Aboriginal Art of Western Australia'
— Undercroft Gallery, University of Western Australia, Perth
1986
'Kimberley Regional Exhibition'
— Goolaraboloo, Broome

COLLECTIONS

ATSIC Collection, Canberra
Art Gallery of South Australia, Adelaide
Art Gallery of Western Australia, Perth
Berndt Museum of Anthropology, University of Western Australia, Perth
Edith Cowan University Art Collection, Perth
Flinders University Collection, Adelaide
Kerry Stokes Collection, Perth
Levi-Kaplan Collection, Seattle, California
National Gallery of Australia, Canberra
National Gallery of Victoria, Melbourne
Parliament House Collection, Canberra
Queensland Art Gallery, Brisbane
South Australian Museum, Adelaide
The Duncan Kentish Collection, Adelaide
The Holmes à Court Collection, Heytesbury
University of New South Wales Collection, Sydney
Wayne Howard Collection, Broome

PUBLISHED REFERENCES

CARUANA, W., *Aboriginal Art*, World of Art Series, Thames & Hudson, London, 1993, p. 157.
HUDSON, J. & RICHARDS, E. et al., *The Walmajarri: An Introduction to the Language and Culture*, Summer Institute of Linguistics, Australian Aborigines Branch, Darwin, 1976, 1978, 1984, pp. 16–21.
KENTISH, D., 'Jarinyanu David Downs', in *Aboriginal Artists of Western Australia*, folder of 16 art posters with story descriptions and biographies of artists, Aboriginal Education Resources Unit, Perth, 1990.
KENTISH, D., 'Fitzroy Crossing', in R. Crumlin (ed.), *Aboriginal Art and Spirituality*, exhibition catalogue for High Court exhibition, Collins Dove, Melbourne, 1991, pp. 47–49 and 129–131.

KENTISH, D., 'Jarinyanu David Downs', in *Contemporary Aboriginal Painting*, poster book of paintings including story descriptions, Craftsman House, Sydney, 1993.

KENTISH, D., 'Jarinyanu David Downs', in A. Brody (ed.), *Stories: Eine Reise zu den großen Dingen — Elf Künstler der australischen Aborigines. Werke aus der Sammlung Holmes à Court, Perth*, exhibition catalogue, Sprengel Museum, Hannover, 1995, pp. 29–32.

KENTISH, D. & von STURMER, J., *You Listen Me! — An Angry Love*, exhibition catalogue for 'Jarinyanu David Downs, Southern Explorations', 1st and 2nd editions, Duncan Kentish Fine Art, Adelaide, 1995.

KOLIG, E., 'Noah's Ark Revisited', *Oceania*, No. 51, 1995.

KRONENBERG, S., 'Aboriginal Art: The Secret Display', *Tension Magazine*, No. 17, 1989, pp. 37, 46–47.

McGUIGAN, C. (ed.), *New Tracks Old Land: Contemporary Prints from Aboriginal Australia*, 1992, pp. 56–57.

MURRAY, L., *Anthology of Australian Religious Poetry*, Collins Dove, North Blackburn, Victoria, 1991.

MYERS, F., 'Beyond the Initial Fallacy: Art Criticism and the Ethnography of Aboriginal Acrylic Painting, *Visual Anthropology Review*, Vol. 10, No.1, spring 1994, pp. 10–43.

O'FERRALL, M. A., 'What Happened After the Cup Way Out West: Aboriginal Art in the Public Eye', *Art Monthly Australia*, No. 56, December –February 1992–93, pp. 16–18.

O'FERRALL, M. A., in T. Uchiyama et al., *Crossroads — Toward a New Reality: Aboriginal Art from Australia*, exhibition catalogue, The National Museum of Modern Art, Kyoto, 1992, pp. 112–114, 156.

QUAIL, A., *Marking Our Times: Selected Works of Art From the Aboriginal and Torres Strait Islander Collection, National Gallery of Australia*, Thames & Hudson, Melbourne, 1996.

RYAN, J., 'Art of Fitzroy Crossing', in J. Ryan & K. Ackerman, *Images of Power: Aboriginal Art of the Kimberley*, exhibition catalogue, National Gallery of Victoria, Melbourne, 1993, pp. 70–71, 85.

von STURMER, J., 'Aborigines, Representation, Necrophilia', *Art and Text*, No. 32, March 1989, pp. 133, 144.

WATSON, C., 'The Bicentenary and Beyond — Recent Developments in Aboriginal Printmaking', *Artlink: Contemporary Aboriginal Art: Landmark Reprint 1992*, Vol. 10, Nos 1 and 2, autumn/winter 1990, Vols 1 and 2, 1990–1992, pp. 70–72.

EUBENA
NAMPITJIN

BORN c. 1929, WANGKAJUNGA
BALGO, WESTERN AUSTRALIA

JOINT EXHIBITIONS

1992
'Eubena and Wimmitji'
 — Gallery Gabrielle Pizzi, Melbourne
1990
'Eubena Nampitjin and Wimmitji Tjapangarti'
 — Gallery Gabrielle Pizzi, Melbourne

GROUP EXHIBITIONS

1996
'Wirrimanu: Aboriginal Art from the Balgo Hills'
 — Artist in Residence, Perth

1995
'Stories: Eine Reise zu den großen Dingen — Elf Künstler der
australischen Aborigines. Werke aus der Sammlung Holmes à
Court, Perth'
 — Sprengel Museum, Hannover
 — Museum für Völkerkunde zu Leipzig
 — Haus der Kulturen der Welt, Berlin
 — Ludwig Forum für internationale Kunst, Aachen
1994
'Power of the Land: Masterpieces of Aboriginal Art'
 — National Gallery of Victoria, Melbourne
1993
'Images of Power: Aboriginal Art of the Kimberley'
 — National Gallery of Victoria, Melbourne

'65e Salon du Sud-Est'
— Palais des Expositions, Lyon, France
'Contemporary Aboriginal Art from The Robert Holmes à
Court Collection'
— Moree Plains Gallery, Moree
1992
'Contemporary Aboriginal Art from The Robert Holmes à
Court Collection'
— Perth Institute of Contemporary Arts (PICA), Perth
1991
'Flash Pictures: by Aboriginal and Torres Strait Islander Artists'
— Australian National Gallery, Canberra
— Tandanya National Aboriginal Cultural Institute,
Adelaide (1993–1994)
'Paintings by Senior Women from the Western Desert'
— Vivien Anderson Gallery, Melbourne
'Aboriginal Women's Exhibition'
— Art Gallery of New South Wales, Sydney
1990
'Contemporary Aboriginal Art from The Robert Holmes à
Court Collection'
— Carpenter Centre for the Visual Arts, Harvard
University, Boston, USA
— James Ford Bell Museum, University of Minnesota,
Minneapolis, USA
— Lake Oswego Festival of the Arts, Oregon, USA
— The Forum, St Louis, Missouri, USA
'The Singing Earth'
— Chapman Gallery, Canberra
'Contemporary Aboriginal Art 1990: From Australia'
— The Third Eye Centre, Glasgow, Scotland
— Glynn Vivian Art Gallery and Museum, Swansea, UK
— Cornerhouse, Manchester, UK
'Paintings from Balgo, WA'
— Hogarth Gallery, Sydney
1989
'Mythscapes: Aboriginal Art of the Desert'
— National Gallery of Victoria, Melbourne
— Gallery Gabrielle Pizzi, Melbourne
'Warlayirti Artists Continuing Links with the Land'
— Coo-ee Aboriginal Art, Sydney
1986
'Art from the Great Sandy Desert'
— Art Gallery of Western Australia, Perth

COLLECTIONS

Kaye Archer Collection
National Gallery of Australia, Canberra
National Gallery of Victoria, Melbourne
The Holmes à Court Collection, Heytesbury

PUBLISHED REFERENCES

BRODY, A., *Contemporary Aboriginal Art from The Robert Holmes à
Court Collection*, exhibition catalogue, Heytesbury Pty Ltd,
Perth, 1990.
BRODY, A. (ed.), *Stories: Eine Reise zu den großen Dingen — Elf
Künstler der australischen Aborigines. Werke aus der Sammlung
Holmes à Court, Perth*, exhibition catalogue, Sprengel
Museum, Hannover, 1995.
COWAN, J., *Wirrimanu: Aboriginal Art from the Balgo Hills*,
Craftsman House, Sydney, 1994.
GLOWCZEWSKI, B., *Yapa: Peintres Aborigènes de Balgo et
Lajamanu*, Baudoin Lebon Editeur Gallery, France, 1991.
JOHNSON, V., *The Dictionary of Western Desert Artists*,
Craftsman House, Sydney, 1994.
LUTHI, B. (ed.), *Aratjara: Art of the First Australians*, exhibition
catalogue, Dumont Buchverlag, Cologne, Germany, 1993.
PERKINS, H., *Aboriginal Women's Exhibition*, exhibition
catalogue, Art Gallery of New South Wales, Sydney,
1991.
RYAN, J., *Mythscapes: Aboriginal Art of the Desert from the National
Gallery of Victoria* , exhibition catalogue, National Gallery
of Victoria, Melbourne, 1989.
RYAN, J. & ACKERMAN, K., *Images of Power: Aboriginal Art of
the Kimberley*, exhibition catalogue, National Gallery of
Victoria, Melbourne, 1993.
WALLACE, D., DESMOND, M. & CARUANA, W., *Flash
Pictures: by Aboriginal and Torres Strait Islander Artists*,
exhibition catalogue, Australian National Gallery,
Canberra, 1991.
WATSON, C., 'Eubena Nampitjin and Wimmitji Tjapangarti',
in A. Brody (ed.), *Stories: Eine Reise zu den großen Dingen — Elf
Künstler der australischen Aborigines. Werke aus der Sammlung
Holmes à Court, Perth*, exhibition catalogue, Sprengel
Museum, Hannover, 1995, pp. 43–46.

WIMMITJI TJAPANGARTI

BORN c. 1924, WANGKAJUNGA
BALGO, WESTERN AUSTRALIA

JOINT EXHIBITIONS

1992
'Eubena and Wimmitji'
— Gallery Gabrielle Pizzi, Melbourne
1990
'Eubena Nampitjin and Wimmitji Tjapangarti'
— Gallery Gabrielle Pizzi, Melbourne

GROUP EXHIBITIONS

1995
'Stories: Eine Reise zu den großen Dingen — Elf Künstler der australischen Aborigines. Werke aus der Sammlung Holmes à Court, Perth'
— Sprengel Museum, Hannover
— Museum für Völkerkunde zu Leipzig
— Haus der Kulturen der Welt, Berlin

— Ludwig Forum für internationale Kunst, Aachen
1991
'Yapa: Peintres Aborigènes de Balgo et Lajamanu'
— Baudoin Lebon Editeur Gallery, Paris
'Mulan: The Art of the Great Sandy Desert'
— Coo-ee Aboriginal Art, Sydney
1990
'Aboriginal Art'
— Dreamtime Gallery, Broadbeach, Queensland
'Paintings from Balgo, WA'
— Hogarth Galleries, Sydney
'The Singing Earth'
— Chapman Gallery, Canberra
1989
'Mythscapes: Aboriginal Art of the Desert'
— National Gallery of Victoria, Melbourne

COLLECTIONS

Kaye Archer Collection
National Gallery of Australia, Canberra
National Gallery of Victoria, Melbourne
The Holmes à Court Collection, Heytesbury

PUBLISHED REFERENCES

BERNDT, R. M. & BERNDT, C. H., *The Speaking Land: Myth and Story in Aboriginal Australia*, Penguin, Ringwood, Victoria, 1989.

BRODY, A. (ed.), *Stories: Eine Reise zu den großen Dingen — Elf Künstler der australischen Aborigines. Werke aus der Sammlung Holmes à Court, Perth*, exhibition catalogue, Sprengel Museum, Hannover, 1995.

COWAN, J., *Wirrimanu: Aboriginal Art from the Balgo Hills*, Craftsman House, Sydney, 1994.

GLOWCZEWSKI, B., *Yapa: Peintres Aborigènes de Balgo et Lajamanu*, Baudoin Lebon Editeur Gallery, France, 1991.

RYAN, J., *Mythscapes: Aboriginal Art of the Desert from the National Gallery of Victoria*, exhibition catalogue, National Gallery of Victoria, Melbourne, 1989.

RYAN, J., *Paint Up Big: Warlpiri Women's Art of Lajamanu*, exhibition catalogue, National Gallery of Victoria, Melbourne, 1990.

RYAN, J. & ACKERMAN, K., *Images of Power: Aboriginal Art of the Kimberley*, exhibition catalogue, National Gallery of Victoria, Melbourne, 1993.

WATSON, C., 'Eubena Nampitjin and Wimmitji Tjapangarti', in A. Brody (ed.), *Stories: Eine Reise zu den großen Dingen — Elf Künstler der australischen Aborigines. Werke aus der Sammlung Holmes à Court, Perth*, exhibition catalogue, Sprengel Museum, Hannover, 1995, pp. 43–46.

ROVER THOMAS

BORN C. 1926, KUKATJA/WANGKAJUNGA
WARMUN, WESTERN AUSTRALIA

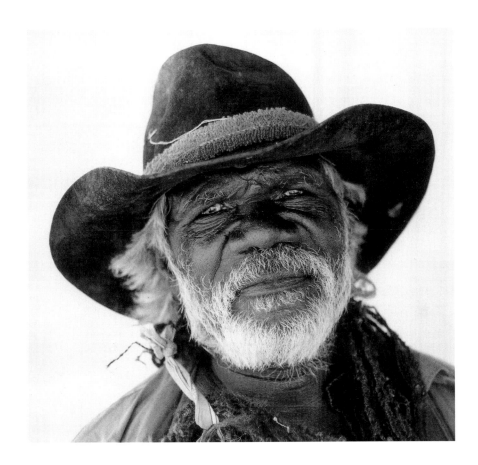

AWARDS

1990
John McCaughey Prize, Art Gallery of New South Wales

SOLO EXHIBITIONS

1995
'Latest Landscapes'
— Utopia Art Sydney
1994
'Roads Cross: The Paintings of Rover Thomas'
— National Gallery of Australia, Canberra
'Rover Thomas: New Paintings'
— Utopia Art Sydney

GROUP EXHIBITIONS

1996
'This is My Country. This is Me.'
— Seattle Art Museum, Downtown, Seattle, USA
'Contemporary Australian Abstraction'
— Niagara Galleries, Melbourne
'Flagging the Republic'
— Sherman Galleries/New England Regional Art Museum
(touring)
'Nangara: The Australian Aboriginal Art Exhibition — From
the Ebes Collection'
— Sichting Sint-Jan, Brugges, Belgium
1995
'Rover Thomas: Well 33 Revisited'

— William Mora Galleries, Melbourne
'Painting Up the Country: Aboriginal Art from the
Kimberley, WA'
 — Coo-ee Aboriginal Art, Sydney
'The Festival of Darwin Art Exhibition: Kimberley
Printmakers'
 — Framed – The Darwin Gallery, Darwin
'Offset and Intaglio'
 — Fremantle Arts Centre, Fremantle
'Made in the Kimberley'
 — Moores Building, Fremantle
'Northwest and Kimberley Artists'
 — Durack Gallery – Kimberley Fine Art, Broome
'Stories: Eine Reise zu den großen Dingen — Elf Künstler der
australischen Aborigines. Werke aus der Sammlung Holmes à
Court, Perth'
 — Sprengel Museum, Hannover
 — Museum für Völkerkunde zu Leipzig
 — Haus der Kulturen der Welt, Berlin
 — Ludwig Forum für internationale Kunst, Aachen

1994
'This Land: A Celebration'
 — Utopia Art Sydney, Stanmore
'Rover Thomas: An Artist from Turkey Creek'
 — Hogarth Galleries, Sydney
'Identities: Art from Australia'
 — Taipei Fine Arts Museum, Taiwan
 — Wollongong City Gallery, NSW
'Yiribana: An Introduction to the Aboriginal and Torres Strait
Islander Collection from the Art Gallery of New South
Wales'
 — Art Gallery of New South Wales, Sydney

1993
'Aratjara: Art of the First Australians'
 — Kunstsammlung Nordrhein-Westfalen, Düsseldorf
 — Hayward Gallery, London
 — Louisiana Museum, Humlebaek
'Images of Power: Aboriginal Art of the Kimberley'
 — National Gallery of Victoria, Melbourne
'Contempory Aboriginal Art from The Robert Holmes à
Court Collection'
 — Moree Plains Gallery, Moree
'Trevor Nickolls and Paintings by Emily Kame Kngwarreye,
Ginger Riley Munduwalawala and Rover Thomas'
 — Hogarth Galleries, Sydney
'On Our Selection: Recent Acquisitions of Contemporary
Australian Painting and Sculpture from The Robert Holmes à
Court Collection'
 — Perth Institute of Contemporary Arts (PICA), Perth

1992
'Crossroads — Toward a New Reality: Aboriginal Art from
Australia'
 — The National Museum of Modern Art, Kyoto
 — The National Museum of Modern Art, Tokyo

1991
'Contemporary Aboriginal Art from The Robert Holmes à
Court Collection'
 — Perth Institute of Contemporary Arts (PICA), Perth
'Flash Pictures: by Aboriginal and Torres Strait Islander
Artists'
 — Australian National Gallery, Canberra
 — Tandanya Aboriginal Cultural Institute, Adelaide
 (1993–1994)

'Walkabout in the Dreamtime'
 — Virginia Miller Gallery, Miami, Florida, USA
'Aboriginal Art and Spirituality'
 — The High Court of Australia, Canberra
 — Parliament House, Canberra
 — The Waverley Centre, Victoria
 — Ballarat Fine Art Gallery, Ballarat

1990
'Adelaide Biennial of Australian Art'
 — Art Gallery of South Australia, Adelaide
'Anatjari Tjampitjinpa, Dini Campbell Tjampitjinpa and
Rover Thomas'
 — John Weber Gallery, New York, USA
'Balance 1990: Views, Visions, Influences'
 — Queensland Art Gallery, Brisbane
'La Biennale di Venezia, XLIV esposizione internazionale
d'arte'
 — Venice, Italy
'L'été Australien'
 — Musée Fabre, Montpellier, France
'Contemporary Aboriginal Art from The Robert Holmes à
Court Collection'
 — Carpenter Centre for the Visual Arts, Harvard
University, Boston, USA
 — James Ford Bell Museum, University of Minnesota,
 Minneapolis, USA
 — Lake Oswego Festival of the Arts, Oregon, USA
 — The Forum, St Louis, Missouri, USA
 — Art Gallery of New South Wales
'Abstraction'
 — Art Gallery of New South Wales, Sydney
'The Singing Earth'
 — Chapman Gallery, Canberra
'Innovations in Aboriginal Art'
 — Hogarth Galleries, Sydney
'Contemporary Aboriginal Art 1990: From Australia'
 — Third Eye Centre, Glasgow, Scotland
 — Glynn Vivian Art Gallery and Museum, Swansea, UK
 — Cornerhouse, Manchester, UK

1989
'On the Edge: Five Contemporary Aboriginal Artists'
 — Art Gallery of Western Australia, Perth
'Turkey Creek: Recent Work'
 — Deutscher Fine Art, Melbourne
'Aboriginal Art: The Continuing Tradition'
 — Australian National Gallery, Canberra
'A Myriad of Dreaming: Twentieth Century Aboriginal Art:
Lauraine Diggins Fine Art'
 — Westpac Gallery, Melbourne
 — Design Warehouse, Sydney

1988
'Art from the Kimberley'
 — Aboriginal Artists' Gallery, Sydney
'Innovative Aboriginal Art of Western Australia'
 — Undercroft Gallery, University of Western Australia,
 Perth
'Recent Aboriginal Painting'
 — Art Gallery of South Australia, Adelaide
'Creating Australia: 200 Years of Art 1788–1988'
 — International Cultural Corporation of Australia
 (touring)
'ANCAAA and Boomalli'
 — Boomalli Aboriginal Artists Co-operative, Sydney

'European and Australian Paintings from The Robert Holmes
à Court Collection'
— S. H. Ervin Gallery, Sydney
1987
'Art of the East Kimberley'
— Birukmarri Gallery, Fremantle
'Recent Art from Western Australia'
— Australian National Gallery, Canberra

COLLECTIONS

Artbank, Sydney
Art Gallery of New South Wales, Sydney
Art Gallery of South Australia, Adelaide
Art Gallery of Western Australia, Perth
Berndt Museum of Anthropology, University of Western
Australia, Perth
Edith Cowan University Art Collection, Perth
Kerry Stokes Collection, Perth
National Gallery of Australia, Canberra
National Gallery of Victoria, Melbourne
Parliament House, Canberra
Queensland Art Gallery, Brisbane
The Holmes à Court Collection, Heytesbury

PUBLISHED REFERENCES

ACKERMAN, K., 'Western Australia: A Focus on Recent
Developments in the East Kimberley', in W. Caruana
(ed.), *Windows on the Dreaming: Aboriginal Paintings in the
Australian National Gallery*, Australian National Gallery,
Canberra, and Ellsyd Press, Sydney, 1989.

ACKERMAN, K., 'Rover Thomas and Warmun Art', in L.
Diggens et al., *A Myriad of Dreaming: Twentieth Century
Aboriginal Art*, Malakoff Fine Art Press, Melbourne, 1989.

BAROU, J. P. & CROSSMAN, S. (eds), *L'été australien à
Montpellier: 100 chefs-d'œuvre de la peinture australienne*,
exhibition catalogue, Libération, Paris, and Musée Fabre,
Montpellier, France, 1990.

BRODY, A., *Contemporary Aboriginal Art from The Robert Holmes à
Court Collection*, Heytesbury Pty Ltd, Perth, 1990.

BRODY, A. & HART, D., 'Rover Thomas', in D. Hart et al.,
Identities: Art From Australia, exhibition catalogue, Taipei
Fine Arts Museum, Taiwan, 1993.

BRODY, A., 'Rover Thomas, in A. Brody (ed.), *Stories: Eine
Reise zu den großen Dingen — Elf Künstler der australischen
Aborigines. Werke aus der Sammlung Holmes à Court, Perth*,
exhibition catalogue, Sprengel Museum, Hannover, 1995,
pp. 55–58.

CARUANA, W., *Aboriginal Art*, World of Art Series, Thames &
Hudson, London, 1993.

GRISHIN, S., 'Retrospective Works Display Rare Intensity',
Canberra Times, March 1994, p. C7.

HART, D., *Place and Perception: New Acquisitions: Parliament House
Art Collection*, Parliament House, Canberra, 1995.

LOXLEY, A., 'Realising a Vibrant Dream', *Sydney Morning
Herald*, May 1994.

LUTHI, B. (ed.), *Aratjara: Art of the First Australians*, exhibition
catalogue, Dumont Buchverlag, Cologne, Germany, 1993.

LYNN, V., *Abstraction*, exhibition catalogue, Art Gallery of
New South Wales, 1990.

MENDELSSOHN, J., 'An Affirmation of Black Visual Power:
Rover Thomas Evokes Much More than the Rainbow
Serpent', *Bulletin*, May 1994, pp. 92–93.

NEALE, M., 'The Cult of Cultural Convergence: Black on
White or White on Black?', *Art Monthly Australia*, 1994, pp.
7–8.

NEALES, S., 'Vibrant Images from An Arid Zone', *Age*, 16
November 1995.

NUTTALL, W., *Contemporary Australian Abstraction*, Niagara
Galleries, Melbourne, 1996.

O'FERRALL, M. A., *On the Edge: Five Contemporary Aboriginal
Artists*, exhibition catalogue, Art Gallery of Western
Australia, Perth, 1989.

O'FERRALL, M. A., 'Painting the Country, Rover Thomas',
Tension Magazine, August 1989, pp. 43–45.

O'FERRALL, M. A., *1990 Venice Biennale Australia, Artists: Rover
Thomas — Trevor Nickolls*, exhibition catalogue, Art Gallery
of Western Australia, Perth, 1990.

O'FERRALL, M. A., 'Australia to the World', *Artlink*, Vol. 10,
Nos 1 and 2, 1990, pp. 66–67.

O'FERRALL, M. A., in T. Uchiyama, et al., *Crossroads —
Toward a New Reality: Aboriginal Art from Australia*, exhibition
catalogue, The National Museum of Modern Art, Kyoto,
1992.

RYAN, J., & ACKERMAN, K., *Images of Power: Aboriginal Art of
the Kimberley*, exhibition catalogue, National Gallery of
Victoria, Melbourne, 1993.

SMOKER, J., *Turkey Creek: Recent Work*, Deutcher Gertrude
Street, Melbourne, 1989.

SMOKER, J., 'Waringarri Aboriginal Arts, Kununurra, W.A.',
Artlink, Vol. 10., Nos 1 and 2, 1990.

STANTON, J. E., *Innovative Aboriginal Art of Western Australia*,
exhibition catalogue, Anthropology Museum, University
of Western Australia, Perth, 1988.

STANTON, J. E., *Painting the Country: Contemporary Aboriginal
Art from the Kimberley Region, Western Australia*, University of
Western Australia Press, Perth, 1989.

WALLACE, D., DESMOND, M. & CARUANA, W., *Flash
Pictures: by Aboriginal and Torres Strait Islander Artists*,
exhibition catalogue, Australian National Gallery,
Canberra, 1991.

E M I L Y K A M E
K N G W A R R E Y E

C . 1 9 1 0 — 1 9 9 6 , A N M A T Y E R R

U T O P I A , N O R T H E R N T E R R I T O R Y

W I T H R E S P E C T T O T H E A B O R I G I N A L P E O P L E O F A U S T R A L I A ,

A P H O T O G R A P H O F E M I L Y K A M E K N G W A R R E Y E I S N O T R E P R O D U C E D H E R E .

AWARDS

1992
Australian Artists Creative Fellowship

SOLO EXHIBITIONS

1995
'Emily Kame Kngwarreye: Recent Paintings 1993–1994'
— William Mora Galleries, Melbourne
'The Delmore Collection: Selected Exhibition and Survey of
Works 1989–1995'
— Mary Place Gallery, Sydney
'Emily Kame Kngwarreye: Recent Work 1994–1995'
— Dacou Gallery, Adelaide
'Emily Kame Kngwarreye: Paintings from 1989–1995'
— Parliament House, Canberra
'A New Expression'
— Utopia Art Sydney

1994
'New Directions'
— Utopia Art Sydney
— Rebecca Hossack Gallery, London
'The Power of the Line'
— Chapman Gallery, Canberra

1993
'The Alhalkere Suite'
— Utopia Art Sydney
'Recent Paintings by Emily Kame Kngwarreye'
— Gallery Gabrielle Pizzi, Melbourne
'Emily Kame Kngwarreye'
— Hogarth Galleries, Sydney

1992
'Alhalkere'
— Utopia Art Sydney
'Emily Kame Kngwarreye'
— Gallery Gabrielle Pizzi, Melbourne

1991
'Emily Kame Kngwarreye'
— Utopia Art Sydney
'Emily Kame Kngwarreye'
— Hogarth Galleries, Sydney

1990
'First Solo Exhibition'
— Utopia Art Sydney
'Emily Kame Kngwarreye'
— Coventry Gallery, Sydney
'Paintings by Emily Kame Kngwarreye'
— Gallery Gabrielle Pizzi, Melbourne

JOINT EXHIBITIONS

1995
'Ian Fairweather and Emily Kame Kngwarreye'
— Niagara Galleries, Melbourne

1990
'Utopia Artists in Residence Project: Louie Pwerle and Emily
Kame Kngwarreye 1989–1990'
— Perth Institute of Contemporary Arts (PICA), Perth

GROUP EXHIBITIONS

1996
'Emily Kame Kngwarreye: The First Ochres'
— Lauraine Diggins Fine Art, Melbourne
'Women of Utopia'
— Creative Native, Perth
'Contemporary Australian Abstraction'
— Niagara Galleries Melbourne
'Dots'
— National Gallery of Victoria, Melbourne
'Women Hold Up Half the Sky'
— Monash University Gallery, Victoria

'The Third National Aboriginal and Torres Strait Islander Heritage Award'
— Old Parliament House, Canberra
'The Gesture'
— Utopia Art Sydney
'This is My Country. This is Me.'
— Seattle Art Museum, Downtown, Seattle, USA
'Utopia Women'
— Utopia Art Sydney
'Flagging the Republic'
— Sherman Galleries, Sydney/New England Regional Art Museum (touring)
'Nangara: The Australian Aboriginal Art Exhibition — From the Ebes Collection'
— Sichting Sint-Jan, Brugges, Belgium

1995

'Painted Dreams: Western Desert Paintings from the Johnson Collection'
— Art Gallery of New South Wales, Sydney
'Place and Perception: New Acquisitions: Parliament House Art Collection'
— Parliament House, Canberra
'Emily Kame Kngwarreye, Barbara Weir, Gloria Ngarla and Mixed Utopia'
— Dacou Gallery, Adelaide
'Emily Kame Kngwarreye, Motorcar Jim and Barbara Weir'
— Davis Gallery, South Yarra
'Ironsides'
— Powerhouse Museum, Sydney
'Creators and Inventors: 130 Years of Australian Women's Art'
— National Gallery of Victoria, Melbourne
'Asia and Oceania Influence'
— Ivan Dougherty Gallery, Sydney
'Pathways'
— Queensland Art Gallery
'Works on Paper'
— Utopia Art Sydney
'International Works on Paper Fair'
— Mitchell Galleries, State Library of New South Wales
'New Works/ New Directions: Recent Acquisitions by the Chartwell Collection'
— Waikato Museum of Art and History Te Whare Taonga, Waikato
'Stories: Eine Reise zu den großen Dingen — Elf Künstler der australischen Aborigines. Werke aus der Sammlung Holmes à Court, Perth'
— Sprengel Museum, Hannover
— Museum für Völkerkunde zu Leipzig
— Haus der Kulturen der Welt, Berlin
— Ludwig Forum für internationale Kunst, Aachen

1994

'Identities: Art from Australia'
— Taipei Fine Arts Museum, Taiwan
— Wollongong City Gallery, NSW
'Utopia Body Paint: The Oval Paintings Collection'
— Bishop Museum, Hawaii
'The Land'
— National Gallery of Australia, Canberra
'Desert Painting'
— Fire-Works Gallery, Brisbane
'ACAF 4 — The Fourth Australian Contemporary Art Fair'
— Royal Exhibition Centre, Melbourne
'Yiribana: An Introduction to the Aboriginal and Torres Strait Islander Collection, the Art Gallery of New South Wales'
— Art Gallery of New South Wales, Sydney
'Ink Lines: Mapping the Printer'
— Coo-ee Aboriginal Art, Sydney
'This Land: A Celebration'
— Utopia Art Sydney

1993

'On Our Selection: Recent Acquisitions of Contemporary Australian Painting and Sculpture from The Robert Holmes à Court Collection'
— Perth Institute of Contemporary Arts (PICA), Perth
'Trevor Nickolls and Paintings by Emily Kame Kngwarreye, Ginger Riley Munduwalawala and Rover Thomas'
— Hogarth Galleries, Sydney
'Contemporary Aboriginal Art from The Robert Holmes à Court Collection'
— Moree Plains Gallery, Moree
'Joan and Peter Clemenger Triennial Exhibition of Contemporary Australian Art'
— National Gallery of Victoria, Melbourne
'After the Field … A Contemporary Australian Abstraction'
— Utopia Art Sydney
— Manly Art Gallery, Sydney
'Landmarks'
— Chapman Gallery, Canberra
'Chandler Coventry: A Private Collection'
— Campbelltown City Art Gallery
'Aratjara: Art of the First Australians'
— Kunstsammlung Nordrhein-Westfalen, Düsseldorf
— Hayward Gallery, London
— Louisiana Museum, Humlebaek
'Scarf'
— Greenway Gallery, Hyde Park Barracks, Sydney
'Tjukurrpa, Desert Dreamings: Aboriginal Art from Central Australia (1971–1993)'
— Art Gallery of Western Australia, Perth

1992

'Crossroads — Toward a New Reality: Aboriginal Art from Australia'
— The National Museum of Modern Art, Kyoto
— The National Museum of Modern Art, Tokyo
'Contemporary Aboriginal Art from The Robert Holmes à Court Collection'
— Perth Institute of Contemporary Arts (PICA), Perth
'Bubbles, Baubles and Beads'
— Utopia Art Sydney
'Desert Journeys'
— Chapman Gallery, Canberra
'Paintings from Utopia: Emily Kame Kngwarreye, Ada Bird Petyarre and Gloria Petyarre'
— Gallery Gabrielle Pizzi, Melbourne
'ACAF 3 — The Third Australian Contemporary Art Fair'
— Royal Exhibition Centre, Melbourne
'Aboriginal Art: Utopia in the Desert'
— Nogazaka Arthall, Tokyo, Japan
'Nineteen Ninety Two: New Work'
— Utopia Art Sydney
'My Story My Country: Aboriginal Art and the Land'
— Art Gallery of New South Wales, Sydney
'Aboriginal Painting from the Desert'
— State Ethnographic Museum, St Petersburg, Ukraine
— State Byelorussian Museum of Modern Art, Minsk, Byelorussia (touring)

'Central Australian Aboriginal Art and Craft Exhibition'
— The Araluen Centre, Alice Springs
1991
'Aboriginal Women's Exhibition'
— Art Gallery of New South Wales, Sydney
'Utopia Batik'
— Utopia Art Sydney
'Utopia'
— Utopia Art Sydney
'Utopia Artists'
— Hogarth Galleries, Sydney
'Flash Pictures: by Aboriginal and Torres Strait Islander Artists'
— Australian National Gallery, Canberra
— Tandanya National Aboriginal Cultural Institute,
Adelaide (1993–1994)
'Aboriginal Art and Spirituality'
— The High Court of Australia, Canberra
— Parliament House, Canberra
— The Waverley Centre, Victoria
— Ballarat Fine Art Gallery, Ballarat
'Images of Women'
— S. H. Ervin Gallery, Sydney
'Utopia — A Picture Story: 88 Silk Batiks from The Robert
Holmes à Court Collection'
— Meat Market Gallery, Melbourne
'Australian Aboriginal Art from the Collection of Donald Kahn'
— Lowe Art Museum, University of Miami, USA
'Aboriginal Painting from the Desert'
— Union Gallery, Moscow, Russia
'Through Women's Eyes'
— ATSIC travelling exhibition
1990
'The Last Show'
— Utopia Art Sydney
'Abstraction'
— Art Gallery of New South Wales, Sydney
'Contemporary Aboriginal Art from The Robert Holmes à
Court Collection'
— Carpenter Centre for the Visual Arts, Harvard
University, Boston, USA
— James Ford Bell Museum, University of Minnesota,
Minneapolis, USA
— Lake Oswego Festival of the Arts, Oregon, USA
— The Forum, St Louis, Missouri, USA
— Art Gallery of New South Wales, Sydney
'Painting from the Desert: Contemporary Aboriginal Paintings'
— Plimsoll Gallery, University of Tasmania, Hobart
'New Acquisitions'
— National Gallery of Victoria, Melbourne
'ARCO'
— Madrid, Spain
'CAAMA/Utopia Artists in Residence Project'
— Perth Institute of Contemporary Arts (PICA), Perth
'ACAF 2 — The Second Australian Contemporary Art Fair'
— Royal Exhibition Centre, Melbourne
'Utopian Artists'
— Flinders Lane Gallery, Melbourne
'New Year — New Art'
— Utopia Art Sydney
'Utopia — A Picture Story: 88 Silk Batiks from The Robert
Holmes à Court Collection'
— Tandanya National Aboriginal Cultural Institute,
Adelaide

— The Royal Hibernian Academy, Dublin, Ireland
1989
'Utopian Women'
— Coventry Gallery, Sydney, in association with Utopia
Art, Sydney
'Art from Utopia'
— Austral Gallery, St Louis, USA
'A Summer Project: Utopia Women's Paintings (The First
Works on Canvas)'
— S. H. Ervin Gallery, Sydney
— Orange Regional Gallery, NSW
'Utopia Batik'
— The Araluen Centre, Alice Springs
'Mythscapes: Aboriginal Art of the Desert'
— National Gallery of Victoria, Melbourne
'Aboriginal Art from Utopia'
— Gallery Gabrielle Pizzi, Melbourne
1988
'Contemporary Aboriginal Art'
— Utopia Art Sydney
'A Changing Relationship'
— S. H. Ervin Gallery, Sydney
1977–1987
Exhibited with the Utopia Women's Batik Group in Australia
and abroad

COLLECTIONS

Allen, Allen and Hemsley, Sydney
Artbank, Sydney
Art Gallery of New South Wales, Sydney
Art Gallery of Western Australia, Perth
Auckland City Art Gallery, New Zealand
Benalla Art Gallery, Benalla, Victoria
BP Australia
Campbelltown City Art Gallery, NSW
Chartwell Collection, New Zealand
Coventry Collection, Sydney
Delmore Collection, NT
Donald Kahn Collection, Lowe Art Museum, University of
Miami, USA
Kelton Foundation, Los Angeles, USA
National Gallery of Australia, Canberra
National Gallery of Victoria, Melbourne
Parliament House Art Collection, Canberra
Queensland Art Gallery, Brisbane
The Araluen Centre, Alice Springs
The Holmes à Court Collection, Heytesbury
The Vatican Collection
Transfield Collection
University of New England, NSW
University of New South Wales, Sydney
University of Sydney Union, Sydney

PUBLISHED REFERENCES

ATSIC, *Through Women's Eyes*, Australian Institute of
Aboriginal and Torres Strait Islander Studies, Canberra,
1991.
BATTY, P. & SHERIDAN, N., *CAAMA/UTOPIA Artists-in-
Residence Project: Louie Pwerle and Emily Kame Kngwarreye
1989–1990*, exhibition catalogue, Perth Institute for
Contemporary Arts (PICA), Perth, 1990.

BOULTER, M., *First Solo Exhibition*, Utopia Art Sydney, 1990.

BOULTER, M., *The Art of Utopia: A New Direction in Contemporary Aboriginal Art*, Craftsman House, Sydney, 1991.

BOULTER, M. & HODGES, C., *Australia's First International Art Movement*, Utopia Art Sydney, 1990.

BRASSINGTON, P., SCOTT, M. & BURNS, T. (eds), *Painting from the Desert*, exhibition catalogue, University of Tasmania, Hobart, 1990.

BRODY, A., *Utopia Women's Paintings: The First Works on Canvas — A Summer Project*, exhibition catalogue, Heytesbury Pty Ltd, Perth, 1989.

BRODY, A., *Contemporary Aboriginal Art from The Robert Holmes à Court Collection*, exhibition catalogue, Heytesbury Pty Ltd, Perth, 1990.

BRODY, A., *Utopia — A Picture Story: 88 Silk Batiks from The Robert Holmes à Court Collection*, exhibition catalogue, Heytesbury Pty Ltd, Perth, 1990.

BRODY, A., 'Emily Kame Kngwarreye', in A. Brody (ed.), *Stories: Eine Reise zu den großen Dingen — Elf Künstler der australischen Aborigines. Werke aus der Sammlung Holmes à Court, Perth*, exhibition catalogue, Sprengel Museum, Hannover, 1995, pp. 65–69.

CADZOW, J., 'Emily's Gift: The Late Flowering of a Desert Genius', *Good Weekend, Sydney Morning Herald Magazine*, 5 August, 1995.

CARUANA, W., *Aboriginal Art*, World of Art Series, Thames & Hudson, London, 1993.

COOKE, L. (ed.), *Jurassic Technologies Revenant: 10th Biennale of Sydney*, exhibition catalogue, Biennale of Sydney, 1996, pp. 87, 131.

CRUMLIN, R. & KNIGHT, A., *Aboriginal Art and Spirituality: A Souvenir Book of Aboriginal Art in the Australian National Gallery*, Collins Dove, Melbourne, 1991.

FENNER, F., 'A New Approach to Landscape', *Sydney Morning Herald (Arts)*, 4 July 1992, p. 41.

FENNER, F., 'Making a Break with Tradition', *Sydney Morning Herald, (Arts)* 6 February 1993.

GREEN, C., *Peripheral Vision: Contemporary Australian Art 1970–1994*, Craftsman House, Sydney, 1995.

GREEN, J., *Utopia: Women, Country and Batik*, Utopia Women's Batik Group, Alice Springs, 1981.

GREEN, J., 'Utopian Women', in I. White., D. Barwick, & B. Meehan (eds) *Fighters and Singers: The Lives of Some Aboriginal Women*, George Allen & Unwin, Sydney, 1985.

GUINNESS, D., 'Kngwarreye Colours the World', *Australian (The Arts on Friday)*, 11 December 1992, p. 10.

HART, D., *Emily Kame Kngwarreye: Paintings from 1989–1995, Works from the Delmore Collection*, Parliament House, Canberra, 1995.

HART, D., *Place and Perception: New Acquisitions: Parliament House Art Collection*, exhibition catalogue, Parliament House, Canberra, 1995.

HART, D. et al., *Identities: Art from Australia*, exhibition catalogue, Taipei Fine Arts Museum, Taiwan, 1993.

HODGES, C., 'Utopia', *Artlink: Contemporary Aboriginal Art*, Special Double Issue, Vol. 10, Nos 1 and 2, 1992, pp. 9–10.

INGRAM, T., 'Emily Starts an Art Movement so the Artist Changes her Spots', *Financial Review*, 11 August 1994, p. 29.

JOHNSON, V., 'Twentieth Century Dreaming: Contemporary Aboriginal Art', *Art Asia Pacific*, Vol. 1, No. 1, December 1993.

JOHNSON, V., *Aboriginal Artists of the Western Desert: A Biographical Dictionary*, Craftsman House, Sydney, 1994.

KAVANAGH, J., 'Different Ages of a Painter's Style', *Business Review Weekly*, 1 August, 1994, p. 122.

LOWE ART MUSEUM, *Australian Aboriginal Art from the Collection of Donald Kahn, 1991*, University of Miami, Florida, 1991.

LUTHI, B. (ed.), *Aratjara: Art of the First Australians*, exhibition catalogue, Dumont Buchverlag, Cologne, Germany, 1993.

LYNN, E., 'Beguiled by Black Woman's Adventures in the Abstract', *Australian (Weekend Review)*, 19–20 June, 1993.

LYNN, V., *Abstraction*, exhibition catalogue, Art Gallery of New South Wales, Sydney, 1990.

McCULLOCH, S., 'Abstract Artistry Rooted in Tradition', *Australian*, 4 September 1996, p. 16.

NEALE, M., *Yiribana: An Introduction to the Aboriginal and Torres Strait Islander Collection: The Art Gallery of New South Wales*, exhibition catalogue, Art Gallery of New South Wales, Sydney, 1994.

NUTTALL, W., *Contemporary Australian Abstraction*, exhibition catalogue, Niagara Galleries, Melbourne, 1996.

O'FERRALL, M. A., in T. Uchiyama et al., *Crossroads — Toward a New Reality: Aboriginal Art from Australia*, exhibition catalogue, The National Museum of Modern Art, Kyoto, 1992.

O'FERRALL, M. A., *Tjukurrpa — Desert Dreamings: Aboriginal Art from Central Australia (1971–1993)*, exhibition catalogue, Art Gallery of Western Australia, Perth, 1993.

PERKINS, H., *Aboriginal Women's Exhibition*, exhibition catalogue, Art Gallery of New South Wales, Sydney, 1991.

QUAIL, A., *Marking Our Times: Selected Works of Art from the Aboriginal and Torres Strait Islander Collection, National Gallery of Australia*, Thames & Hudson, Sydney, 1996.

RYAN, J., *Mythscapes: Aboriginal Art of the Desert from the National Gallery of Victoria*, exhibition catalogue, National Gallery of Victoria, Melbourne, 1989.

SMITH, T., 'Rethinking Regionalism: Art in the Northern Territory', *Art and Australia*, Vol. 31, No. 4, Winter 1994.

TALMACS, R., *Communicative Abstraction /Philosophical Reflections*, Utopia Art Sydney, 1992.

WALLACE, D., DESMOND, M. & CARUANA, W., *Flash Pictures: by Aboriginal and Torres Strait Islander Artists*, exhibition catalogue, Australian National Gallery, Canberra, 1991.

MAXIE
TJAMPITJINPA

BORN c. 1945, WARLPIRI

PAPUNYA/ALICE SPRINGS, NORTHERN TERRITORY

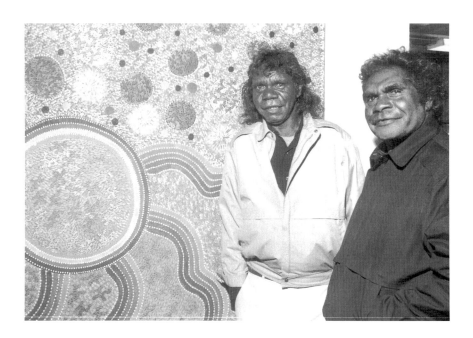

SOLO EXHIBITIONS

1996
'Spinifex Burning'
 — Utopia Art Sydney
1993
'Works on Paper'
 — Utopia Art Sydney
1992
'Bush Fire'
 — Utopia Art Sydney
1991
Gallery Gabrielle Pizzi, Melbourne

JOINT EXHIBITION

1993
'Mick Namararri: New Works and Maxie Tjampitjinpa:
Works on Paper'
 — Utopia Art Sydney

GROUP EXHIBITIONS

1996
'Contemporary Australian Abstraction'
 — Niagara Galleries, Melbourne
'Summer Project'
 — Utopia Art Sydney
1995
'Stories: Eine Reise zu den großen Dingen — Elf Künstler der
australischen Aborigines. Werke aus der Sammlung Holmes à
Court, Perth'
 — Sprengel Museum, Hannover
 — Museum für Völkerkunde zu Leipzig
 — Haus der Kulturen der Welt, Berlin
 — Ludwig Forum für internationale Kunst, Aachen
'Painted Dreams: Western Desert Paintings from the Johnson
Collection'
 — Art Gallery of New South Wales, Sydney
'Australian Art 1940–1990 from the Collection of The
National Gallery of Australia'

— Museum of Fine Arts
'Works on Paper'
— Utopia Art Sydney
'International Works on Paper Fair'
— Mitchell Galleries, State Library of NSW, Sydney
1994
'ACAF 4 – The Fourth Australian Contemporary Art Fair'
— Royal Exhibition Centre, Melbourne
'Eunice Napangardi, Maxie Tjampitjinpa and Pansy
Napangardi'
— Hogarth Galleries, Sydney
1993
'Tarinoita: Contemporary Australian Aboriginal Art'
— Keravan Taidemuseo, Helsinki, Finland
'Gold Coast City Conrad Jupiter's Art Prize'
— Gold Coast City Art Gallery, QLD
'International Works on Paper Fair, Stage 1'
— Powerhouse Museum, Sydney
'Contemporary Aboriginal Art from The Robert Holmes à
Court Collection'
— Moree Plains Gallery, Moree
1992
Gallery Rai, Tokyo
'ACAF 3 — The Third Australian Contemporary Art Fair'
— Royal Exhibition Centre, Melbourne
'Contemporary Aboriginal Art from The Robert Holmes à
Court Collection'
— Perth Institute of Contemporary Arts (PICA), Perth
'My Story, My Country — Aboriginal Art and the Land'
— Art Gallery of New South Wales, Sydney
'New Work'
— Utopia Art Sydney
'Seven'
— Ivan Dougherty Gallery, Sydney
'Bubbles, Baubles and Beads'
— Utopia Art Sydney
1991
'Flash Pictures: by Aboriginal and Torres Strait Islander Artists'
— Australian National Gallery, Canberra
— Tandanya National Aboriginal Cultural Institute,
Adelaide (1993–1994)
'The Painted Dream'
— Auckland City Art Gallery, New Zealand
— National Art Gallery and Museum, Wellington, New
Zealand
'Small Paintings Major Works'
— Utopia Art Sydney
'Desert Paintings'
— S. H. Ervin Gallery, Sydney
'Long Hot Summer'
— Utopia Art Sydney
1990
'New Year — New Art'
—Utopia Art Sydney
— Dreamtime Gallery, Broadbeach, Queensland
'Contemporary Aboriginal Art from The Robert Holmes à
Court Collection'
— Carpenter Centre for the Visual Arts, Harvard
University, Boston, USA
— James Ford Bell Museum, University of Minnesota,
Minneapolis, USA
— Lake Oswego Festival of the Arts, Oregon, USA
— The Forum, St Louis, Missouri, USA

1989
John Weber Gallery, New York, USA
Gallery Gabrielle Pizzi, Melbourne
1988
'Dreamings: The Art of Aboriginal Australia'
— Asia Society Gallery, USA
'Papunya Tula Artists'
— Wagga Wagga City Art Gallery
'EXPO 88'
— Brisbane
'Ageless Art'
— Queensland Museum, Brisbane
'European and Australian Paintings from The Robert Holmes
à Court Collection'
— S. H. Ervin Gallery, Sydney
1987
'Central Australian Paintings from The Robert Holmes à
Court Collection'
— Undercroft Gallery, University of Western Australia,
Perth
— Gallery Gabrielle Pizzi, Melbourne
1986
'Roar 2 Studios, Melbourne'
Sydney Opera House Exhibition Hall, Sydney

COLLECTIONS

Allen, Allen and Hemsley, Sydney
Art Gallery of South Australia, Adelaide
Art Gallery of Western Australia, Perth
Auckland City Art Gallery, Auckland, NZ
Berndt Museum of Anthropology, University of Western
Australia, Perth
Moree Plains Gallery, Moree
Museums and Art Galleries of the Northern Territory, Darwin
National Gallery of Australia, Canberra
National Gallery of Victoria, Melbourne
Parliament House, Canberra
Queensland Art Gallery, Brisbane
Sydney University Union, Sydney
The Araluen Centre, Alice Springs
The Holmes à Court Collection, Heytesbury
The Kelton Foundation, Los Angeles, USA

PUBLISHED REFERENCES

ARMADIO, N. & KIMBER, R., *Wildbird Dreaming: Aboriginal
Art from the Central Deserts of Australia*, Greenhouse
Publications, Melbourne, 1988.
BRODY, A., *Contemporary Aboriginal Art from The Robert Holmes à
Court Collection*, Heytesbury Pty Ltd, Perth, 1990.
BRODY, A. (ed.), *Stories: Eine Reise zu den großen Dingen — Elf
Künstler der australischen Aborigines. Werke aus der Sammlung
Holmes à Court, Perth*, exhibition catalogue, Sprengel
Museum, Hannover, 1995.
CARUANA, W. (ed.), *Windows on the Dreaming: Aboriginal
Paintings in the Australian National Gallery*, Australian
National Gallery, Canberra and Ellsyd Press,
Chippendale, Sydney, 1989.
CARUANA, W., *Aboriginal Art*, World of Art Series, Thames &
Hudson, London, 1993.
CROSSMAN, S. & BAROU, J. P., *L'été australien à Montepellier*,
exhibition catalogue, Liberation, Paris, France, 1990.

CRUMLIN, R. & KNIGHT, A., *Aboriginal Art and Spirituality: A Souvenir Book of Aboriginal Art in the Australian National Gallery*, Collins Dove, Melbourne, 1991.

JOHNSON, V., *The Painted Dream*, exhibition catalogue, Auckland City Art Gallery, 1991.

JOHNSON, V., 'Maxie Tjampitjinpa', *Art and Text*, No. 50, January 1995.

KEAN, J. et al., *East to West: Land in Papunya Tula Painting*, The National Aboriginal Cultural Institute, Adelaide, 1990.

MARSHALL-STONEKING, B., *Papunya Tula Paintings*, exhibition catalogue, Wagga Wagga City Art Gallery, 1988.

O'FERRALL, M. A., *Tjukurrpa — Desert Dreamings: Aboriginal Art from Central Australia (1971–1993)*, exhibition catalogue, Art Gallery of Western Australia, Perth, 1993.

PREMONT, R. & LENNARD, M., *Tjukurrpa Desert Paintings of Central Australia*, Centre for Aboriginal Artists, Alice Springs, 1988.

WALLACE, D., DESMOND, M. & CARUANA, W. *Flash Pictures: by Aboriginal and Torres Strait Islander Artists*, exhibition catalogue, Australian National Gallery, Canberra, 1991.

ABIE JANGALA

BORN c.1920, WARLPIRI

LAJAMANU, NORTHERN TERRITORY

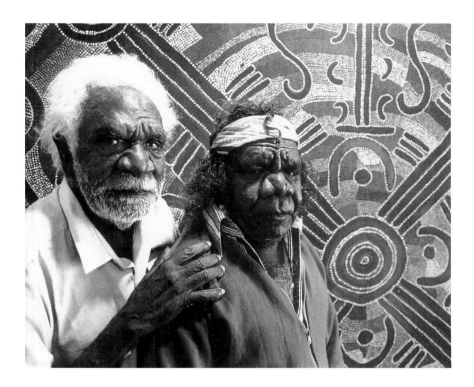

SOLO EXHIBITIONS

1993
'Abie Jangala – Boss of the Water – Rain – Clouds and
Thunder Dreaming'
— Coo-ee Aboriginal Art, Sydney

GROUP EXHIBITIONS

1996
'Abie Jangala and Artists from Lajamanu'
— Coo-ee Aboriginal Art, Sydney
'This is My Country. This is Me.'
— Seattle Art Museum, Downtown, Seattle, USA
'Nangara: The Australian Aboriginal Art Exhibition – From
the Ebes Collection'
— Sichting Sint-Jan, Brugges, Belgium
1995
'Stories: Eine Reise zu den großen Dingen — Elf Künstler der
australischen Aborigines. Werke aus der Sammlung Holmes à
Court, Perth'
— Sprengel Museum, Hannover
— Museum für Völkerkunde zu Leipzig

— Haus der Kulturen der Welt, Berlin
— Ludwig Forum für internationale Kunst, Aachen
1993
'Tjukurrpa Desert Dreamings: Aboriginal Art from Central
Australia (1971–1993)'
— Art Gallery of Western Australia, Perth
'Contemporary Aboriginal Art from The Robert Holmes à
Court Collection'
— Moree Plains Gallery, Moree
1992
'Crossroads — Toward a New Reality: Aboriginal Art from
Australia'
— The National Museum of Modern Art, Kyoto
— The National Museum of Modern Art, Tokyo
'Contemporary Aboriginal Art from The Robert Holmes à
Court Collection'
— Perth Institute of Contemporary Arts (PICA), Perth
1991
'Yapa: Peintres Aborigènes de Balgo et Lajamanu'
— Baudoin Lebon Editeur Gallery, Paris
'Flash Pictures: by Aboriginal and Torres Strait Islander Artists'
— Australian National Gallery, Canberra
— Tandanya National Aboriginal Cultural Institute,

Adelaide (1993–1994)

'Aboriginal Art and Spirituality'
— The High Court of Australia, Canberra
— Parliament House, Canberra
— The Waverley Centre, Victoria
— Ballarat Fine Art Gallery, Ballarat

1990

'Contemporary Aboriginal Art from The Robert Holmes à Court Collection'
— Carpenter Centre for the Visual Arts, Harvard University, Boston, USA
— James Ford Bell Museum, University of Minnesota, Minneapolis, USA
— Lake Oswego Festival of the Arts, Oregon, USA
— The Forum, St Louis, Missouri, USA
— Art Gallery of New South Wales, Sydney

1989

'Mythscapes: Aboriginal Art of the Desert'
— National Gallery of Victoria, Melbourne
'Lajamanu Painters'
— Dreamtime Gallery, Perth

1988

'Paintings from Lajamanu, N.T.'
— Gallery Gabrielle Pizzi, Melbourne

1987

'Australian Made'
— Hogarth Galleries, Sydney

1983

'D'un autre continent: L'Australie le rêve et le réel'
— ARC/Musée d'Art Moderne de la Ville de Paris, Paris

COLLECTIONS

Art Gallery of Western Australia, Perth
Bromberg Collection, Cincinnati, USA
Kaplan Levi Collection, Seattle, USA
National Gallery of Australia, Canberra
National Gallery of Victoria, Melbourne
Queensland Art Gallery, Brisbane
The Holmes à Court Collection, Heytesbury

PUBLISHED REFERENCES

BRODY, A., *Contemporary Aboriginal Art from The Robert Holmes à Court Collection*, exhibition catalogue, Heytesbury Pty Ltd, Perth, 1990.

BRODY, A., 'Abie Jangala', in A. Brody (ed.), *Stories: Eine Reise zu den großen Dingen — Elf Künstler der australischen Aborigines. Werke aus der Sammlung Holmes à Court, Perth*, exhibition catalogue, Sprengel Museum, Hannover, 1995, pp. 89–98.

CARUANA, W., *Aboriginal Art*, World of Art Series, Thames & Hudson, London, 1993.

GLOWCZEWSKI, B., *Yapa: Peintres Aborigènes de Balgo et Lajamanu*, Baudoin Lebon Editeur Gallery, France, 1991.

JANGALA, A., 'Abe Jangala', in *Stories From Lajamanu*, Northern Territory Department of Education, Curriculum and Assessment Branch, Darwin, 1977.

JOHNSON, V., *Aboriginal Artists of the Western Desert: A Biographical Dictionary*, Craftsman House, Sydney, 1994.

MEGGITT, M. J., *A Study of the Walpiri Aborigines of Central Australia*, Angus & Robertson, Sydney, 1962.

MONTY, S., 'Abie Jangala: Despite Trucking and Resettlement Still Boss of the Water Dreaming', *Artlink, Contemporary Aboriginal Art*, Vol. 10, Nos 1 and 2, autumn/winter 1990.

O'FERRALL, M. A., in T. Uchiyama et al., *Crossroads — Toward a New Reality: Aboriginal Art from Australia*, exhibition catalogue, The National Museum of Modern Art, Kyoto, 1992.

O'FERRALL, M. A., *Tjukurrpa — Desert Dreamings: Aboriginal Art from Central Australia (1971—1993)*, exhibition catalogue, Art Gallery of Western Australia, Perth, 1993.

PAGE, S. (ed.), *D'un autre continent: l'Australie le rêve et le réel*, ARC/Musée d'Art Moderne de la Ville de Paris, Paris, 1983.

RYAN, J., *Mythscapes: Aboriginal Art of the Desert from the National Gallery of Victoria*, exhibition catalogue, National Gallery of Victoria, Melbourne, 1989.

WALLACE, D., DESMOND, M. & CARUANA, W., *Flash Pictures: by Aboriginal and Torres Strait Islander Artists*, exhibition catalogue, Australian National Gallery, Canberra, 1991.

GINGER RILEY
MUNDUWALAWALA

BORN c. 1939, MARA
NGUKURR, NORTHERN TERRITORY

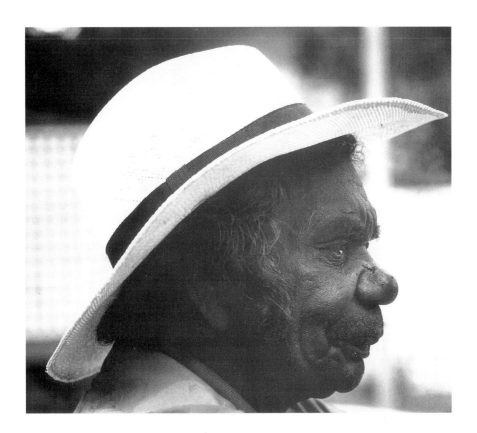

AWARDS AND COMMISSIONS

1996
AFL Centennial Art Expo: group commission
1993
Australia Post, Aboriginal Australia stamp series
Australian Heritage Commission Art Award for the Year of
 the World's Indigenous People
1992
The Alice Prize: The Alice Springs Art Foundation
Poster Design, Northern Territory Art Award
The Australian Government for the Australian Embassy, Beijing

SOLO EXHIBITIONS

1996
'Ginger at Le Louvre'
 — Alcaston House Gallery, Melbourne
1995
'Ginger Riley Munduwalawala — "You can see for a long
way"'
 — Alcaston House Gallery, Melbourne
1994
'Ginger Riley Munduwalawala'
 — Alcaston House Gallery, Melbourne

1991

'Ginger Riley Munduwalawala: Limmen Bight Country'
— Tandanya National Aboriginal Cultural Institute,
Adelaide, in conjunction with Alcaston House Gallery,
Melbourne
'Ginger Riley Munduwalawala: My Mother's Country,
Limmen Bight'
— Hogarth Galleries, Sydney, in conjunction with
Alcaston House Gallery, Melbourne
'Ginger Riley Munduwalawala'
— The Australia Gallery, Soho, New York, in conjunction
with Alcaston House Gallery, Melbourne
'Ginger Riley Munduwalawala: Limmen Bight Country'
— William Mora Gallery, Melbourne, in conjunction
with Alcaston House Gallery, Melbourne

1990

'Limmen Bight Country: Works on Canvas, Paper and Board'
— William Mora Gallery, Melbourne, in conjunction
with Alcaston House Gallery, Melbourne

GROUP EXHIBITIONS

1996

'Hidden Treasures'
— AFL Centennial Art Expo, Melbourne Function
Centre, Melbourne
'Nangara: The Australian Aboriginal Art Exhibition — From
the Ebes Collection'
— Sichting Sint-Jan, Brugges, Belgium

1995

'Stories: Eine Reise zu den großen Dingen — Elf Künstler der
australischen Aborigines. Werke aus der Sammlung Holmes à
Court, Perth'
— Sprengel Museum, Hannover
— Museum für Völkerkunde zu Leipzig
— Haus der Kulturen der Welt, Berlin
— Ludwig Forum für internationale Kunst, Aachen
'Interweave — Tapestry: A Collaborative Art'
— Museum of Modern Art at Heide, Melbourne
'Roper River'
— Hogarth Gallery, Sydney
'12th National Aboriginal and Torres Strait Islander National
Art Award'
— Museums and Art Galleries of the Northern Territory,
Darwin
— Westpac Gallery, Melbourne
— Brisbane City Hall Art Gallery and Museum, Brisbane
— S. H. Ervin Gallery, Sydney
— Tandanya, National Aboriginal Cultural Institute,
Adelaide

1994

'Power of the Land: Masterpieces of Aboriginal Art'
— National Gallery of Victoria, Melbourne
'Icons of Aboriginal Australia'
— Gallery Australis, Adelaide
'Contemporary Territory'
— Museums and Art Galleries of the Northern Territory,
Darwin
'Yiribana: An Introduction to the Aboriginal and Torres Strait
Islander Collection at the Art Gallery of New South Wales'
— Art Gallery of New South Wales, Sydney
'Tyerabarrbowaryaou 11'
— Museum of Contemporary Art (MOCA), Sydney

— The Fifth Havana Biennal, Cuba
'The John McCaughey Memorial Art Prize'
— National Gallery of Victoria, Melbourne

1993

'Aratjara: Art of the First Australians'
— Kunstsammlung Nordrhein-Westfalen, Düsseldorf
— Hayward Gallery, London
— Louisiana Museum, Humlebaek
'Contemporary Aboriginal Art from The Robert Holmes à
Court Collection'
— Moree Plains Gallery, Moree
'National Bank: River Collection'
—Travelling exhibition
'Trevor Nickolls and Paintings by Emily Kame Kngwarreye,
Ginger Riley Munduwalawala and Rover Thomas'
— Hogarth Galleries, Sydney

1992

'The Alice Prize'
— The Araluen Centre, Alice Springs
'Contemporary Aboriginal Art from The Robert Holmes à
Court Collection'
— Perth Institute of Contemporary Arts (PICA), Perth
'Heritage of Namatjira'
— Travelling exhibition
'Ngundungunya Association of Artists — Ngukurr, NT'
— Hogarth Galleries, Sydney in conjunction with
Alcaston House Gallery, Melbourne
'Crossroads — Toward a New Reality: Aboriginal Art from
Australia'
— The National Museum of Modern Art, Kyoto
— The National Museum of Modern Art, Tokyo

1991

'Aboriginal Art and Spirituality'
— The High Court of Australia, Canberra
— Parliament House, Canberra
— The Waverley Centre, Victoria
— Ballarat Fine Art Gallery, Ballarat
'Flash Pictures: by Aboriginal and Torres Strait Islander Artists'
— Australian National Gallery, Canberra
— Tandanya National Aboriginal Cultural Institute,
Adelaide (1993–1994)

1990

'Contemporary Aboriginal Art from The Robert Holmes à
Court Collection'
— Carpenter Centre for the Visual Arts, Harvard
University, Boston, USA
— James Ford Bell Museum, University of Minnesota,
Minneapolis, USA
— Lake Oswego Festival of the Arts, Oregon, USA
— The Forum, St Louis, Missouri, USA
— Art Gallery of New South Wales, Sydney
'Balance 1990: Views, Visions, Influences'
— Queensland Art Gallery, Brisbane
'Ngukurr: Recent Paintings'
— Gallery Gabrielle Pizzi, Melbourne

1989

'A Myriad of Dreaming: Twentieth Century Aboriginal Art'
— Westpac Gallery, Melbourne
— Design Warehouse, Sydney

1988

'Art from Ngukurr'
— Aboriginal and Islander Studies Unit, University of
Queensland

1987
'National Aboriginal Art Award'
— Museums and Art Galleries of the Northern Territory, Darwin

COLLECTIONS

Art Gallery of New South Wales, Sydney
Art Gallery of Western Australia, Perth
Australian Embassy, Beijing
Australia Post, Sydney
Ballarat Fine Art Gallery, Ballarat
Margaret Carnegie Collection
Museums and Art Galleries of the Northern Territory, Darwin
National Gallery of Australia, Canberra
National Gallery of Victoria, Melbourne
Supreme Court, Darwin
Queensland Art Gallery, Brisbane
Tandanya National Aboriginal Cultural Institute, Adelaide
The Araluen Centre, Alice Springs
The Australian Embassy, Beijing
The Holmes à Court Collection, Heytesbury
The National Bank of Australia
Victorian Tapestry Workshop

PUBLISHED REFERENCES

BRODY, A., *Contemporary Aboriginal Art from The Robert Holmes à Court Collection*, exhibition catalogue, Heytesbury Pty Ltd, Perth, 1990.

BRODY, A., 'Ginger Riley Munduwalawala: His Own Man', *Art and Australia*, Vol. 33, No. 1, spring 1995, pp. 70–79.

'Caring for Country: Aboriginal Perspectives on Conservation', *Habitat Australia*, Vol. 19, No. 3, June 1991.

CARUANA, W., *Aboriginal Art*, World of Art Series, Thames & Hudson, London, 1993.

CRUMLIN, R., & KNIGHT, A., *Aboriginal Art and Spirituality: A Souvenir Book of Aboriginal Art in the Australian National Gallery*, Collins Dove, Melbourne, 1991.

DIGGINS, L. et al., *A Myriad of Dreaming: Twentieth Century Aboriginal Art*, Malakoff Fine Art Press, Melbourne, 1989.

LUTHI, B. (ed.), *Aratjara: Art of the First Australians*, exhibition catalogue, Dumont Buchverlag, Cologne, Germany, 1993.

MERRIGAN, K., 'Picturing the Land of Our Diplomats', *Sunday Age*, 22 February 1992.

MUNDINE, D., 'Ginger Riley Munduwalawala', in A. Brody (ed.), *Stories: Eine Reise zu den großen Dingen — Elf Künstler der australischen Aborigines. Werke aus der Sammlung Holmes à Court, Perth*, exhibition catalogue, Sprengel Museum, Hannover, 1995, pp. 99–101.

NEALE, M., *Yiribana: An Introduction to the Aboriginal and Torres Strait Islander Collection: The Art Gallery of New South Wales*, exhibition catalogue, Art Gallery of New South Wales, Sydney, 1994.

O'FERRALL, M. A., in T. Uchiyama et al., *Crossroads — Toward a New Reality: Aboriginal Art from Australia*, exhibition catalogue, The National Museum of Modern Art, Kyoto, 1992.

WALLACE, D., DESMOND, M. & CARUANA, W., *Flash Pictures: by Aboriginal and Torres Strait Islander Artists*, exhibition catalogue, Australian National Gallery, Canberra, 1991.

WEST, M., *12th National Aboriginal and Torres Strait Islander Art Award*, exhibition catalogue, Museums and Art Galleries of the Northern Territory, Darwin, 1995.

WICKS, G., 'Art on Issue', *Australia Now*, Vol. 16, No. 2, 1993.

JACK WUNUWUN

1930–1990 MURRUNGUN/DJINANG
GAMERDI, NEAR MANINGRIDA, NORTHERN TERRITORY

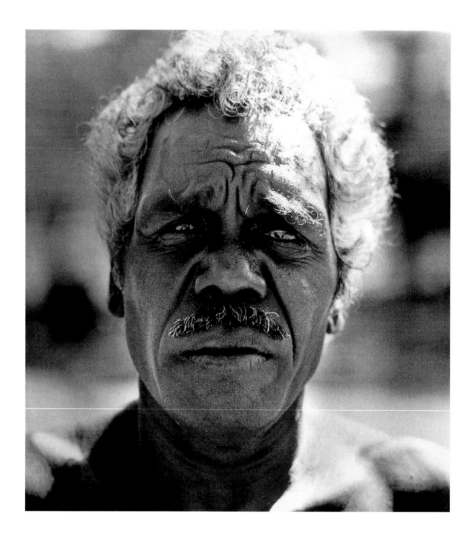

AWARDS

1987
National Aboriginal Artist of the Year
Aboriginal Arts Board Professional Development Grant
1984
Second Prize, Inaugural National Aboriginal Art Award,
 Museums and Art Galleries of the Northern Territory,
 Darwin

SOLO EXHIBITION

1990
Garry Anderson Gallery, Sydney

GROUP EXHIBITIONS

1995
'Stories: Eine Reise zu den großen Dingen — Elf Künstler der
australischen Aborigines. Werke aus der Sammlung Holmes à
Court, Perth'
 — Sprengel Museum, Hannover
 — Museum für Völkerkunde zu Leipzig
 — Haus der Kulturen der Welt, Berlin
 — Ludwig Forum für internationale Kunst, Aachen
1994
'Aratjara: Art of the First Australians'
 — Kunstsammlung Nordrhein-Westfalen, Düsseldorf
 — Hayward Gallery, London

— Louisiana Museum, Humlebaek

1993

'Ten Years of Acquisitions from the ANU Collection'
— Drill Hall Gallery, Canberra

'Contemporary Aboriginal Art from The Robert Holmes à Court Collection'
— Moree Plains Gallery, Moree

1992

'Contemporary Aboriginal Art from The Robert Holmes à Court Collection'
— Perth Institute of Contemporary Arts (PICA), Perth

1991

'Flash Pictures: by Aboriginal and Torres Strait Islander Artists'
— Australian National Gallery, Canberra
— Tandanya National Aboriginal Cultural Institute, Adelaide (1993–1994)

1990

'Contemporary Aboriginal Art from The Robert Holmes à Court Collection'
— Centre for the Visual Arts, Harvard University, Boston, USA
— James Ford Bell Museum, University of Minnesota, Minneapolis, USA
— Lake Oswego Festival for the Arts, Oregon, USA
— The Forum, St Louis, Missouri, USA

1988

'Bulawirri/Bugaja — A Special Place'
— National Gallery of Victoria, Melbourne

'Morning Star Song Cycle'
— Garry Anderson Gallery, Sydney

1986

'My Country, My Story, My Painting: Recent Paintings by Twelve Arnhem Land Artists'
— Australian National Gallery, Canberra

'Arnhem Land Painters'
— Kobei Museum, Japan

1983

'Artists of Arnhem Land'
— Canberra School of Art

COLLECTIONS

Art Gallery of Western Australia, Perth
Central Collection, Australian National University, Canberra
Museums and Art Galleries of the Northern Territory, Darwin
Museum of Contemporary Art, Sydney
Museum of Victoria, Melbourne
National Gallery of Australia, Canberra
National Gallery of Victoria, Melbourne
National Museum of Ethnology, Osaka, Japan
The Holmes à Court Collection, Heytesbury

PUBLISHED REFERENCES

BRODY, A., *Contemporary Aboriginal Art from The Robert Holmes à Court Collection*, exhibition catalogue, Heytesbury Pty Ltd, Perth, 1990.

BRODY, A. (ed.), *Stories: Eine Reise zu den großen Dingen — Elf Künstler der australischen Aborigines. Werke aus der Sammlung Holmes à Court, Perth*, exhibition catalogue, Sprengel Museum, Hannover, 1995.

CARUANA, W., *Australian Aboriginal Art: A Souvenir Book of Aboriginal Art in the Australian National Gallery*, Australian National Gallery, Canberra, 1987.

CARUANA, W. (ed.), *Windows on the Dreaming: Aboriginal Paintings in the Australian National Gallery*, Australian National Gallery, Canberra, and Ellsyd Press, Sydney, 1989.

CARUANA, W., *Aboriginal Art*, World of Art Series, Thames & Hudson, London, 1993.

GANDADILLA, T. & EDOLS, M., *Songs of the Dreamtime*, Australia Post publication, Fidado, Sydney, 1995.

LUTHI, B. (ed.), *Aratjara: Art of the First Australians*, exhibition catalogue, Dumont Buchverlag, Cologne, Germany, 1993.

MOON, D., 'Jack Wunuwun', in A. Brody (ed.), *Stories: Eine Reise zu den großen Dingen — Elf Künstler der australischen Aborigines. Werke aus der Sammlung Holmes à Court, Perth*, exhibition catalogue, Sprengel Museum, Hannover, 1995, pp. 111–115.

SMITH, B. & SMITH, T., *Australian Painting 1788–1990*, 3rd edition, Oxford University Press, Melbourne, 1991.

J I M M Y W U L U L U

BORN c. 1936, DAYURRGURR/GUPAPUYNGU
RAMINGINING, NORTHERN TERRITORY

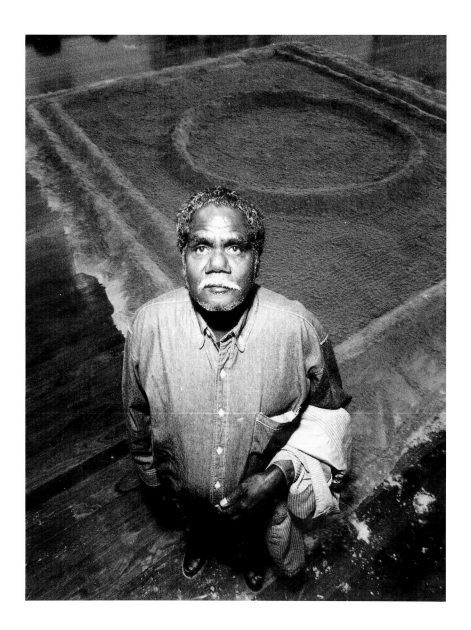

SOLO EXHIBITION

1987
'Jimmy Wululu'
— The Esplanade Gallery, Darwin

JOINT EXHIBITIONS

1993
'Dimensions: Jimmy Wululu/Phillip Gudthaykudthay'
— Fremantle Arts Centre, Perth
1992
'Paintings and Sculptures from Ramingining: Jimmy Wululu
and Phillip Gudthaykudthay'
— Drill Hall Gallery, Canberra School of Art, Canberra

1995

'Stories: Eine Reise zu den großen Dingen — Elf Künstler der australischen Aborigines. Werke aus der Sammlung Holmes à Court, Perth'
— Sprengel Museum, Hannover
— Museum für Völkerkunde zu Leipzig
— Haus der Kulturen der Welt, Berlin
— Ludwig Forum für internationale Kunst, Aachen

1994

'Gemaltes Land: Kunst der Aborigines aus Arnhemland'
— Linden Museum, Stuttgart

'Tyerabarrbowaryaou II'
— Museum of Contemporary Art, Sydney

1993

'Aratjara: Art of the First Australians'
— Kunstsammlung Nordrhein-Westfalen, Düsseldorf
— Hayward Gallery, London
— Louisiana Museum, Humlebaek

1992

'Couleur du Temps'
— Collector au Trianon, Le Petit Trianon, Paris

'Ramingining Artists'
— Gold Coast City Art Centre, QLD

1991

'Flash Pictures: by Aboriginal and Torres Strait Islander Artists'
— Australian National Gallery, Canberra
— Tandanya National Aboriginal Cultural Institute, Adelaide (1993–1994)

1990

'L'été Australien'
— Musée Fabre, Montpellier, France

'Tagari Lia: My Family — Contemporary Aboriginal Art 1990: From Australia'
— The Third Eye Centre, Glasgow, Scotland
— Glynn Vivian Art Gallery and Museum, Swansea, UK
— Cornerhouse, Manchester, UK

1989

'Magiciens de la Terre'
— Centre Georges Pompidou, Musée National d'Art Moderne, Paris

'Aboriginal Art: The Continuing Tradition'
— Australian National Gallery, Canberra

1988

'Dreamings: The Art of Aboriginal Australia'
— The Asia Society Galleries, New York USA

'The Inspired Dream'
— Museums and Art Galleries of the Northern Territory, Darwin, in association with the Queensland Art Gallery, Brisbane

1986

'Ramingining Art'
— The Araluen Centre, Alice Springs

1984

'Objects and Representations from Ramingining'
— Power Institute, Sydney

COLLECTIONS

Art Gallery of Western Australia, Perth
Berndt Museum of Anthropology, WA
John Kluge Collection, Virginia, USA
Kelvingrove Museum, Glasgow, Scotland
Linden Museum, Stuttgart, Germany
Museums and Art Galleries of the Northern Territory, Darwin
Museum of Contemporary Art, Sydney
National Gallery of Australia, Canberra
National Gallery of Victoria, Melbourne
South Australian Museum, Adelaide
The Holmes à Court Collection, Heytesbury

PUBLISHED REFERENCES

BRODY, A. (ed.), *Stories: Eine Reise zu den großen Dingen — Elf Künstler der australischen Aborigines. Werke aus der Sammlung Holmes à Court, Perth*, exhibition catalogue, Sprengel Museum, Hannover, 1995.

CARUANA, W., *Australian Aboriginal Art: A Souvenir Book of Aboriginal Art in the National Gallery of Australia*, Australian National Gallery, Canberra, 1987.

CARUANA, W.(ed.), *Windows on the Dreaming: Aboriginal Paintings in the Australian National Gallery*, Australian National Gallery, Canberra, and Ellsyd Press, Sydney, 1990.

CARUANA, W., *Aboriginal Art*, World of Art Series, Thames & Hudson, London, 1993.

MARTIN, J. H., *Magicienes de la Terre*, Musée National d'Art Moderne, Centre Georges Pompidou, Paris, 1989.

MUNDINE, D., 'Jimmy Wululu', in A. Brody (ed.), *Stories: Eine Reise zu den großen Dingen — Elf Künstler der australischen Aborigines. Werke aus der Sammlung Holmes à Court, Perth*, exhibition catalogue, Sprengel Museum, Hannover, 1995, pp. 125–127.

SUTTON, P. (ed.), *Dreamings: The Art of Aboriginal Australia*, exhibition catalogue, Viking, New York, 1988.

WALLACE, D., DESMOND, M. & CARUANA, W., *Flash Pictures: by Aboriginal and Torres Strait Islander Artists*, Australian National Gallery, Canberra, 1991.

BIBLIOGRAPHY

ACKERMAN, K., 'Western Australia: A Focus on Recent Developments in the East Kimberley', in W. Caruana (ed.), *Windows on the Dreaming: Aboriginal Paintings in the Australian National Gallery*, Australian National Gallery, Canberra, and Ellsyd Press, Sydney, 1989.

ARMADIO, N. & KIMBER, R., *Wildbird Dreaming: Aboriginal Art from the Central Deserts of Australia*, Greenhouse Publications, Melbourne, 1988.

Artlink: Contemporary Australian Aboriginal Art: Landmark Reprint 1992, Vol. 10, Nos 1 and 2, autumn/winter 1990.

ATSIC, *Through Women's Eyes*, Australian Institute of Aboriginal and Torres Strait Islander Studies, Canberra, 1991.

BARDON, G., *Aboriginal Art of the Western Desert*, Rigby, Adelaide, 1979.

BARDON, G., *Papunya Tula: Art of the Western Desert*, McPhee Gribble/Penguin, Ringwood, Victoria, 1991.

BAROU, J. P. & CROSSMAN, S. (eds), *L'été australien à Montpellier: 100 chefs-d'œuvre de la peinture australienne*, exhibition catalogue, Libération, Paris, and Musée Fabre, Montpellier, France, 1990.

BATTY, P., 'Money, Corruption and Authenticity', *Artlink*, Vol. 10, Nos 1 and 2, 1990.

BATTY, P. & SHERIDAN, N., *CAAMA/UTOPIA Artists-in-Residence Project: Louie Pwerle and Emily Kame Kngwarreye 1989–1990*, exhibition catalogue, Perth Institute of Contemporary Arts (PICA), Perth, 1990.

BERNDT, R M. & BERNDT, C H., *The Speaking Land: Myth and Story in Aboriginal Australia*, Penguin, Ringwood, Victoria, 1989.

BISKUP, P., *Not Slaves, Not Citizens: The Aboriginal Problem in Western Australia, 1898–1954*, University of Queensland Press, St Lucia, 1965.

BOULTER, M., *The Art of Utopia: A New Direction in Contemporary Aboriginal Art*, Craftsman House, Sydney, 1991.

BOULTER, M. & HODGES, C., *Australia's First International Art Movement*, Utopia Art Sydney, 1990.

BRASSINGTON, P., SCOTT, M. & BURNS, T. (eds), *Painting from the Desert*, exhibition catalogue, University of Tasmania, Hobart, 1990.

BRODY, A., *The Face of the Centre: Papunya Tula Paintings 1971–84*, exhibition catalogue, National Gallery of Victoria, Melbourne, 1985.

BRODY, A., *Contemporary Aboriginal Art from The Robert Holmes à Court Collection*, exhibition catalogue, Heytesbury Pty Ltd, Perth, 1990.

BRODY, A., *Utopia—A Picture Story: 88 Silk Batiks from The Robert Holmes à Court Collection*, exhibition catalogue, Heytesbury Pty Ltd, Perth, 1990.

BRODY, A., 'Ginger Riley Munduwalawala: His Own Man', *Art and Australia*, Vol. 33, No. 1, spring 1995.

BRODY, A. (ed.), *Stories: Eine Reise zu den großen Dingen — Elf Künstler der australischen Aborigines. Werke aus der Sammlung Holmes à Court, Perth*, exhibition catalogue, Sprengel Museum, Hannover, 1995.

CARUANA, W., *Australian Aboriginal Art: A Souvenir Book of Aboriginal Art in the Australian National Gallery*, Australian National Gallery, Canberra, 1987.

CARUANA, W. (ed.), *Windows on the Dreaming: Aboriginal Paintings in the Australian National Gallery*, Australian National Gallery, Canberra, and Ellsyd Press, Sydney, 1989.

CARUANA, W., *Aboriginal Art*, World of Art Series, Thames & Hudson, London, 1993.

COWAN, J., *Wirrimanu: Aboriginal Art from the Balgo Hills*, Craftsman House, Sydney, 1994.

CRUMLIN, R. & KNIGHT, A., *Aboriginal Art and Spirituality: A Souvenir Book of Aboriginal Art in the Australian National Gallery*, Collins Dove, Melbourne, 1991.

DAVIE, A., *Contemporary Aboriginal Art 1990: From Australia*, exhibition catalogue, Aboriginal Arts Management Association, Sydney, in association with Third Eye Centre, Glasgow, 1990.

DIGGINS, L. et al., *A Myriad of Dreaming: Twentieth Century Aboriginal Art*, Malakoff Fine Art Press, Melbourne, 1989.

EBES, H. et al., *Nangara: The Australian Aboriginal Art Exhibition from the Ebes Collection*, exhibition catalogue, Aboriginal Gallery of Dreamings, Melbourne, 1996.

FRY, T. & WILLIS, A., 'Aboriginal Art: Symptom or Success?', *Art in America*, Vol. 77, No. 7, 1989, pp. 108–117, 159–163.

GANDADILLA, T. & EDOLS, M., *Songs of the Dreamtime*, Australia Post publication, Fidado, Sydney, 1995.

GLOWCZEWSKI, B., *Yapa: Peintres Aborigènes de Balgo et Lajamanu*, Baudoin Lebon Editeur Gallery, France, 1991.

GREEN, C., *Peripheral Vision: Contemporary Australian Art 1970–1994*, Craftsman House, Sydney, 1995.

GREEN, J., *Utopia: Women, Country and Batik*, Utopia Women's Batik Group, Alice Springs, 1981.

GROGER-WURM, H., *Australian Aboriginal Bark Paintings and their Mythological Interpretation*, Vol. 1, *Eastern Arnhem Land*, Australian Institute of Aboriginal Studies, Canberra, 1973.

HART, D., *Place and Perception: New Acquisitions: Parliament House Art Collection*, Parliament House, Canberra, 1995.

HART, D. et al., *Identities: Art from Australia*, exhibition catalogue, Taipei Fine Arts Museum, Taiwan, 1993.

HORTON, D. (ed.), *The Encyclopedia of Aboriginal Australia*, Aboriginal Studies Press for the Australian Institute of Aboriginal and Torres Strait Islander Studies, Canberra, 1994.

HUDSON, J.& RICHARDS, E. et al., *The Walmajarri: An Introduction to the Language and Culture*, Summer Institute of Linguistics, Australian Aborigines Branch, Darwin, 1976, 1978, 1984.

JANGALA, A. et al., *Stories from Lajamanu*, Northern Territory Department of Education, Curriculum & Assessment Branch, Darwin, 1977.

JOHNSON, V., 'Twentieth Century Dreaming: Contemporary Aboriginal Art', *Art Asia Pacific*, Vol. 1, No. 1, December 1993.

JOHNSON, V., *Aboriginal Artists of the Western Desert: A Biographical Dictionary*, Craftsman House, Sydney, 1994.

JOHNSON, V., *The Art of Clifford Possum Tjapaltjarri*, Craftsman House, and G & B Arts International, Sydney, 1994.

JOHNSON, V., *Copyrites: Aboriginal Art in the Age of Reproductive Technologies*, NIAAA, Sydney, 1996.

JOHNSON, V., *Michael Jagamara Nelson*, Craftsman House, Sydney and G & B Arts International, Sydney, 1996.

KEAN, J. et al., *East to West: Land in Papunya Tula Painting*, Aboriginal Cultural Institute, Adelaide, 1990.

KENTISH, D. & von STURMER, J., *You Listen Me! — An Angry Love*, exhibition catalogue, 1st and 2nd editions, Duncan Kentish Fine Art, Adelaide, 1995.

KRONENBERG, S., 'Aboriginal Art: The Secret Display', *Tension Magazine*, No. 17, August 1989, pp. 37, 46–47.

LANGTON, M., 'Aboriginal Art in 1988: A Complex Reality', *Artlink*, Vol. 8, No. 2, June 1988.

LOWE ART MUSEUM, *Australian Aboriginal Art from the Collection of Donald Kahn, 1991*, University of Miami, Florida, 1991.

LUTHI, B. (ed.), *Aratjara: Art of the First Australians*, exhibition catalogue, Dumont Buchverlag, Cologne, Germany, 1993.

LYNN, V., *Abstraction*, exhibition catalogue, Art Gallery of New South Wales, Sydney, 1990.

McGUIGAN, C. (ed.), *New Tracks Old Land: Contemporary Prints from Aboriginal Australia*, Aboriginal Arts Management Association, Sydney, 1992.

MARTIN, J., *Magiciens de la terre*, Musée National d'Art Moderne, Centre Georges Pompidou, Paris, 1989.

MEGGITT, M. J., *A Study of the Warlpiri Aborigines of Central Australia*, Angus & Robertson, Sydney, 1962.

MICHAELS, E., 'Bad Aboriginal Art', *Art & Text*, March–May 1988, pp. 59–73.

MYERS, F., 'Truth, Beauty and Pintupi Painting', *Visual Anthropology Review*, Vol. 2, 1989, pp. 163–195.

MYERS, F., 'Beyond the Initial Fallacy: Art Criticism and the Ethnography of Aboriginal Acrylic Painting', *Visual Anthropology Review*, Vol. 10, No. 1, spring 1994, pp. 10–43.

NEALE, M., 'The Cult of Cultural Convergence: Black on White or White on Black', *Art Monthly Australia*, 1994, pp. 7–8.

NEALE, M., *Yiribana: An Introduction to the Aboriginal and Torres Strait Islander Collection: The Art Gallery of New South Wales*, exhibition catalogue, Art Gallery of New South Wales, Sydney, 1994.

NUTTALL, W., *Contemporary Australian Abstraction*, exhibition catalogue, Niagara Galleries, Melbourne, 1996.

O'FERRALL, M. A., *On the Edge: Five Contemporary Aboriginal Artists*, exhibition catalogue, Art Gallery of Western Australia, Perth, 1989.

O'FERRALL, M. A., 'Australia to the World', *Artlink*, Vol. 10, Nos 1 and 2, 1990, pp. 66–67.

O'FERRALL, M. A., in T. Uchiyama et al., *Crossroads — Toward a New Reality: Aboriginal Art from Australia*, exhibition catalogue, The National Museum of Modern Art, Kyoto, 1992.

O'FERRALL, M. A., *Tjukurrpa —— Desert Dreamings: Aboriginal Art from Central Australia (1971–1993)*, exhibition catalogue, Art Gallery of Western Australia, Perth, 1993.

PAGE, S., *D'un autre continent: l'Australie le rêve et le réel*, ARC/Musée d'Art Moderne de la Ville de Paris, Paris, 1983.

PERKINS, H., *Aboriginal Women's Exhibition*, exhibition catalogue, Art Gallery of New South Wales, Sydney, 1991.

PETERSON, N., 'Art of the Desert', in C. Cooper et al., *Aboriginal Australia*, exhibition catalogue, Art Gallery Directors Council of Australia, Sydney, 1981, pp. 43–50.

PREMONT, R. & LENNARD, M., *Tjukurrpa Desert Paintings of Central Australia*, Centre for Aboriginal Artists, Alice Springs, 1988.

PROCTOR, G. (comp.), *Yarnangu Ngaanya: Our Land — Our Body: Contemporary Cultural Expression by the Ngaanyatjarra People of the Western Desert*, exhibition catalogue, Perth Institute of Contemporary Arts (PICA), Perth, 1993.

QUAIL, A., *Marking Our Times: Selected Works of Art from the Aboriginal and Torres Strait Islander Collection, National Gallery of Australia*, Thames & Hudson, Melbourne, 1996.

RUBINSTEIN, M., 'Outstations of the Postmodern', *Arts Magazine*, March 1989.

RYAN, J., *Mythscapes: Aboriginal Art of the Desert from the National Gallery of Victoria*, exhibition catalogue, National Gallery of Victoria, Melbourne, 1989.

RYAN, J., *Paint Up Big: Warlpiri Women's Art of Lajamanu*, exhibition catalogue, National Gallery of Victoria, Melbourne, 1990.

RYAN, J. & ACKERMAN, K., *Images of Power: Aboriginal Art of the Kimberley*, exhibition catalogue, National Gallery of Victoria, Melbourne, 1993.

SMITH, B. & SMITH, T., *Australian Painting 1788–1990*, 3rd edition, Oxford University Press, Melbourne, 1991.

SMITH, T., 'Rethinking Regionalism: Art in the Northern Territory', *Art and Australia*, Vol. 31, No. 4, winter 1994.

SMOKER, J., *Turkey Creek: Recent Work*, Deutcher Gertrude Street, Melbourne, 1989.

SMOKER, J., 'Waringarri Aboriginal Arts, Kununurra, WA', *Artlink*, Vol. 10, Nos 1 and 2, 1990.

STANTON, J. E., *Innovative Aboriginal Art of Western Australia*, exhibition catalogue, Anthropology Museum, University of Western Australia, 1988.

STANTON, J. E., *Painting the Country: Contemporary Aboriginal Art from the Kimberley Region, Western Australia*, University of Western Australia Press, Perth, 1989.

SUTTON, P. (ed.), *Dreamings: The Art of Aboriginal Australia*, exhibition catalogue, Viking, New York, 1988.

THOMAS, R. et al., *Roads Cross: The Paintings of Rover Thomas*, exhibition catalogue, National Gallery of Australia, Canberra, 1994.

von STURMER, J., 'Aborigines, Representation, Necrophilia', *Art and Text*, No. 32, March 1989, pp. 133, 144.

von STURMER, J., 'Devotedly Yours', in *Yarnangu Ngaanya: Our Land — Our Body*, exhibition catalogue, Perth Institute of Contemporary Arts (PICA), Perth, 1993.

WALLACE, D., DESMOND, M. & CARUANA, W., *Flash Pictures: by Aboriginal and Torres Strait Islander Artists*, exhibition catalogue, Australian National Gallery, Canberra, 1991.

WATSON, C., 'Contemporary Aboriginal Art: The Bicentenary and Beyond — Recent Developments in Aboriginal Printmaking', *Artlink*, Vols 1 and 2, 1990–1992, pp. 70–72.

WEST, M., *The Inspired Dream: Life as Art in Aboriginal Australia*, Queensland Art Gallery, Brisbane, 1988.

WEST, M., *12th National Aboriginal & Torres Strait Islander Art Award*, exhibition catalogue, Museums and Art Galleries of the Northern Territory, Darwin, 1995.

WHITE, I., Barwick, D. & Meehan, B. (eds), *Fighters and Singers: The Lives of Some Aboriginal Women*, George Allen & Unwin, Sydney, 1985.

WICKS, G., 'Art on Issue', *Australia Now*, Vol. 16, No. 2, Department of Foreign Affairs and Trade, Canberra, 1993.

ABOUT THE AUTHORS

ANNE BRODY

Anne Brody was born in Melbourne in 1948. She has a Bachelor of Arts (Hons) in Fine Arts and English Literature from Melbourne University (1971). In 1973 she joined the Decorative Arts Department of the National Gallery of Victoria. In 1978 Brody received a VPS Post Graduate Studies Award and obtained an MSc in Social Anthropology from University College, London.

In 1980 Brody returned to the National Gallery of Victoria as Assistant Curator (Tribal Art). In 1984 she curated 'Kunwinjiku Bim: Western Arnhem Land' paintings and in 1985 'The Face of the Centre: Papunya Tula Paintings' 1971–1985.

In mid-1987 Brody joined The Robert Holmes à Court Collection as Curator of Aboriginal Art and one year later she became Curator of the entire Collection to 1995. During the period 1990 to 1991 she produced the exhibitions and catalogues *Contemporary Aboriginal Art* and *Utopia — A Picture Story*.

Since late 1995 Brody has been a freelance art consultant and researcher. Brody lives in Perth and her current projects include publications on Emily Kame Kngwarreye and Gloria Tammerre Petyarre.

VIVIEN JOHNSON

Dr Vivien Johnson is a Sydney writer who has been an active supporter and researcher of Western Desert art for over fifteen years. A Senior Lecturer in sociology at Macquarie University, she has taught and written extensively on Aboriginal art, including a biographical dictionary of Western Desert artists.

Other publications Johnson has written include *The Last Resort*, a product of her experience working in the women's refuge movement in the 1970s, and *Radio Birdman*, the biography of a legendary Australian rock band. She is also the author of a monograph on the artist Clifford Possum Tjapaltjarri and has written another on Michael Tjakamarra Nelson published in 1996.

Vivien Johnson lives in Sydney with her two daughters.

DUNCAN KENTISH

Duncan Kentish was born at Mt Gambier in South Australia in 1945. He studied Economics and History at the University of Adelaide during 1964 and 1965. Conscripted to participate in the Vietnam War, Kentish developed a concern with the morality and politics of warfare, culminating in being granted exemption as a conscientious objector in 1966. From 1966 to 1969 he became a Patrol Officer in Papua New Guinea in the Department of District Administration (DDA) in the period of self-government prior to independence.

During 1970 and 1973 he completed a BA in Social Anthropology and History at the University of Queensland. In 1974 he was Tour Manager for the Aboriginal Dance Theatre of North Queensland, which opened the inaugural Queensland Festival for the Arts in Brisbane. From 1982 to 1985 he worked as a project officer with the Department of Aboriginal Affairs (DAA) in Alice Springs, including a four-month period as acting Outstations Adviser at Docker River. During this period his interest in Aboriginal art developed and he began to commission and collect works by the Pintubi artist Anajjari Tjakamarra.

In late 1986 Kentish visited Fitzroy Crossing where he met Jarinyanu David Downs and Peter Skipper. As a result of this encounter, he became commissioning agent and exhibitions curator for both artists. Kentish, who is currently working on a monograph on Jarinyanu David Downs, lives in Adelaide.

DIANE MOON

Diane Moon was born in Brisbane in 1942. Moon trained as a weaver and potter. In 1983 she went to live in Ramingining where she was Assistant Art Adviser. From 1985 to 1994 she was Art Adviser with Maningrida Arts and Crafts. Moon has worked on numerous special projects and collections with the artists in this community, including the prestigious Maningrida Collection housed at the Museum of Contemporary Art, Sydney, and 'Bulawirri/Bugaja — A Special Place', an exhibition held at the National Gallery of Victoria in 1988. She has also contributed articles on Maningrida art and artists to journals and other publications.

In 1993 Moon accompanied John Bulun Bulun to Ujung Pandang in Sulawesi where he led his group in presenting *Marayarr Murrukundja*, a public ceremony of diplomacy centred on gift exchange. This important ceremony involving Aboriginal and Macassan people reaffirmed links between the two countries and people which pre-date the European presence in the area.

Diane Moon has two children from her marriage to the Australian painter John Peart and three grandchildren. She is currently working as a consultant in the Aboriginal arts field.

DJON MUNDINE

Djon Mundine was born at Grafton, NSW, in 1951. During 1971 and 1972 he studied Economics and Accounting at Macquarie University. In the mid-1970s he became involved in the Federal Government's agency for Aboriginal Arts and Crafts in Sydney. He moved to Milingimbi in 1979, working as Arts Adviser until 1982. Then he moved to Ramingining, where he held the position of Arts Adviser from 1993 until 1995. He also held the position of Curator-in-the-Field for the Art Gallery of New South Wales from 1982 to 1992.

Throughout 1992 and 1993 Djon was guest Curator of Special Projects at the Museum of Contemporary Art in Sydney. He co-curated 'Tyerabarrbowaryaou' with Fiona Foley in 1993, and 'Tyerabarrbowaryaou 2', which travelled to the Havana Biennale in May 1994. During 1993 and 1994 Djon was Touring Curator for the 'Aratjara: Art of the First Australians' exhibition that toured Düsseldorf, London and Humlebaek (Denmark). Djon is currently Senior Curator, Aboriginal Art, at the Museum of Contemporary Art and lives in Sydney.

CHRISTINE WATSON

Christine Watson completed her BA (Hons) in History at the University of Sydney from 1970 to 1973. From 1974 to 1985 she was employed within the Commonwealth Department of Aboriginal Affairs. During this time she travelled to Aboriginal communities in Central Australia, Arnhem Land, New South Wales and Victoria.

From 1981 to 1983 she completed a BA from the Australian National University, majoring in Anthropology and Art History. In 1985 she obtained a Diploma of Museums Studies from the University of Sydney.

Watson co-curated the Aboriginal art exhibitions 'Urban Koories' in 1986, and 'Aboriginal Australian Views in Print and Poster' in 1987. From 1989 to 1992 Watson worked as an Exhibition Organiser, Gallery Manager and Curator for Coo-ee Aboriginal Art in Sydney. During this time she organised exhibitions of artworks by local Koori artists and works from remote communities, and began writing catalogue articles.

In 1992 Watson undertook a Master of Art to research Balgo women's painting and its relation to traditional media, continuing her fieldwork in the Balgo area of Western Australia.